UNDERSTANDING
OWLS

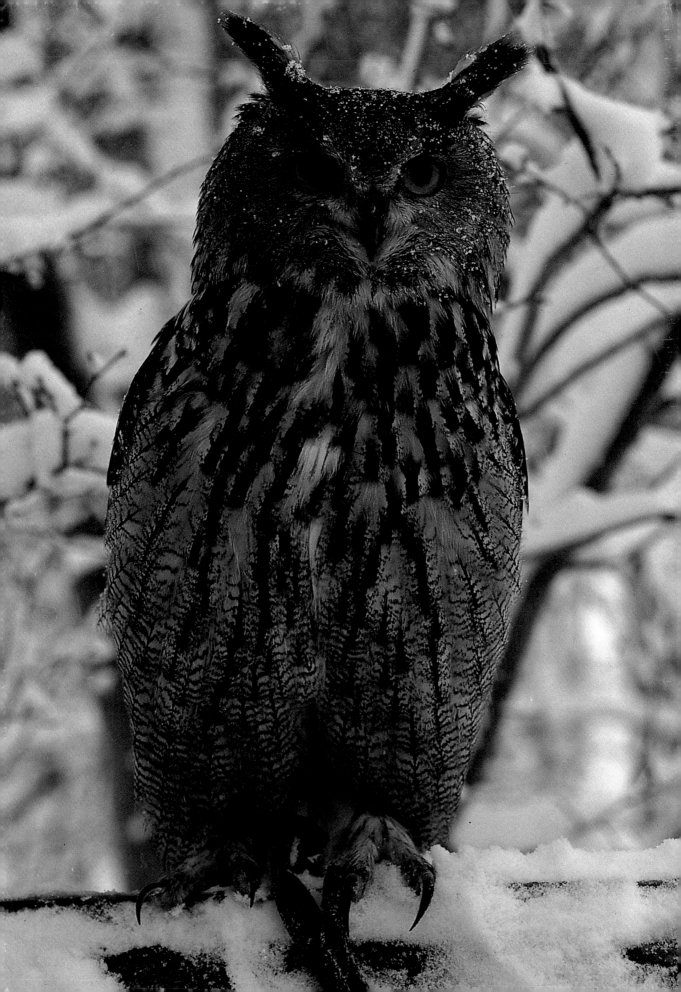

UNDERSTANDING
OWLS

BIOLOGY • MANAGEMENT • BREEDING • TRAINING

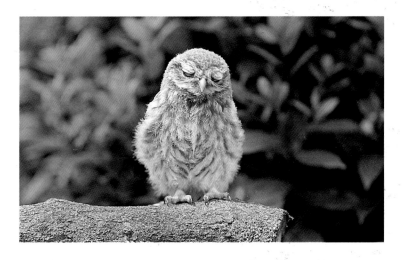

Jemima Parry-Jones

DAVID & CHARLES

▩ *Page 2: A very old picture of Mozart before we built his aviary – which explains the tether!*
Page 3: Young Little Owl handed in from the wild for rehabilitation
Page 5: Moosehead Premium – a Snowy Owl in snow!
Page 6–7: The National Birds of Prey Centre

A DAVID & CHARLES BOOK

First published in the UK in 1998

A catalogue record for this book is available from the British Library.

ISBN 0 7153 0643 X

Book design by Visual Image
Printed in France by Impremerie Pollina S.A.
for David & Charles
Brunel House Newton Abbot Devon

598.97

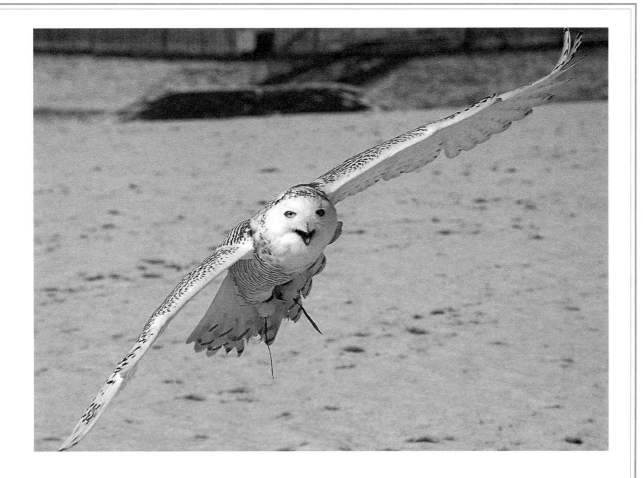

CONTENTS

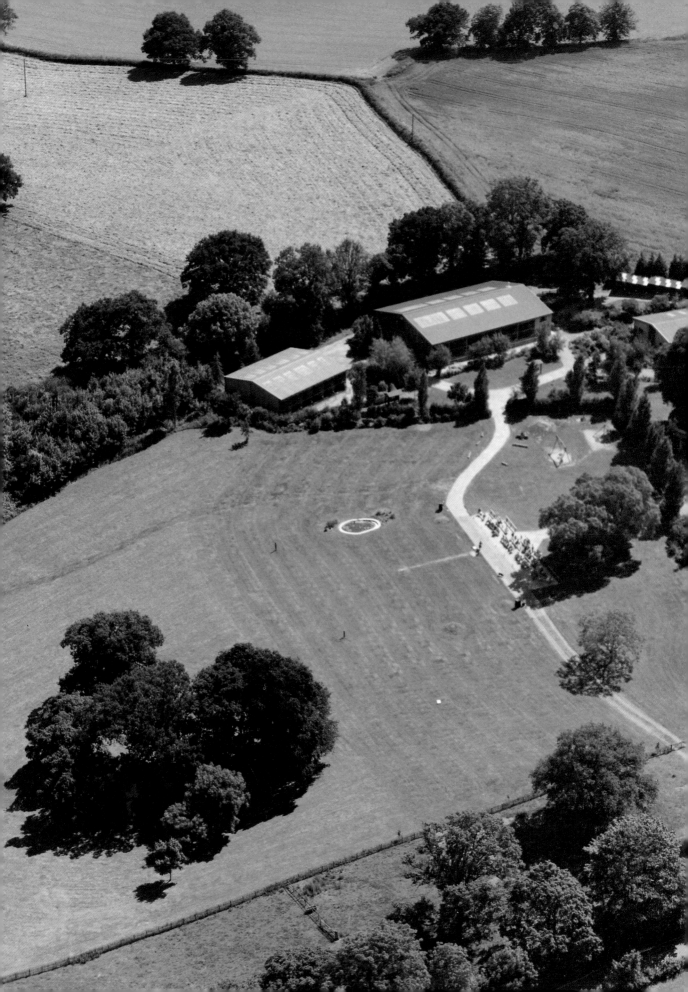

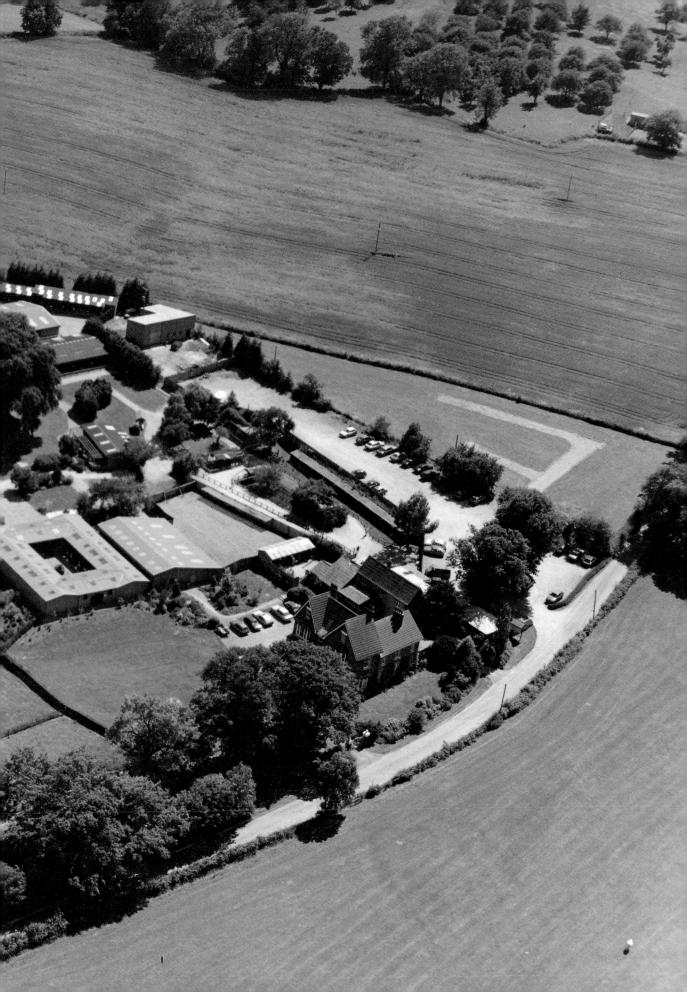

INTRODUCTION

As I start to write this book it is early January and Britain is in the grip of arctic weather – it is well below freezing for most, if not all of the day as well as at night. This alone makes it quite difficult to keep all our diurnal and nocturnal birds of prey well and comfortable. To add to that we have this morning had notice through the post from MAFF (Ministry of Agriculture, Fisheries and Food) to say that there has been a Newcastle's disease outbreak in the UK, and that we are in the 'surveillance area'. A phone call from Neil Forbes, our vet, and a discussion as to how this might affect us, has meant that we have now, twelve hours after the letter arriving, received the vaccine that was brought down by courier from Stoke-on-Trent, and inoculated over half the collection, with the other half to do tomorrow. Neil Forbes was with us for today so that we could do the birds that are more difficult and might be more inclined to suffer from stress. Injecting tiny Pearl Spotted Owlets weighing about 2oz (50g) is not fun, but as far as the owls were concerned it all went well. We lost a breeding female Merlin to stress, but that was the price I paid for protecting all the birds – it was a calculated risk and I had to accept the consequences, hard though it was.

Right now I am really supposed to be writing – namely this book on Owls! – not spending hours inoculating; but as those of you who have livestock will know – and what those of you who are considering having owls *should* know – what you plan to do in life, and what your livestock actually needs you to do, are completely different!

Owls have become increasingly popular recently: as pets; as birds that specialists want to breed, or that people want to fly for pleasure; or to train and fly for demonstrations at zoos and bird of prey centres; and even as birds to use for hunting, although I have to say I think they are far from ideal for that last objective or aim.

As an owl sits looking at you, its round face, large head, forward-facing eyes and alert look might persuade you that it is wise, as is so often stated. Sadly that is probably not the case, and having trained a fair number of owls now, I have to say that if there was anything going on in their heads I would be surprised. That aside, they are these days probably one of the most popular group of birds there are.

This was not always the case, however, and during Victorian times owls, like other birds of prey, were mercilessly persecuted for supposedly taking game birds. Game keepers these days are much more aware of conservation issues, and so the shooting of owls is far less prevalent today. But in times gone by, owls, as a general rule, were poor news, the symbols of death and destruction, of illness, of ill luck and heaven knows what else, and thought of as sad, moody, grim, curst, ghostly and lots more besides, particularly by poets and writers. On looking through old poems and books, these writers did not do a lot in the owl's favour – in fact it is amazing that attitudes have changed so much and that the owl now comes so high in the popularity polls.

Anyway, enough of all this; I have to say that I am not particularly interested in the history of things, preferring to look forwards rather than back. Presumably you have bought this book because you want to learn more about owls, either to keep them, breed them, or to train and fly one. You will find that it will help you to do that if you understand a little about where owls fit into the scheme of things in the wild, what problems they are having at this time, and their habits and habitats – it will make it easier to understand the owl. And in furthering your education it should assure your owl of the best possible situation in captivity.

For those of you who are dubious about keeping birds in captivity, remember this: most of the owls that you see in aviaries have probably never been in the wild, and so are unlikely to have feelings

A very young Mozart – our first hand-reared European Eagle Owl

of missing something, if indeed they are capable of that, which I very much doubt. A considerable amount of the knowledge that we have on birds in general and particularly diurnal and nocturnal birds of prey, has come from captive birds. With families of birds such as the owls which are nocturnal and therefore harder to study in the wild, captive study means that there is less stress on both the captive owls and on those in the wild. If they are kept well, they do well, because like the diurnal birds of prey,

they spend enormous amounts of their time in the wild sitting still, doing not a lot, and so adapt to captivity with ease.

There is a phenomenal amount that we don't know about many of the species of owl, much of which could be learnt from good captive breeding and management programmes.

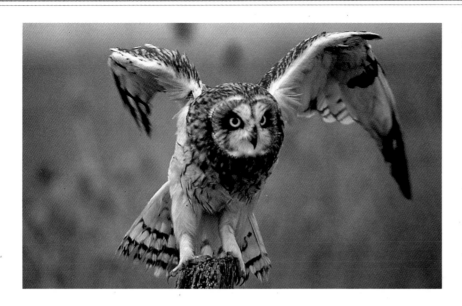

TAXONOMY

WHERE DO OWLS FIT IN?

*T*he owls are divided into families and genera (groups of species) in a similar fashion to that of the diurnal raptors, although there are disagreements as to which owl species belong where, and even more disagreements about subspecies. But this is partly because, even with the understanding and knowledge that we have today, owls need a great deal more research done on them to resolve all the differences of opinion.

Which owl evolved first on this planet is almost impossible to know. Feathers are too fragile to fossilise well, and bird bones, as we shall see, are very light and fine to assist in flight, so they too tend to be destroyed over time. Archaeopteryx was the first known bird, but it has recently been overtaken by some remains found by a Texan paleontologist called Chatterjee who called his new bird Protoavis, (I think he could have done better myself) thus pushing Archaeopteryx out of first place. But as with all new scientific discoveries, some people go with Chatterjee and others are saying the evidence is not good enough.

The beautiful Savigny's Eagle Owl (also known as the Pharoah's or Desert Eagle Owl): well coloured for their desert habitat

The first known owl was thought to be an American owl, not much like any of the owls we know today; it was named *Ogygoptynx wetmorei* and was thought to exist about 60 million years ago. But this chap lost his pride of place because of some leg bones (*tarsometatarsi*) found in Europe and thought to have come from as far back as 135 and 70 million years ago. Suffice it to say that owls have been around for a while.

The interesting fact is that no fossils have been found to link the owl's evolution to the common ancestors of any other group of birds. These days it is virtually accepted that owls are probably most closely related to a group of birds called the *Caprimulgiformes* – which to you and me are the Nightjars, Oilbirds and Frogmouths. It is also known that the *Strigidae* – that is, all the owls that are *not* barn owls or the two related Bay owls – evolved before the *Tytonidae* (which are the barn and bay owls). Actually the barn owls could be as much as 24 million years younger!

Owls, as far as is known, are not related to the diurnal birds of prey: they don't have the same physical structure, feathers or eggs, nor do they have a crop, and they sit with their toes facing differently – two forwards and two back, rather than three forwards and one back. However, with modern techniques and in particular the use of DNA, things may be proved differently, and that there *is* possibly a link with the falcons.

Nevertheless, owls have achieved parallel evolution – that is, they have evolved along the same lines as the hawks, having many similar characteristics such as large, powerful feet and talons, hooked beaks, excellent hearing and eyesight and carnivorous or meat-eating habits. In fact, the owls can be found to replace all the families of diurnal birds of prey at night, except for two: there are no owls that behave in the same way as the large falcons, and none that replace the vultures. This is probably because it would do owls little good to fly and soar high up, or to swoop down at speed when they are using their hearing as much, if not more than their eyesight to locate their prey; nor are they built for speed. And although owls do eat carrion, none specialise quite like the vultures – besides which, dead things tend to be on the still and quiet side, and so would be difficult to locate by sound! Having said that, there are owls that replace the eagles and buzzards, the harriers and the kites, the hawks and even the fish-eating raptors.

OWL TAXONOMY

All living things have been given an order, a scheme of things where every living organism has a place. So the scientist, or just people like you and I, can find out where and what they are – all have been put into some sort of order or list. The order that owls belong to is called *Strigiformes*, as opposed to the diurnal raptors who belong to the order *Falconiformes*, and mankind – or in my case, womankind – who belong to the order *Primata*.

The order is then divided into families, of which the owls have two: *Tytonidae* and *Strigidae*. These in turn are divided into subfamilies: *Tytoninae*, *Phodilinae*, *Buboninae* and *Striginae*. The subfamilies then divide into genus: this is divided twice more, into species and lastly subspecies. Here is an example of how it all works (see page 13): this is the Iranian Eagle Owl, a slightly smaller race of the European Eagle Owl, but a paler colour.

IRANIAN EAGLE OWL *Bubo bubo nikolskii*

PHYLUM *Chordata*, meaning it is a living creature with a hollow dorsal nervecord (like our spinal cord) and a flexible skeletal rod, which in us, and in birds, developed into a backbone, as will be seen in the sub-phylum.

SUB-PHYLUM *Vertebrata*, meaning it is a living thing with a backbone.

CLASS *Aves*, meaning it is a bird, and all that that entails.

ORDER *Strigiformes*, meaning it has the bone structure that is defined as an owl; also defining the order are characteristics such as the colour of the inside of the egg shell and a million other things that I don t really understand and leave to the taxon experts. DNA is now making a huge difference to this field, as it is showing exactly where birds fit in and who is really related to whom.

FAMILY *Strigidae*, meaning that this bird belongs to one of the two owl families.

SUBFAMILY *Buboninae*, a further division of the families, bringing the bird closer to what our eagle owl looks like and how it behaves.

GENUS *Bubo*, the specific group of owls — the eagle owls in this case — into which our owl fits all with particular and similar characteristics.

SPECIES *bubo*, the particular, individual kind of owl it is according to its build, colour, shape, habits and all the other characteristics that differentiate it from other members of its genus.

SUBSPECIES *nikolskii*, when a species covers either a huge area; or different continents; or islands; or even islands of special habitat, and has developed different colours, or calls or size, but not enough to become recognised as a separate species.

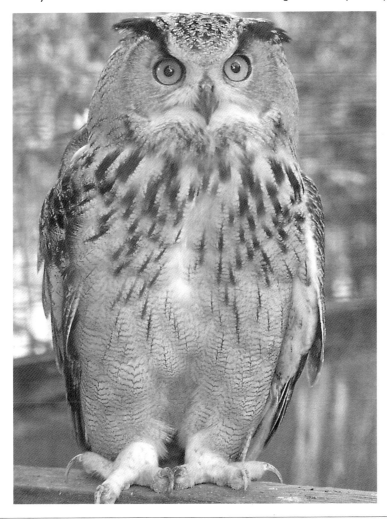

The true Eagles

The Hawk Eagle

■ *The owls developed along a different evolutionary branch as this illustration clearly shows*

The Harriers

The Fish Eagles

The Hawks

The Snake Eagles

The Buzzards

The Old World Vultures

The Kites

The Fishing Owls

All other owls

The Secretary Bird

The Osprey

The Bay and Barn Owls & species

The New World Vultures

The Falcons

Once the subfamilies divide up into genera (the plural for genus) things get a little more complicated. The *Tytonidae* have only two genera and this makes them reasonably easy to deal with, but the *Strigidae* are more of a problem because all the rest of the owls, from huge to tiny, belong here. There are twenty-three genera, although Burton puts *Mimizuku*, the Giant Scops Owl, in with the genus *Otus*. Also referring to Burton's book (*Owls of the World*, see Bibliography), he does not have the genus *Xenoglaux*, the Long-whiskered Owl, because it was discovered three years after his book was published! And I have to say I think that counting the genus *Sceloglaux*, the Laughing Owl of New Zealand, is a bit of a cheat because it hasn't been spotted since 1889 – but then the Madagascar Serpent Eagle was thought to be extinct for a long time, until some researchers found one again in the 1990s.

So there you have it! Complicated, isn't it? But if you read it several times and have a look at the books I have referenced in the back, you will begin to understand it and see where any owl you might have, or want to learn about, fits in and who it is related to, and so on.

I know that all this may be a little more scientific than many might prefer, but it is interesting to know and it is sometimes useful. Really it is only the last three categories that need be understood, and these will help you to look up information in books if, for example, you didn't know the common name for an owl that you were interested in, or that you might see on a trip to somewhere unusual abroad. You would never credit the number of times I receive letters and faxes from abroad about birds in a language I don't understand – yet if the writer had put the scientific name for the bird, I would have known straightaway what species he or she was talking about, with no chance of mistakes.

Anyone who is interested enough to keep an owl, or indeed any animal, is well advised to have a few books on the subject. I would always suggest buying the more up-to-date editions, because research and studies on living things continues apace and so the knowledge is updated, and the old books, attractive though they might be, are often very inaccurate. Also try to get books that are written by people who are known to know their subject, rather than authors who have been asked to write simply because they have a name in another field.

Having sorted out where owls fit in and how the system works, let's go on to look at the owls themselves.

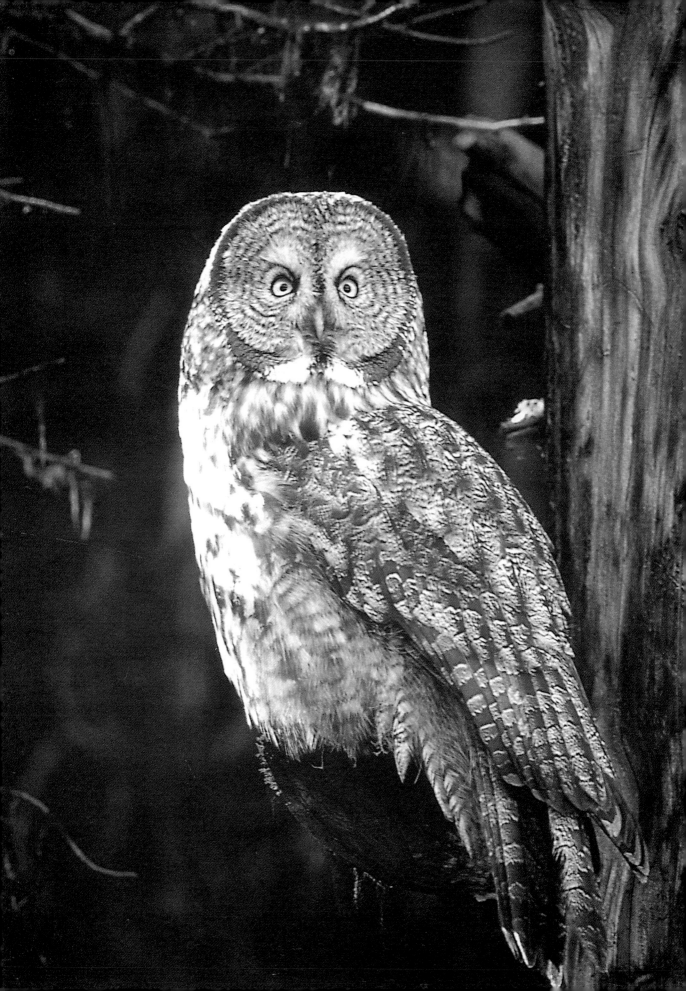

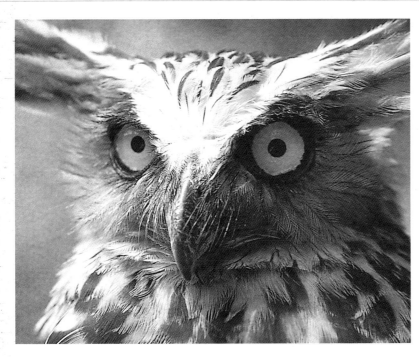

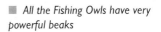
All the Fishing Owls have very powerful beaks

BIOLOGY
OWL ANATOMY,
MORPHOLOGY & BEHAVIOUR

To understand any animal, you need to find out as much as possible about it. Knowing how owls function, both physically and mentally will give you a greater insight into the family as a whole.

Discovering such things as how the skeleton stands, that most of the flight muscles are not on the wings and understanding the way the eyes and ears work all adds up to being able to care for them more sympathetically. As your fund of knowledge grows so will your enthusiasm for keeping owls.

It's also really important to know how they behave in the wild and how to adapt this to their life in captivity.

The Great Gray Owl, like the Snowy Owl circumnavigates the globe. These owls are found in Europe and North America

ANATOMY

(The study of what things look like on the inside)

I don't want to go into great deal of detail here, but it is useful to understand some of how a bird works, in the general sense. It makes it easier to understand weight loss, how birds manage, or not, to fly well, and many other subjects that may come up over the course of your relationship with an owl. I will leave the innards – the gut, heart and so on – to others who are better qualified, or the vet.

Birds have a very different skeleton from mammals in that it is designed for both walking and flying – yes, I know there are some species that don't fly, and others that are not good at all at walking, but as a general rule that is what birds do: fly, or walk, and you would be amazed at how much *walking* most of them do. Many of the bones which would be separated in mammals are fused together in birds, making them strong enough to support their weight on the ground. All birds, with the exception of the rarities – the ostriches and their ilk – have a keel or breast-bone; you will have seen it if you have ever carved a turkey or chicken. This does two jobs: it protects their innards, namely the lungs and heart; and this is where almost all the flight muscles are attached, instead of on the wing bones. This puts the bulk of the weight of a bird away from its wings, and it is these huge muscles that give a bird the power to fly. The flight muscles take up 30 per cent of the bird's total weight, which should help you to understand why a thin bird is weak and unable to fly well: those breast muscles are vital to its well-being.

Many of the bones in a bird are hollow and filled with air in order to bring down the total body-weight and so facilitate flight. To make a bird even lighter and able to fly, it has what are called aircells or airsacs: these are distributed around the body and some actually enter the hollow wing bones.

These airsacs are used when the bird breathes and give it extra buoyancy while in the air. It is these air-sacs that are affected if a bird contracts a disease called *aspergillosis*.

Because a bird is not able to use its wings to pick things up – unlike other creatures which stand on two legs – it has instead a long and very flexible neck which allows it to reach all parts of its body. This means it can keep its feathers in top

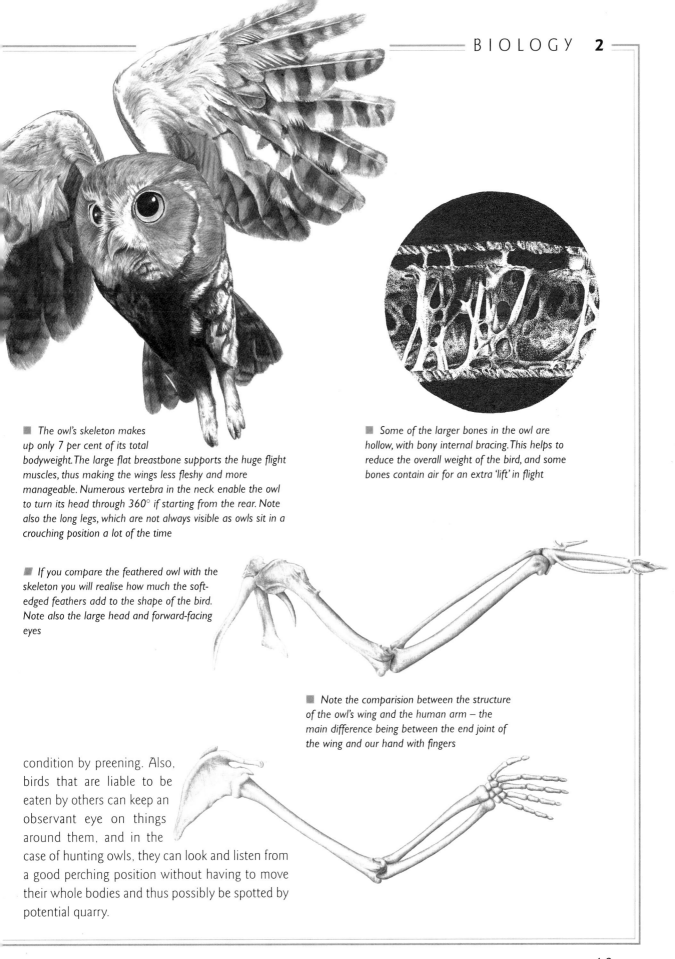

■ The owl's skeleton makes up only 7 per cent of its total bodyweight. The large flat breastbone supports the huge flight muscles, thus making the wings less fleshy and more manageable. Numerous vertebra in the neck enable the owl to turn its head through 360° if starting from the rear. Note also the long legs, which are not always visible as owls sit in a crouching position a lot of the time

■ Some of the larger bones in the owl are hollow, with bony internal bracing. This helps to reduce the overall weight of the bird, and some bones contain air for an extra 'lift' in flight

■ If you compare the feathered owl with the skeleton you will realise how much the soft-edged feathers add to the shape of the bird. Note also the large head and forward-facing eyes

■ Note the comparision between the structure of the owl's wing and the human arm – the main difference being between the end joint of the wing and our hand with fingers

condition by preening. Also, birds that are liable to be eaten by others can keep an observant eye on things around them, and in the case of hunting owls, they can look and listen from a good perching position without having to move their whole bodies and thus possibly be spotted by potential quarry.

MORPHOLOGY

(The study of what things look like on the outside)

The most well-known part of a bird's body – its unique identifying feature – is its feathers, and these are really most amazing in structure. They perform several jobs: first and foremost, they allow the bird to fly (well, except for those that can't!); they keep it warm (and cool); they are used in breeding displays; they keep offspring warm; they can even carry water to young. They come in different shapes and sizes: the visible ones that cover the bird's body and give it its shape are called the contour feathers. The large ones in wing and tail, the flight feathers, are called remiges and rectrices respectively; these are also known as primary and secondary feathers in the wing and tail feathers or train. Keeping the bird warm under these feathers are the semiplumes and the down feathers, and these are vital to maintain body temperature in cold weather. Owls and some other birds also have what are called 'bristles' round the beak: it is these which help me to feed young owls because they are very sensitive, and if you touch them with a tiny piece of meat the owl feels it and will open its beak for food. There are also some weird feathers called filoplumes which are long and hair-like, and work as sensors.

It always annoys me to see paintings or sculptures of birds where the feathers are all sort of thrown together, because *the* most important thing a bird does is to keep its feathers in good condition – without them it can't fly, and then it is doomed. Birds constantly clean, oil, groom, bathe and check their feathers.

■ *Down feathers provide warmth*

■ *Filoplumes give the owl sensitivity*

■ *Contour or body feathers which give the owl its shape*

MORPHOLOGY OF THE DIFFERENT OWL GROUPS

Subfamily *Tytoninae*

The Tytoninae are the youngest in terms of evolution, and they are the twelve species of Barn Owl (although this number of species is not agreed by all); they are classified separately because their bone structure is different from the other owls, amongst other things. The Barn Owl has probably the most pronounced facial disc of all the owls, its heart-shaped face and dark eyes making it unmistakable. The facial disc of soft filo feathers that surround its beak, eye and opening of its ears acts as a parabolic reflector, bouncing the available sound, and to a certain extent light, to eyes and ears, thus making possible the location of the quarry even when it is hidden under leaves, grasses or snow. The disc is really the feather equivalent of our external ears. Most of the Barn Owls have long legs; indeed, some are called Grass Owls and are very agile on the ground. Most have a mottled golden-brown colouring, some all over, others on the back and tops of the wings. The Sooty Owl (*Tyto tenebricosa*) is a notable exception: it is a dark sooty brown with white flecks.

But despite differing colour and size, all the Tytos still look like only a Barn Owl can look, and there is no mistaking them.

Subfamily *Phodilinae*

The two Bay Owls look a little like the barn owls, although the facial disc, which is as marked as the Barn Owl's, is shaped differently, the top part looking almost as if it were ears. A small owl with dark brown

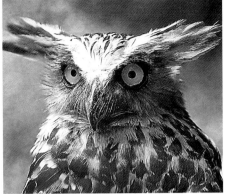

■ *The marked facial disc of the Barn Owl (left), which is far less obvious in, for example, the Eagle Owl (right)*

■ *One of the Fishing Owls: note the strong yellow eyes and the long ear tufts*

eyes, the African Bay Owl (*Phodilus prigoginei*), had only been seen once (as a dead specimen from Zaire in 1951), but was rediscovered in the montane forest of Itombwe in Zaire in May 1996, and so is assumed to still survive in small numbers.

Subfamily *Buboninae*

Also known as the 'typical owls', although what makes them any more typical than any of the others I really don't know, plus it's a huge mixture of owls, including as it does sixteen genera, from the Scops Owls (*Otus*) through to the Eagle Owls (*Bubo*), the Fishing Owls (*Ketupa*) and the Pygmy Owls (*Glaucidium*), to name but a few.

Most of these owls have yellow eyes, like the Scops Owls, the Eagle Owl and most of the Fishing Owls. They vary in size from the smallest of all the owls, the Elf Owl (*Micrathene whitneyi*) and the Pearl Spotted Owlet (*Glaucidium perlatum*), through to the huge Eagle Owls, the largest being the European Eagle Owl. They can have incredibly thick underdown and heavily feathered feet like the Snowy Owl (*Nyctea scandica*), or at the other end of the scale the completely bare legs and toes of the fishing owls.

Subfamily *Striginae*

These include our own commonest British owl, the Tawny Owl (*Strix aluco*). Most of them are medium to small owls; even the Great Grey (*Strix nebulosa*), although looking huge and having a rather grand-sounding name, is literally all feathers – it looks as large as a European Eagle Owl, but actually weighs well under half the weight and has very diminutive feet for the rest of its size. But then it needs lots of feathers to keep it warm as it lives in the freezing north. It feeds mainly on voles. Most of the wood owls have dark brown eyes, until you get to the smaller-eared owls such as the Long-eared Owl (*Asio otus*) and Short-eared Owl (*Asio flammeus*), both of which have yellow eyes.

The last of this group are the four species of tiny forest owls: Tengmalms Owl (*Aegolius funereus*) as it is known in Europe, and the Boreal Owl which is the same species in the US; two Saw-whet Owls; and the Buff-fronted Owl (*Aegolius harrisii*) from South America. These also have yellow eyes, a wide facial disc and a large, flat-topped head and are very small.

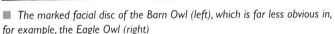

■ *The serrated edge of the outer flight feathers on the owl's wing*

■ *The feather surface is held together by tiny hooks called barbules, which act like Velcro*

DISTRIBUTION/HABITAT

(Where they are, and what type of place they live in)

Tytoninae

The *Tytoninae* are distributed pretty much all over the world except Antarctica – although having said that, it is not a genus that likes the cold and the furthest north it is found is Britain, and here probably only because the gulf stream is supposed to make it warmer in the winter. This Barn Owl (*Tyto alba*) is reputed to be the most widespread land bird in the world, covering most of North and South America, and the more temperate parts of Europe, Afric, India, South-East Asia and Australia. There are thought to be thirty-four subspecies of *Tyto alba*, and they vary in size

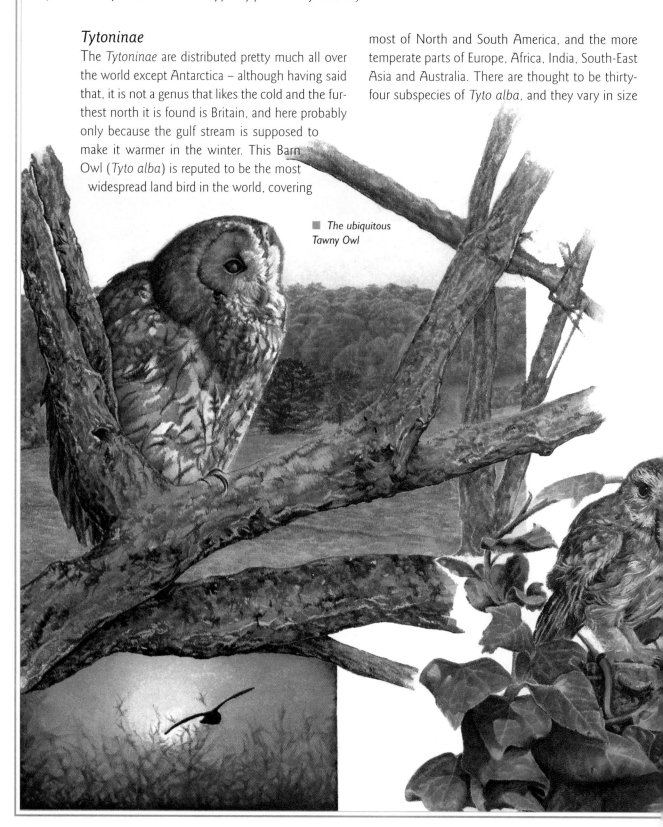

■ The ubiquitous Tawny Owl

and colour: for example the North American Barn Owl (*Tyto a. pratincola*) is larger than the British species; the African Barn Owl (*Tyto a. affinis*) is larger and darker; and the European Barn Owl (*Tyto a. guttata*) is about the same size, but darker – these two subspecies intermingle and probably interbreed. Often a subspecies is only found on one tiny island, for example *Tyto alba punctatissima* which comes only from James Island in the Galapagos and has been there long enough to become different enough from others of the same species, and thus be termed a subspecies.

The other eleven full species of Barn Owl are less widely spread, and some come from tiny areas in the world. The Masked Owl (*Tyto novaehollanndiae*) is the largest of the barn owls, and has a much more marked size difference between the females and males – the female is twice as big, and looks so much larger that at one time the females were thought to be a different species.

The barn owls inhabit vastly different areas. Many live in open farm or grasslands where they can

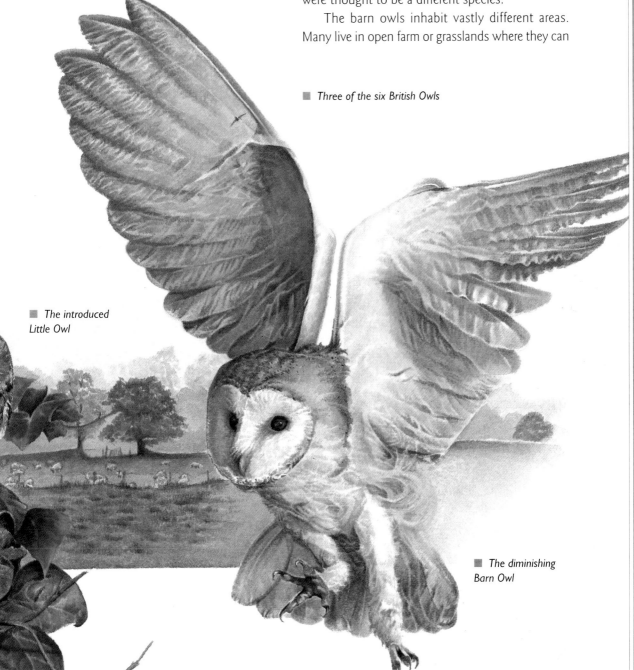

■ *Three of the six British Owls*

■ *The introduced Little Owl*

■ *The diminishing Barn Owl*

quarter the ground like a harrier, looking and listening for quarry, but some species have evolved to live in forests and even jungles, such as the Madagascar Grass Owl; this was first sighted in 1934, not seen again until 1973 and then found and photographed in 1995.

Phodilinae

As there are only two of this genus, their distribution and habitat are easy to describe. The Bay Owl – also known as the Oriental Bay Owl – inhabits the dense forests of northern India, Thailand, Malaysia, Borneo and some of the islands such as Sri Lanka. The African Bay Owl is found in the forested mountains of Zaire in Africa.

Buboninae

This subfamily covers the largest groups of owls so they are found just about everywhere in all habitats. The scops owls have the largest number of species, many of them being forest owls although, needless to say, there are exceptions. The Striated Scops Owl (*Otus brucei*) is a desert and oasis bird, and the Pacific Screech Owl (*Otus cooperi*) inhabits low scrub and mangroves. The eagle owls, too, span the world, living in forests and woodlands from high mountainous areas through to lowland savannas, with a few inhabiting arid desert areas. All the fish owls inhabit woodlands and forests along rivers, mainly in the more tropical zones of the world, the exception being Blakistons Fish Owl living in some very cold areas in north eastern Asia and Japan.

The Snowy Owl (*Nyctea scandiaca*) is the oddity: the size of the larger eagle owls and yet with no feather ear tufts, its white colour and thick underdown are the result of having to adapt to the freezing tundra that it inhabits. Also alone in its genus is the Northern Hawk Owl (*Surnia ulula*), which is not that closely related to the more numerous species of southern hawk owls. Like the Snowy, it circumnavigates the top of the world, but lives a little further south where the treeline begins.

The tiny pygmy owls cover the open woodlands and forests of the world. Most prefer forest edges or more sparsely treed areas, but some are dense forest birds.

The southern hawk owls all have a longer tail than most owls for their size, and it is this that gives them their 'hawk-like' appearance, as do the yellow eyes. Like the hawks they tend to be forest species, some liking more open woodland, but generally found in thickly forested areas.

Quite the opposite are the little owls, which although liking trees, are as happy in open areas. They are found in all continents except Australia. The Eurasian Little Owl (*Athene noctua*) inhabits farmland, old buildings and ruins in the Middle East, as well as places such as olive groves.

One of the most specialist and diurnal of all the owls is the Burrowing Owl (*Athene cunicularia*) which is found throughout most of North and South America and lives in open treeless grasslands in burrows. These burrows are often made by other wildlife, such as prairie dogs, but the owls will also excavate their own.

Last in this group are the wood owls, genus *Ciccaba*, although it appears that there is some disagreement as to whether or not all these owls should belong to the *Striginae*. Four out of the five come from the New World; the African Wood Owl (*Ciccaba/Strix woodfordii*), as can be seen, comes from Africa and is called both genera! I told you there was dissension in the owl camps! All the wood owls, as their name denotes, are woodland or forest birds.

Striginae

Like the wood owls above, most of the *Strix* owls are forest-dwelling birds, one notable exception being Hume's Tawny Owl (*Strix butleri*) which is located in the Middle East and lives in desert wadi areas.

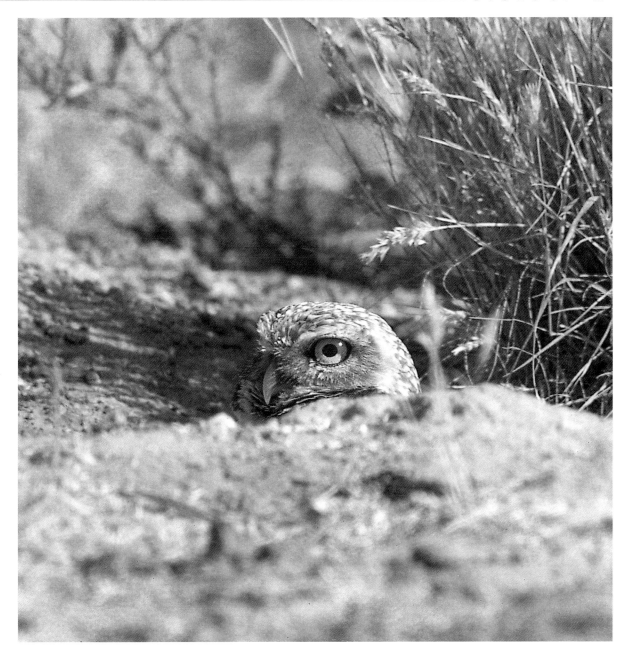

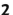

■ *The diurnal and desert-loving Burrowing Owl*

Otherwise this group of owls – which contains Britain's commonest owl, the Tawny Owl (*Strix aluco*) – tends to avoid the more open areas and is found in every climate from northern Canada right through to Southern Africa. There are no *Striginae* found in Australia, only the genera *Ninox* and *Tyto*.

Also in this group are the *Asio* owls, known as the eared owls, although they are no more eared than the eagle owls. They are found in most continents, although they do vary in their choice of habitats: for example the Long-eared Owl (*Asio otus*) prefers forests and woodland areas and is highly nocturnal, whereas the Short-eared Owl (*Asio flammeus*), a much more diurnal owl, prefers open marsh and grasslands, moors and young plantations. The four tiny forest owls, such as the Saw-whet Owl (*Aegolius acadicus*) from North America, avoid the open plains and live in the forests of the world.

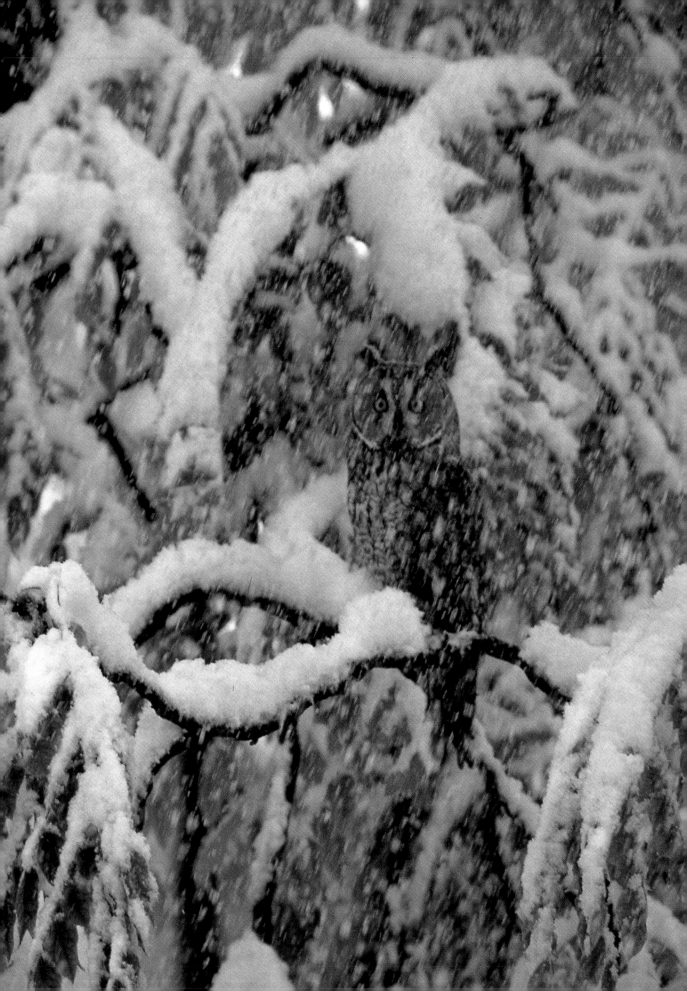

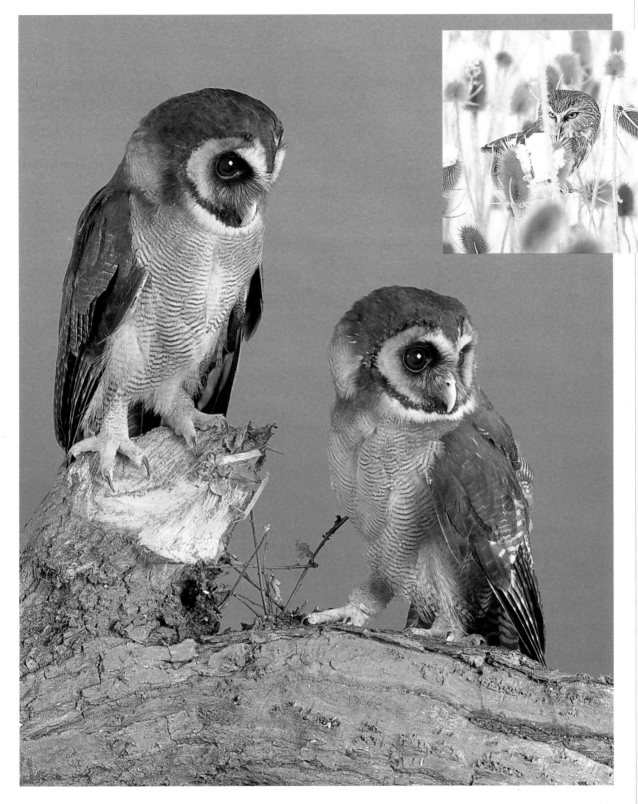

■ *(Left) The more northern owls have to cope with extreme weather conditions*

■ *(Above) A stunning pair of captive-bred Asian Wood Owls*

■ *(Inset) Teasels provide a well-camouflaged yet prickly perch for the Saw-whet Owl*

GENERAL BEHAVIOUR

(What they do with themselves and how they live)

Geneeral is probably the right word to use here, as to investigate the behaviours of all the owls would not leave much room for the rest of this book. Generally owls prefer to get about in the dark or half light, and 'crepuscular' is a good word to describe many of them, as during the summer months in the northern hemisphere, that half light at dawn and dusk is a great time to see owls in the wild.

Like most of the diurnal birds of prey, owls have no sense of smell, and so they use their hearing probably more than their eyesight to go about their daily or nightly business. Most of the owls are very vocal as this is a good way to find partners and mark out territories. They have very good eyesight and can find their way happily in full daylight as well as pitch dark – it often amuses us here at the National Birds of Prey Centre when visitors ask us why our owls work in the daylight. Not that I have any intention of waiting until dark to fly them all, that's for sure! Due to their eye structure – more rods than cones – most owls are unable to see colour, but then neither do humans at night. However, the owls' night vision is enhanced accordingly. For example, the owls that live in the far north have little or no night in which to hunt during the summer months; though of course if they stay in the north for the winter, they have the opposite problem.

■ *The eye contains both rods and cones: cones give good vision with high levels of light, and rods aid vision and sensitivity in low-light conditions: the owl's eyes contain few cones in relation to the number of rods*

Top: Tubular type of eye – the owl; a bony ring supports the huge eye
Middle: Flat (most common type) of avian eye – the mute swan
Bottom: Globose type of eye, as found in eagles

FLIGHT

All the owls have specially adapted feathers which have a fine down over the top surface to aid silent flight. In most species the leading edge of the outer primary is serrated like a comb for the same reason, and unless it is a very windy day it is impossible to hear an owl flying even if it is only one or two feet away from your ears – and that I can tell you from experience, is occasionally painful!

Many of the owls have densely feathered feet which again adds to their silent approach to life; the feathers also protect their feet from the cold, and from the bites of rodents which many of them eat. It is thought that most of the owls are colour blind, which always strikes me as a shame because in that case they can never see each other's gloriously muted colours, typical of all the owl family. It is

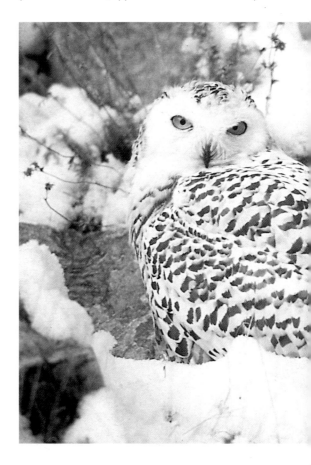

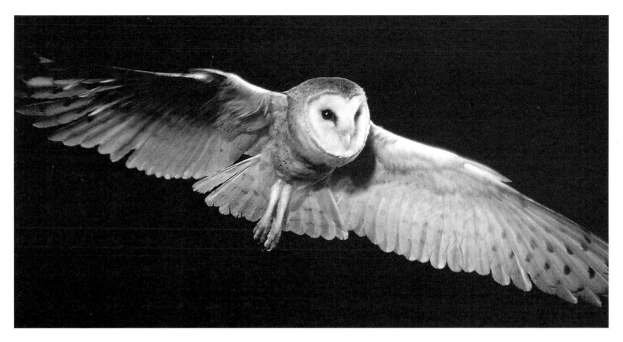

■ *The silent flight of the hunting Barn Owl*

■ *The female Snowy Owl is more heavily marked than the male which gives her better camouflage when nesting among the rocks in late spring*

these patterns and soft colours that give owls such excellent camouflage, which they do need. During daylight hours most owls spend their time hidden away in cover such as ivy, or up against the trunk of a tree or in rocks, trying to pretend that they aren't there. If by chance they do get spotted by other birds they have a rotten time of it because owls are hated and feared and therefore mercilessly mobbed by other birds. We are unable to fly our Tawny Owl in the field during the late spring and summer as the mistle thrushes will fly like a bullet out of nowhere and hit him with a full frontal attack, regardless of the watching visitors. Consequently with this sort of problem, as far as an owl is concerned the less that he or she is seen during the day, the better.

At night it is a different matter, and many owls will find quarry by 'still hunting': they find a good lookout perch and sit there quietly, waiting, watching and listening for available food, be it a rabbit, vole, passing insect or bat. A swift launch into the air and a grab is a good technique, and the wait means that less energy is wasted finding food. If that lookout fails, they move to the next. Other owls will quarter the ground in a low, slow, graceful flight, watching and listening for the movement of mice, voles, insects or reptiles in the grass or cover below them. It is this ghostly flight that one imagines when one thinks of an owl.

Occasionally in the summer I can be sitting in my kitchen in the late evening and see a Little Owl land on the telegraph pole outside. First standing tall and thin, then short, round and fat, it bobs its head, watching the bats that live in my house – and then in a fast flight it is off chasing something. It is a sight that never fails to please.

■ *Many owls sit up against the branches or trunks of trees during the day and their plumage and shape resembles the bark thus hiding them from sight. Here are two good examples: a Western Screech Owl (top left) and a Scops Owl (left)*

■ *(Below) The nictating membrane or third eyelid moves across from the inside of the eye. This translucent lid allows in some light and vision, but protects the eye, especially when hunting*

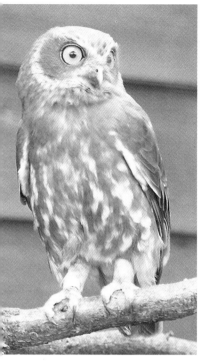

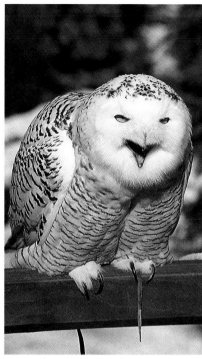

■ *The Boobook's 'cuckoo' or 'boobook' will go on all night at times*

■ *Snowy Owls can bark, grunt, whistle and squeal like a pig – all very entertaining, unless of course you want some sleep!*

■ *Tawny Owls: well known for their 'twit twoo'*

CALL

The noise that owls can make is quite incredible. Because we have upwards of thirty-five species here, the night air in spring time is full of all sorts of very surprising calls. The eagle owls can make a very loud barking noise like an extremely upset dog, the Boobook's 'cuckoo' will go on all night at times, and the snowy owls can bark, grunt, whistle, and squeal like a pig – all very entertaining, unless of course you some sleep! Tawny owls are only too well known for their 'twit twoo'; some people think one owl makes the first call, and that the 'twoo' part is made by a second owl – in Africa it is called 'biphonal calling' and it may well be the case. However, a single owl can do both calls, as we see and hear regularly from our trained Tawny, Mugwort. They can also do the most horrific rape and murder scream which makes you jump out of your skin if they do it just outside an open bedroom window at 3.00am!

One good way to find wild owls is to play a tape of the species you are looking for, if there are owls of that species in the area – if you play the tape at the right time of night, you will hear them. Many surveys on wild owls have been done in this fashion.

■ *The feathered ear tufts are nothing to do with the ears, but are indicators of the owl's mood; they can show fear, excitement or anger in a similar way that a dog signals his mood with his ears*

DIET AND FEEDING BEHAVIOUR

(What they eat and how they catch it)

All the owls catch the bulk of their food with their feet, as do the diurnal birds of prey. Consequently even the small owls have powerful feet, and the large owls have *very* powerful feet, not to be argued with.

As can be imagined, with a family of birds that varies so much in size and habitat, the diet is also liable to be extremely varied – although it would be fair to say that the owls of the world would not get very far were it not for the existence of the lowly vole. The size of prey that any species takes, whatever the order of birds, will mostly depend on the size of the bird doing the hunting, although contrary to popular belief, birds of prey and owls don't go catching the biggest thing they can find – quite the opposite, in fact, as the majority of prey caught is surprisingly small, even with quite large eagle owls.

The very small owls such as scops owls, the pygmy owls, the little owls and the four tiny forest owls rely mainly on insects of all descriptions, but they also catch small reptiles, bats, frogs and sometimes surprisingly large prey for their size. I have seen a Little Owl carrying off a baby rabbit – or at least half of it; I think it had eaten the rest. Now that does not mean that the little owl caught the rabbit: it could have been carrion, though they are documented as taking rabbit. Nevertheless I have to say that where I can just about believe in their taking a baby rabbit – about the size of the bird itself – I really find it hard to accept that they can kill a medium-sized rabbit, unless they are using a weapon other than their own feet!

The medium-sized owls – the barn owls, the hawk owls, the eared owls such as Short-eared Owls – almost all rely on a good supply of small mammals, particularly voles, to breed and survive. Like all the owls, they swallow all but the largest prey species whole. These owls will also eat insects, reptiles and amphibians, bats and birds. Most of the information on the diet of owls has come from their pellets. Actually pellets or castings are made by many birds, not just owls. The diurnal raptors produce pellets, and so do birds such as blackbirds and thrushes when they are feeding on partially indigestible food such as beetles or snails.

Owls, however, appear to have a different digestive system to the diurnal birds of prey, and where a kestrel eating a mouse will often only show mouse fur in a casting, an owl will bring back up undigested major bones such as the skull and leg bones. This does make it much easier to identify the food item eaten, but it means they are not using quite so much of the animal eaten.

The larger owls tend to eat correspondingly larger prey, although again the bulk of what they eat is small rodents. However, the Eagle Owls can catch rabbits and hares, deer fawns and young jackal pups, and some of them are known to take snakes and even other birds of prey. The fishing owls not surprisingly take fish, but Blakistons Fish Owl (*Ketupa blakistoni*), which is also the only fish owl to have fully feathered legs, wades in shallow streams hunting crayfish. Spectacled owls (*Pulsaatrix perpicillata*) are also thought to catch crabs where they live near mangroves.

REPRODUCTION AND BREEDING

(How they behave towards one another, what the nests and eggs are like, and how the young grow)

Owls are nice and simple here – none of them builds a nest (a few will add certain items to the nest scrape, e.g. plant fibres and animal dung for the Burrowing Owl) and they all lay white eggs (unlike the diurnal raptors who build huge nests, tiny nests, dreadful nests, no nests, and lay white, blue, brown and mottled eggs).

Owls will use other people's nests, even old raptor nests – and on very rare occasions, eat the raptor first, and then swipe the nest; Great Horned Owls (*Bubo virginianus*) are known to do this, but then they are one of the most rapacious of all the owls. Mostly owls prefer holes in trees, caves, roots of trees and even burrows, and the smaller owls almost all nest in cavities of some sort. The very large owls such as the eagle owls find this most difficult because of their size and so will use old nests or will even nest on the ground in crevices, or like the Snowy Owl (*Nyctea scandiaca*), which is a little pushed to find trees, find a sheltered place on the ground in the open.

All the owls lay white eggs, and this lack of camouflage is probably because they tend to nest in more hidden places rather than on the top of the tree canopy or on an exposed cliff face, so they don't have to be so concerned about hiding their eggs from aerial predators; nor does colour really help hide eggs from creatures such as snakes or arboreal mammals. Owl eggs also tend to be much rounder in shape than the diurnal raptors, again because they nest in holes and so the eggs do not have to be shaped in such as way that they will not roll out of the nest, because there is nowhere to go. Gulls, for instance, have very pointed eggs so they will roll in a circle and not off the edge of a cliff – eggs don't bounce well!

Most of the small owls can breed in their first year, the larger species take longer to mature and Verreaux Eagle Owls, also known as Milky Eagle Owls, can take over five years to come into breeding condition.

Owls do much of their courtship in the same way as the diurnal raptors, the males having to prove their ability to feed young and to be food-gathering for the female, so there is much calling and food-passing and showing of the nest. The male will repeatedly fly over to where he considers the female might like to lay, and will call from the nest to encourage her to have a look. It is a very noisy time of the year for owls.

Incubation is done mainly by the female, but males will share the task. Feeding of the young can be done by both parents, although normally the female will take the food from the male and feed the tiny young herself in the early stages. Feeding is done by touch – the female will call to the young and then touch the bristles at the side of the beak, the young bird should then take the food if all is well. Once the young have their secondary down and can thermoregulate (keep themselves warm), the female can afford to leave them to help with the hunting, and both parents will feed the young.

Young animals in general are usually called altricial or pre-cocial: altricial is when they are born – or hatched, in the case of a bird – blind and naked; precocial is when they have a thick coat, can see, and are strong enough to stand and move around within hours of being born. Baby owls are called semi-altricial because when they hatch they have a thin down, can move but not very much, and in my experience can sometimes open their eyes on day one, but don't do so for more than a couple of seconds, before closing them again.

Once they start to feed they grow quickly, and develop a secondary down that keeps them warm without a parent. Unlike the diurnal raptors, young owls appear to keep their down much longer, although size for size they seem to develop at approximately the same rate as diurnal birds of prey. Many young owls leave the nest before they can fly, yet they can climb extremely well using their beaks, talons and wings as aids. How long young owls are dependent on parents after fledging is really not known, or at least not well documented.

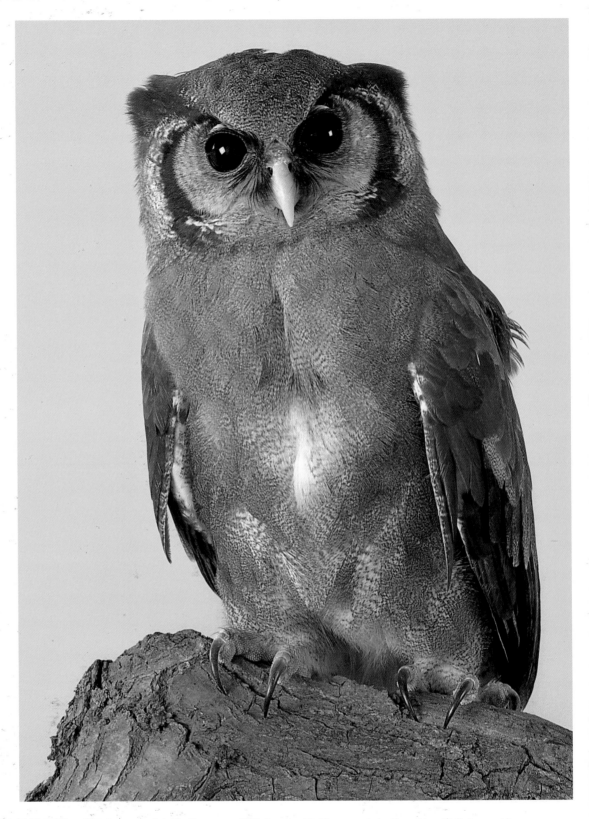

■ The pink eyelids are seen only in the Verreaux or 'Milky' Eagle Owl

■ These two baby Great Horned Owls are sitting precariously on an old Goshawk nest. Many fledgling owls fall out of trees but can climb up again well before they can fly

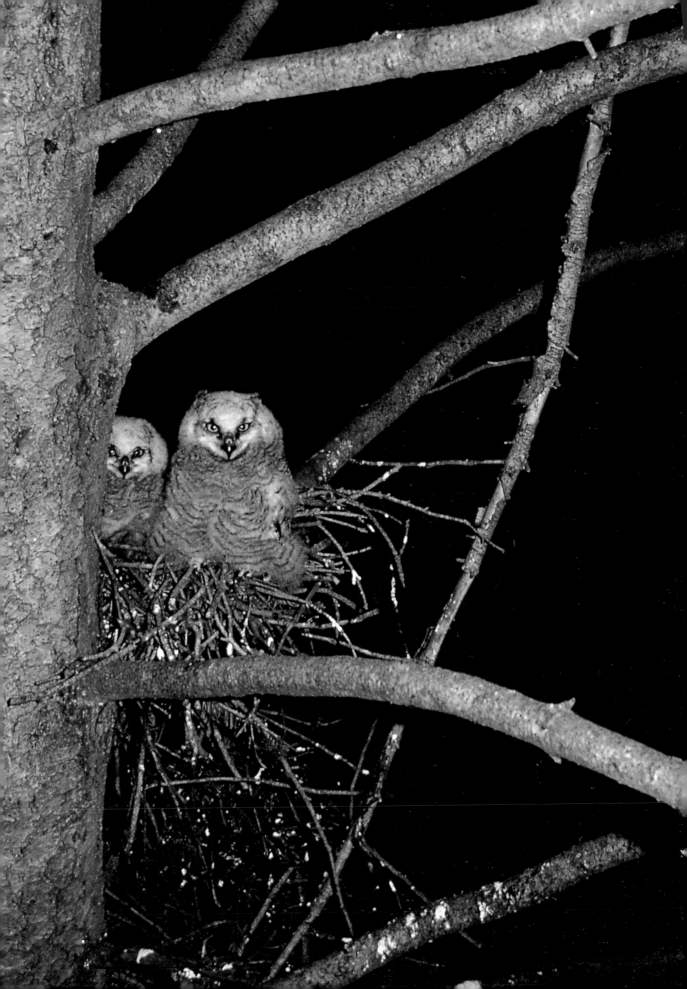

SURVIVAL

(How long they live and what kills them)

Longevity, or the length of time that an owl lives, depends more than anything else on physical size. They will live considerably longer in captivity than in the wild, but that is because the pressures of the wild are removed; Tawny Owls (*Strix aluco*), for example, are given an average lifespan of six years in the wild, yet in captivity we have Tawny Owls that have reached twenty years old and even more.

The tiny owls such as Pearl Spotted Owlets (*Glaucidium perlatum*) would probably live two or three years in the wild, maybe less, but five to ten years in captivity. At the other end of the scale, the large eagle owls such as McKinder's Eagle Owl (*Bubo capensis mackinderii*) might survive fifteen to twenty years in the wild, but have been recorded at thirty years in captivity to date.

FACTORS OF MORTALITY

Because of the large group of owls we are dealing with, mortality factors are many and varied: Little Owls (*Athene noctua*), for example, are eaten by sparrowhawks (*Accipiter nisus*) and by Tawny Owls (*Strix aluco*) (actually there isn't much that won't eat a Little Owl, given the chance), and the small owls are all liable to be predated by other carnivorous birds and mammals. As the owls get larger, fewer creatures will be able even to attempt catching them. They are without doubt still persecuted by man. However, the biggest threat to the owl's survival has to be loss of habitat, not necessarily for nesting sites, but more likely for the prey base that owls need to survive. It is this loss of habitat that is so difficult to quantify, particularly as often we know very little about the species of owls in areas that are most threatened. But it would probably be fair to say that, wherever countryside is being destroyed, the flora and fauna, including owls, will go with it. It seems that owls are generally not as good as the diurnal raptors at evolving quickly to adapt to the changes to their habitats.

CONSERVATION STATUS

(How they are doing in the wild, now and in the future)

To quantify the status of owls in the wild, it is necessary to look at the species of owls given in the 'red list', which contains species on the endangered list in the IUCN *Red Data Book*, and usually it means they are in trouble as a whole species, although sometimes it will mean locally; there are a number of different categories, such as threatened, vulnerable and so on, 'endangered' being the highest category – well, extinct is the highest, but by that time it's too late to worry!

Almost all the owl species present on the red list inhabit islands, either physical landmass islands surrounded by water, so they have to exist (or not) with whatever changes happen on their restricted home; or islands of forest which are becoming increasingly small due to deforestation. Again, destruction of habitat is the largest single factor in the loss of most living things, except for us.

It never fails to amaze me that the powers that be cannot see – or more truthfully, will not look – beyond short-term financial or political gain, and so continue to destroy primary forests, which could be the saving of our race. And it isn't just forests in countries thousands of miles away – in the UK, the changes in farming practices directly correlate with the diminishing numbers of small farmland and garden birds indigenous to this country. Just to give

you one example: not *that* long ago (because I can remember it), after fields of grain were harvested, the stubble fields used to lie untouched over the winter months, waiting to be ploughed in the spring. These fields offered a huge supply of winter food for our British wild birds and small mammals. Now, however, due to the development of grain that can be planted in the autumn growing on through the winter, the harvesters and balers leave the grain fields through one gate as the plough comes in through the other. In fact last autumn I saw one huge tractor with a plough on the front *and* a harrow on the back, doing the two jobs in one go – great for the farmer, but disastrous for wildlife that had always relied on that wonderful, but now lost food source.

So our fast-moving and changing world is damaging fragile ecosystems, often before we even understand what we have done. And does it *really* make that much difference if the grain is ready a little earlier? I don't know, but I somehow doubt if it would make much difference to you and I. And do you *really* need a hardwood front door from the DIY shop to replace your old one – or would a softwood door, from fast-growing renewable forests, look just as nice, only needing a little more care? It is actually surprising how you can, in small ways, have an effect on world policies. But you have to start small – like an avalanche.

Owl species can also be threatened locally: this means that even though on a global scale their numbers are buoyant, in certain areas a species may not be doing so well, such as our barn owl in the UK, and may need some positive conservation to help it out. This is where bodies such as The Hawk and Owl Trust do so much good work; this Trust initiates research into British owls and other birds of prey, and I would strongly recommend that anyone interested in the conservation of wild owls joins this group, as it provides a great deal of information and the chance to become actively involved.

Conservation is not all doom and gloom: the Madagascar Grass Owl, thought to be extinct as it hadn't been seen since 1874, was found and really is not extinct. But if you look through books on owls, and indeed other taxa of birds, you find that often a species has only been described from one specimen – found, usually dead, years and years ago. So we have a long way to go before we understand what is needed for owls. Research of species in the wild, and work with species in captivity can

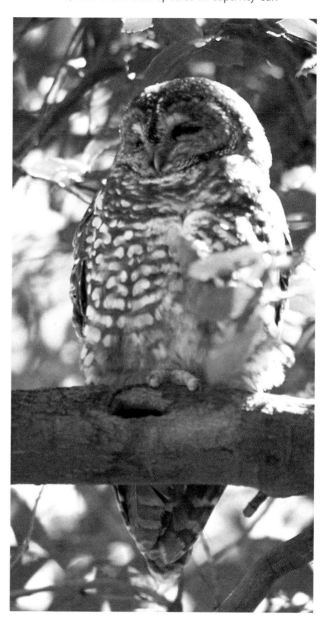

■ *Spotted Owl*

go hand in hand if they are allowed to, but still the overriding factor is that habitats really need to be saved in this country and all over the world so that species we know absolutely nothing about can be studied and conserved.

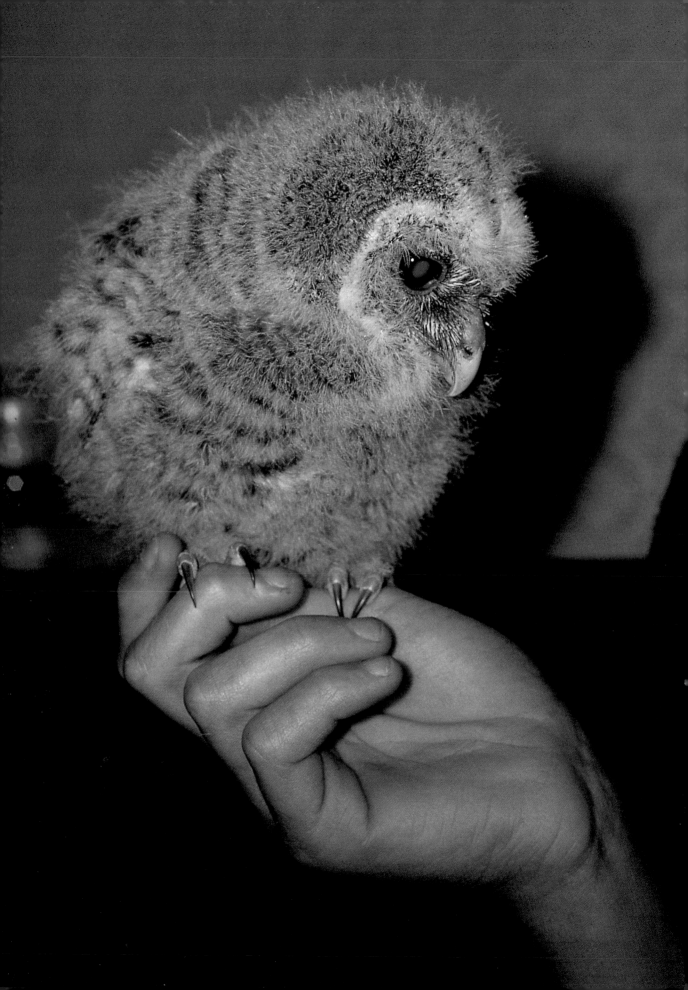

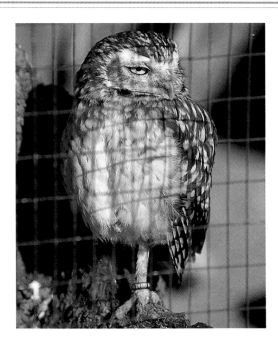

KEEPING OWLS

*T*he first question you need to ask yourself – and I always ask it, to the point of being boring, but nevertheless it is still very relevant – is, why do you want one? There are a number of different reasons for keeping owls; some people want a pair or even a single bird merely to look at in an aviary – although I have to say that owls are generally not good for this because unless they are tame, they are extremely antisocial during daylight hours, and mostly just sit, trying to hide. The best species that I would suggest as being out and about during daylight hours would be the Burrowing Owl (Athene cunicularia), as these are the most diurnal of all the owls and in a roomy, stimulating pen can be very active.

One of the many wild baby (so-called 'orphan') owls brought to the Centre each year. They have to be released eventually: it is illegal to keep them

SOME OF THE PROBLEMS

THE NOISE NUISANCE

The *most* important thing to consider before you get an owl is the noise factor. Owls being mainly nocturnal birds do most of their day-to-day living all night, every night! And that includes calling for, or to a mate; yelling their heads off at wild owls or at each other and giving alarm calls if dogs, cats, foxes, hedgehogs, badgers or anything else upsets them at night. All of these calls might be measured on a scale from noisy, to very, very noisy. You can hear the owls here at the Centre at least one mile away on a still night, and they would certainly be totally unacceptable to neighbours if I had any very near us. Luckily for me, the nearest are over a quarter of a mile away, and anyway all the original people have moved away (I have often wondered about that) so all the new people came here after us and therefore can't really plead ignorance. But that may well not be the case for you.

If there are people living close to you, then you will undoubtedly have problems with complaints about noise, unless you are very lucky. I am often contacted by councils who have had neighbours complaining about noise, and there is no real answer to solving the problem – apart from moving house, which many people are not able to do. And to be fair, the noise can be a confounded nuisance. There have been times here when I could happily have strangled owls who were being particularly persistent noise-wise, especially during the breeding season which can run from December to October. Nor is it

any good blaming neighbours if your owls are keeping them awake and they are complaining. The problem is yours, and there is no way to stop an owl from calling – nor should you want to, either, because it is natural for them to call. So think carefully about this problem before spending any money on pens, birds, food, vets and so on.

If you live in a really built-up area, it is not probably not suitable for the keeping of owls, and it is even less likely to be suitable for flying owls, because if you lose one it is almost impossible to look for it in thousands of gardens. In this situation you should perhaps consider another sort of animal, or move house.

LONGEVITY

Besides the noise problem, there are one or two other things that you should perhaps bear in mind. Remember that owls can live a very long time in captivity – even the smaller ones like the Tawny Owl can live up to twenty years, and I have eagle owls that are now over thirty. That is a long time to house, feed, care for and own any creature – it's a long time to keep even a husband, let alone livestock, and sadly it is far longer than a dog will live. And what are you going to do with your bird when you go on holiday? I know some people who will take it with them, but I have to say I don't think it is a particularly good idea, and it may not give the impression that you expect in terms of how other people think you should look after wildlife. Besides which, unless you have a very good portable aviary, you will have to tether the bird while you are away, and that is not a good practise.

FOOD

Then there is the food that you will have to keep: are you going to keep it in the fridge and freezer that you use for your own food, or are you going to keep it all in a separate fridge and freezer, in a separate room?

VETERINARY EXPERTISE

You will have to find a good vet in your area who is open-minded and will take on your bird. Remember, too, that vets' bills can be substantial if your bird contracts a long-term illness that takes a time to cure.

All these things must be considered before you decide to have an owl.

GIVING A HOME TO WILD DISABLED OWLS

I f you want an owl for no other reason than just to have one in a pen in your garden, and if you have no desire to breed from it or handle it, you could consider having a permanently disabled wild bird. It will probably never become tame, and you may not see much of it during the day, but you may be helping it to have a better lifestyle. Rehabilitation centres often have birds brought in from the wild that cannot be released because their injuries are insufficiently recovered for them to be able to survive in the wild. You will have to 'earn' such a bird, though.

First, find a local rehabilitator; the Department of the Environment, Transport and the Region (DETR) Wildlife Offices used to have a list of people who were prepared for their names to be released to the general public – they may still have it. Also, the RSPCA has an involvement with a group of people called the British Wildlife Rehabilitation Council, and some of these members allow their phone numbers to be released. Give them a ring and ask if you could volunteer to help out; some will be pleased to have help, some will not want you.

You will have to be prepared to spend a good deal of your time doing what our volunteers here – and ourselves – do: it is known as 'shit shovelling'. If you then prove yourself by going regularly, and once they know you are genuine and willing to work, you may well find they would be delighted for you to house a permanently disabled bird. Hopefully you would continue to help out with the injured birds that were being rehabilitated as well.

If you are considering this course of action, be aware of the following point: it is now required by that section of the DETR which deals with British wildlife, that permanently disabled birds have a veterinary certificate to say that in the opinion of the vet the bird is not fit to be released back to the wild. Also bear in mind three things:

1 It is illegal to over-handle a young owl that has been brought in so that it becomes an imprinted bird, and thereby possibly unsuitable for release. There have been a number of court cases to this effect.

2 Owls, or any creature come to that, which have been injured in such a way that their quality of life is not of an acceptable standard, should be put down, rather than just kept alive for the sake of your own feelings. For example one-legged owls do not do well, and unless there are exceptional circumstances, they should be humanely destroyed. Very drooping wings can be a real problem as well, because the bird constantly falls or trips over the wing, which in turn can suffer repeated damage. This sort of thing is really not fair on the bird, and it is *not* a kindness to keep it alive. Be realistic when dealing with rehabilitation: the good rehabilitators eventually learn that not all injured wildlife will survive, or even should do so, but it is sometimes a hard lesson to learn.

3 Thirdly: an adult wild disabled owl is absolutely *not* suitable for training and handling – it is not fair on it. All it needs is a good, quiet, attractive aviary and a good food supply, and to be left alone.

So what have we got? Owls are noisy, and generally not much fun just to watch in a pen; that leaves us with owls for breeding and flying.

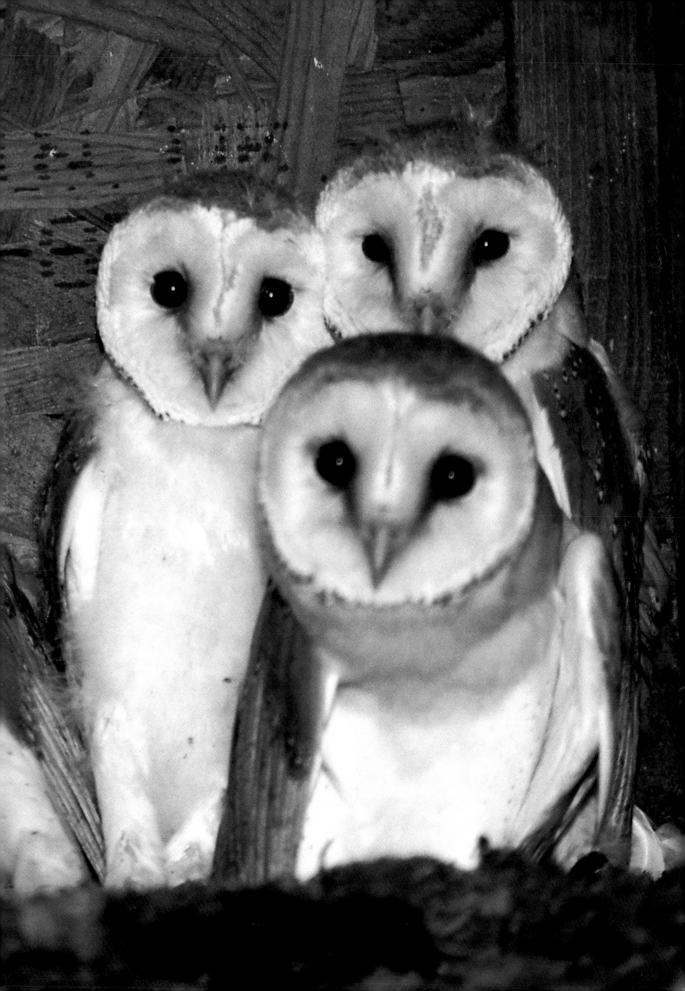

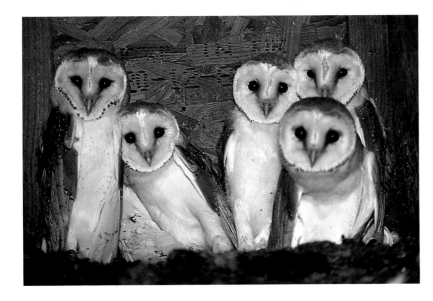

HOUSING & EQUIPMENT

*A*s each year goes by we learn more about managing our owls and other birds, so the designs of aviaries change – often in mid-build. Up until two years ago I built all my pens with completely solid roofs; then we built four pens for trained birds, and I left the front third with an open wire top. Now I regret it. We put the built-in bath at the front which meant it was open to the air from above, and I had a young Yellow-billed Kite go down with Trichamoniasis in the autumn. After a long struggle to pull him through we lost him, which saddened all of us as he was an attractive bird and a really good flyer. The only way he could have got the disease is through wild bird droppings coming through the wire top into the bath water, or possibly onto food. Had I done as usual and had solid roofs he would probably still be alive today. Some lessons are harder to learn than others.

These are royal Barn Owls, taking part in a release scheme on Prince Charles' estate

THE UNACCEPTABLE WAY

I have two real hates in terms of aviaries: one is the completely wire one with little or no refuge or shelter for the occupant, and totally indiscreet way of monitoring what is going on in nestboxes or ledges. Because they are open-sided all round there is no way of approaching it without the birds seeing you and being thoroughly disturbed; this one tends to be a favourite of zoos.

The other is the old favourite of many private breeders: the enclosed or solid-walled aviary, sometimes called 'skylight and seclusion' – basically four solid walls with a net or wire roof, so the birds can see nothing except sky. I think they are outdated, unpleasant and unkind to the point of cruelty to the birds. Several of my friends will probably not like me for saying this, but it is what I sincerely believe. It is so easy to make just a couple of feet at the top on one side open-fronted, and the birds would be so much happier being able to see out. When you understand that most birds of prey spend much of their life sitting still, it is easy to realise, especially if you have had as long as I have to watch them in pens, that they love to look around and see what is going on about them. To see only sky means they get little view and even less visual stimulus, and I think that is a rotten thing to do to any animal, particularly now we know so much more about breeding raptors today.

CHOOSING A SITE

Often it is not possible to choose a site for a pen – it is dictated by where you have space left in the garden, or in my case, in the Centre. But if you do have the choice, pick a warm and sunny place in the garden. Yes, I know: what about the hot summers – well, we have really had only a few of those, and whereas it is quite feasible and simple to add shade to pens, it is much harder and much, *much* more expensive to keep them warm in a really cold winter. The nicest pens we have here for light the whole year round, and for warmth because they are facing away from the coldest of the winds, is a set facing south. Although our prevailing wind is from the south west, the pens are well protected from the winds and they get the sun all through the winter. You may be saying, but owls are not interested in the sun: well, you are wrong, they need it as much as you and I, and although they may not rush out every day to greet it, they do sunbathe occasionally. It is very easy to make dark areas in the pen for them to go to if they don't feel like stretching out in the sun all day, but they must have the option if they want or need it.

So think about where you place your pen. Keep it a little way from the house to give yourself respite from noise, and the owl respite from you. I like to have my pens in view of the house, although that is not easy here. And remember the noise factor with the neighbours (I am going to keep reminding you about that one all through this book).

Avoid building under trees or large branches: in the future these might fall on your pen, and they will definitely reduce light and will make it damper. Do not put it close to a compost heap where you may well have rotting vegetable matter that harbours *Aspergillosis* spores. And don't let it back onto areas where people might have their cars running, and therefore plenty of noxious fumes about.

Just think carefully before deciding where to put it, and remember that you will need to be able to get the roof water away, so have some ground lower than the pen where the water can run off.

WHAT SIZE TO BUILD?

Once you have decided on the site, then you need a size. I have always tried to avoid putting sizes because once in print they are quoted as gospel and often get thrown back at you in the end. *But* I have also had to field numerous phone calls as to what size to build. So I am going to cheat, and will give you the sizes of our own owl pens. Now, some of them I would like to build bigger, but all of them house the occupants in comfort and they seem happy.

These are what I would call *minimum* sizes; if you can go bigger, please do so. Some of our trained flying owls are in slightly smaller pens because they are housed singly and fly loose every day during their work period.

Whatever you build, build it to last, and make it easy to work with, easy to view the birds at all times, easy to maintain and pleasant to look at, for yourself and your family, guests, neighbours and the potential buyers of your house when you move!

AVIARY SIZES

	WIDTH	LENGTH	HEIGHT (from front to back)
Large: eg Eagle Owls, Snowy Owls, Great Grays	12ft 3.6m	16ft 4.8m	9–14ft 2.7–4.2m
Medium: eg Savigny's Eagle Owls, Spectacled Owls	10ft 3.0m	12ft 3.6m	9–14ft 2.7–4.2m
Small: eg Tawny Owls, Barn Owls, Boobook Owls – in varying size pens, figures given are the average	8ft 2.4m	10ft 3.0m	8–12ft 2.4–3.6m
Tiny: eg Pearl Spotted Owlets, European Scops, Collared Scops	5–6ft 1.5–1.8m	10ft 3.0m	8–12ft 2.4–3.6m

PLANNING PERMISSION

By the time you are considering building an aviary, you will presumably know what species you are building it for and therefore the correct minimum sizes. The next thing you will probably have to do is apply for planning permission, or at least check to see if you need it. You may consider this unnecessary, but if by any chance you get a difficult neighbour who discovers that you have put up pens with no planning permission, you could, in the worse case scenario, have to pull them down, or at least have to spend time and money sorting the problem out. One of the three useful things my father taught me was that time spent in reconnaisance is seldom wasted, and he was so right!

These days it is really quite easy to apply for planning: you just have to fill in all the forms five times, get five sets of plans and five maps and the cash, and you are away! Don't do what I tend to do which is leave the application until just before I want to start, and then either have to wait, or annoy my very long-suffering planning officials by starting before it comes through. I am lucky, we have a really helpful Council here, but you may not be so fortunate, so treat them nicely – like your landowners.

■ *THE AVIARY AND WORKROOM COMBINED UNDER ONE ROOF*

Unless you have really strong prevailing southerly winds, position your aviary with the open (wire-fronted) side facing south. Make it as attractive a building as possible to avoid upsetting your family and friends – and to avoid de-valuing your house!

A stable-type door is useful because the top half can be left open to improve ventilation during hot weather. Don't forget to close it when you go into the aviary to work with your owls

■ *FRONT*

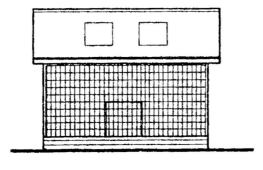

It's a good idea to lay a gravel path all around the aviary building to discourage weeds, to make mowing the surrounding grass easier, and to prevent vermin digging their way in. At the Centre I have tubs full of flowers outside my aviaries to make them look even nicer

■ *SIDE VIEW*

Tongue-and-groove cladding is attractive, and is safer than some other materials. Remember to order it tanalised to avoid having to treat it yourself

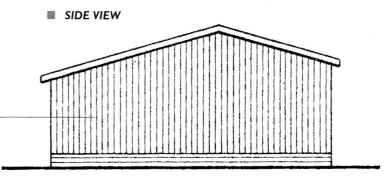

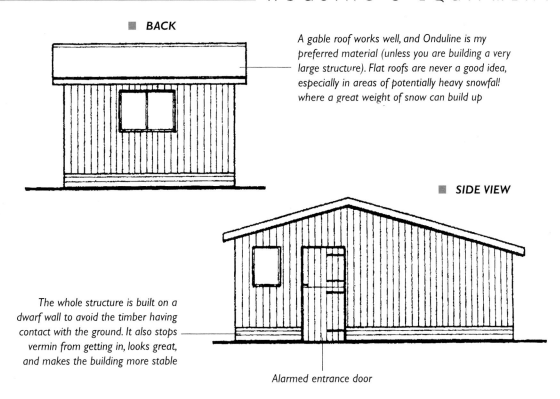

■ **BACK**

A gable roof works well, and Onduline is my preferred material (unless you are building a very large structure). Flat roofs are never a good idea, especially in areas of potentially heavy snowfall where a great weight of snow can build up

■ **SIDE VIEW**

The whole structure is built on a dwarf wall to avoid the timber having contact with the ground. It also stops vermin from getting in, looks great, and makes the building more stable

Alarmed entrance door

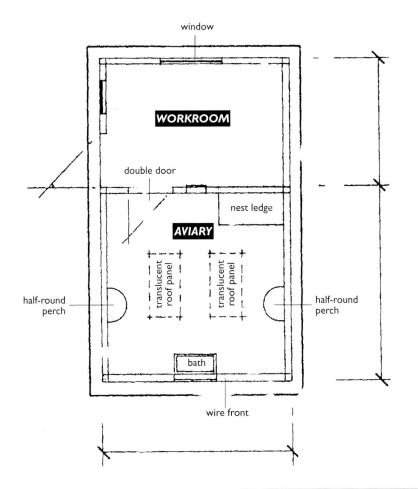

■ **PLAN OF WORKROOM AND AVIARY**

In the workroom you should have your freezer, fridge, travelling box and all your bits and pieces of equipment... including armchair and gin and tonic! Keep it clean and tidy so that you can find what you want easily in the event of an emergency

CHOOSING MATERIALS

While the planning is going through you can be phoning round finding out the best prices for the materials you are going to use and the delivery times.

Every time we build a barn here I change the design a bit, adding new ideas, or taking away things that didn't work as well as I thought they might. So give yourself a bit of time and do some research into what is most suitable for you, the bird, your garden, your family and your lifestyle; you will find that is far better than building in a rush at the last minute and ending up with something that doesn't really work for you.

The first thing you need is good materials. Do *not* use fence panels: they make lousy aviaries, they are made of the cheapest of timber, mass produced, often thrown together and even more often falling apart at what little seams they have. If you must, use them for fencing, but not pens or weatherings.

All the pens we build are of timber, because I understand timber. You can nail or screw things to it easily, it is a reasonably warm material, you can cut holes into it, add to it, and looked after well and used properly, it lasts as long as most materials and longer than some. It also makes construction quicker.

BUILDING THE PENS

There are two good ways of building pens, though one is probably easier than the other if you are not a fairly experienced builder. I will tell you the difficult way first and then give you the alternative.

METHOD ONE

We build nearly all our pens by concreting tanalised timber trusses into the ground; the size of the timber will depend on the size of the roof it is supporting. A good supplier should advise you of the right sizes of timber to get, and should get it for you. A 'truss', in this case, for those of you who don't know, is the back and front leg or stantion of the pen with the rafter already fixed.

First we dig the holes in which the trusses are going to stand, and you can do this either by hand, or by hiring a post-hole borer, which will do a clean, efficient job – as the screw/drill comes out of the ground you can pull the soil off straight into a wheelbarrow and take it away. We then put in a pad for the trusses to stand on – for smaller aviaries, not the very big barns we build, you can just drop in a 4in (10cm) concrete block to the bottom of the hole.

Once the trusses are dropped in onto the pad and squared up, you then fill round them with concrete; this should be left to set well before going any further. Next the roof timbers go up to stabilise the structure, then the gutter and then the roof – and don't put the roof on until you have concreted the legs: the concrete is there more to stop the building lifting in the wind – in other words, to hold it down as much as up! For the roof, unless you are building large barns, as we are here, without doubt the most user-friendly, lightweight and attractive, and the least likely to have condensation problems, is a product called 'Onduline'. Most builders' merchants have it, it comes in various sizes, and it is very kind on the birds. I use it regularly on the smaller blocks of pens. I use the red, but you can get it in green, dark blue and probably other colours as well. You often see it on stable roofs. You will also need to use a number of translucent sheets to make the pen lighter.

A tip here: if you are going to keep tiny owls, lay some fine mesh wire over the roof timbers before fixing on the roof sheets, because this will stop mice, rats or any other unwanted invaders into the pen via the roof. Also, you then don't have to worry about tiny owls getting out along the corrugations of the roof sheets.

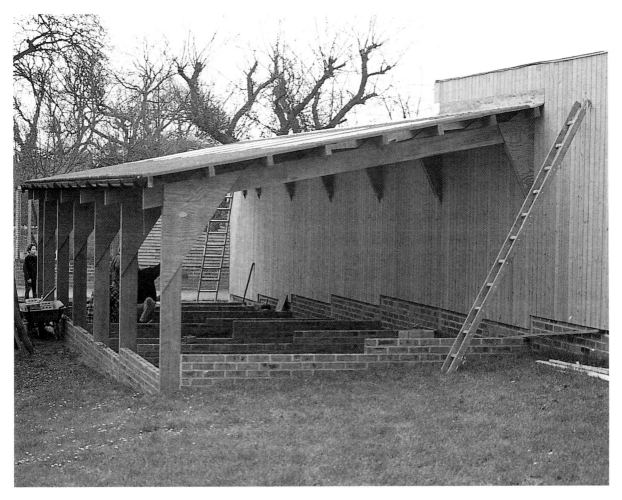

Building the Inside: the Dwarf Brick Wall

Once the roof is on, the weather doesn't matter as much, and we start work inside, under cover. First we build a low brick wall all round, between the legs. It is quicker to dig out the footings by hand, and then to lay a level concrete footing before placing the brickwork on top. There are a number of reasons we build this dwarf wall: nowadays we put a concrete floor in most of the pens, particularly those housing small birds, and it is nice and easy to lay this between the brick walls, which work as a form. You can slope the concrete slightly so any water you might use for cleaning, or driven rain, will run to the front, and we put air bricks in the front wall for the water to run out. The concrete floor makes cleaning the pen easier and stops anything from digging in.

I should hasten to add that once the concrete is

The aviary under construction: dwarf walls finished, roof on and the timber walls about to be started

dry and before the birds go into the completed pen, it is covered in at least 4in (10cm) of sand, so it is nice and soft for landing birds and absorbs droppings well. Don't forget to dig the perch holes before putting down the concrete floor; we line them with a round 5gal (23litre) oildrum, minus its top and bottom, and then the perch can be dropped in at the end of building. If at a later date the perch rots, or you want to change it, this should be easier to do.

The low brick wall acts as one wall of the built-in bath; it also stops the timber studwork from touching the ground and therefore gives it a longer life. It looks attractive, it prevents sand coming out of the pen, or dirt and weeds encroaching into it, and it gives the birds a little more security from foxes, dogs, badgers and cats. A solid roof is also a

great thing to stop birds getting upset about cats.

Don't forget to leave bricks only up to the final level of the concrete in your entrance/service passage; trying to get a barrow over the wall once you have finished is murder! A nice, sloping concrete ramp outside, leading to the passage, will help you with barrows and the like.

Building the Bath

To build the bath, use the same method as building the dwarf brick wall. I usually put the bath in the middle of the front wall if I can, but sometimes it goes in the corner and then two of the walls are already built. Build it up to the height of the dwarf wall, then leave it to dry for a couple of days. We

■ *The footings for the bath and (below) the next stage: this size bath would be suitable for a small species*

then fill up to the bottom of the last course of bricks with rubble, topping off with sand. Next we make up a mix of concrete with some Unibond added to make it waterproof; this is laid on the level sand and carried on up over the bricks to give a curved finish at the same height as the timber frame. We clean our baths by brushing the water out over the edge of the bath. You could, however, put a plug and drainage pipe in while you are building, so you could just pull out the plug and the water will drain away. We can't do that here as I can guarantee that some of our less thoughtful visitors would go round pulling out the plugs, or even pinching them. Sadly I speak from experience here.

Double Door System

All our breeding aviaries have a service passage of at least 3ft (1m) wide, and all are concreted, and these have made an enormous difference to our lives here. Being able to feed the birds in comfort, under cover and on a dry solid path whatever the weather, is just wonderful.

I mention a service passage because you must have a double door system for your bird, whether they are breeding birds, or trained owls for flying. In my opinion anyone who doesn't have some sort of a safety door system in this day and age is not very forward thinking. Single doors will eventually lead to lost birds, you can lay money on that; one day it *will* happen, so put in a double door system to start with. Some of our 'flying aviaries' – meaning they contain trained flying birds rather than breeding ones – do only have a single door, but if I were starting again I would probably put in a second door off a rear or side passage; apart from anything else, the birds are not then expecting you to appear with food at the wire front, and consequently are less likely to fly or crash into it – they will instead be waiting by the solid passage door. This saves feathers from being broken and ceres from being injured.

The main difference with us is that we fly our birds here in our own field, which is very near to the flying aviaries; we can therefore train the birds to fly down to the flying ground on their own when the door is opened. If all goes well they should fly back

again, into their pen at the end of the demonstration. This does, however, lead to different problems, like one eagle owl who goes back to his pen on his own if he is in a bad mood and leaves you standing there looking like an idiot! Or the Secretary Bird who refuses to come out unless there is a large audience. It is also a risk if the door is opened when the birds are moulting and therefore at fat weight, so are basically untrained.

Erecting the Walls

Now you should have the main timbers in place for the walls, the roof up with the gutter in place, a concrete floor if you want one, and a built-in bath. Next come the walls, both the external and internal ones. Here you need to put up a studwork wall to take the cladding material. Don't do what the builders did on my first barn (that was before we started to build them 'in house') – they put up the studwork to fit imperial measurement sheets and the sheets arrived in metric measurements! It was not a pretty sight, I can tell you! We usually use 3 x 2in, or 4 x 2in timber, untreated where it is under cover. We either stick-build it – that is, we put each piece up one at a time – or sometimes we build a frame and just hope we have got it right and that it will fit into the gap.

Once the studwork is up, then comes the cladding. On reflection, I think that the best external cladding I use here is a good quality, tanalised tongue and groove. We have used what is called 'end board', but its main disadvantage is that it leaves a gap, and so vermin can get in. I have used feather-edge which is cheaper than tongue and groove, but it is not as nice a finish and it can warp and leave you with dangerous gaps. Whatever you use, buy reasonable quality stuff and you will not regret it in the long run.

We clad internal walls with stirling board – I think another name is 'norboard'. I have used two different types, but generally both are very good: one sort has a smooth side and a rough side, the other type has both sides the same. When you put it up, leave a gap between each board; don't butt them up close because they tend to expand and contract, and they will start to bend your internal walls.

Doors and Feed Drawer

The internal and external doors should go on with the cladding; use heavy duty, galvanised hinges as there is nothing more annoying than a dropped door that won't shut properly. The inner door need not have a security lock unless you are leaving the birds for someone else to feed while you are on holiday, then it might be an idea. But ours are secured on the outside door and just have either a bolt or drop catch on the inside door.

We also put a feed drawer in the service passage wall. This means the food is not thrown on the floor, so if the birds do not take all you have given them it can be easily cleared away the following morning. You can feed birds without being seen, or having to go into the pen. To clean the feed drawer, just pull it out, clean and replace. Alternatively, if you have tiny birds that could get out into the service passage when the drawer is removed – have a clean spare, and you just pull out the dirty one and immediately replace it with a clean one, then clean the dirty one ready for next time.

Nesting Areas

Now your pen should be starting to look rather good. Next come the nest ledges or boxes, and even if you are not putting breeding owls in the pen it is nice to give all owls a ledge or box, depending on the species of owl, because even the single imprinted hand-reared ones may use it. Nesting areas should be put up on a back wall to give the birds privacy, but part of the box or ledge should be on your service passage; this way you have the chance of monitoring the nest from the service passage to see what is happening, and at the same time not disturb the birds. Build boxes or ledges large enough to accommodate both adult owls and offspring as well. Put a door in the back of one of the walls supporting the nest ledge/box, so that you have access to the nesting area from the service passage. We put about 4–6in (10–15cm) of sand in the bottom of nestboxes or ledges so the owls can dig a good scrape in which to lay their eggs. And make sure that you can view all the nest area through spy holes in the back wall of the pen – you need to be able to see what is going on.

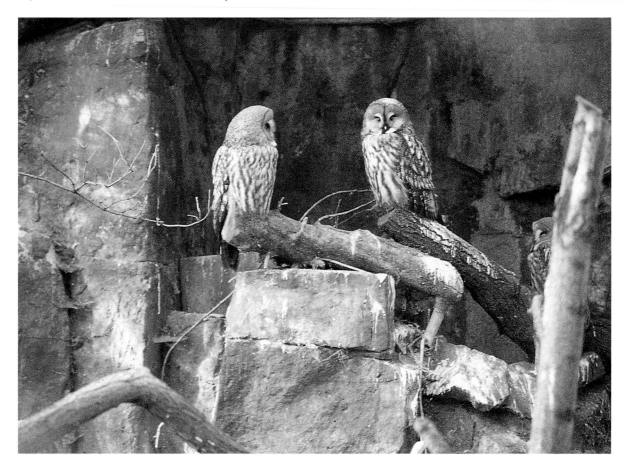

■ *These owls are not at the Centre, but have really nice, chunky perches*

Perches

Perches come next, and my pet hate is for branches stuck across corners: they look horrid, they are not good for the birds, and they lead to very dirty walls or wire. I have been saddened to see rough-sawn, squared timber with no covering used as perches in pens that are in establishments which are open to the public – this is very bad for the birds, and all I can say is that people who do this really should not be keeping birds, and certainly should not be open to the public. Use decent-sized branches with the bark on, also varying sizes so that birds have different thicknesses to perch on.

We go out and look for good-sized branches that will have plenty of horizontal off-shoots if we place them upright in the holes we have left in the concrete floor. If you are careful about placing your perches you can keep pens much cleaner, especially with owls who don't have quite the same velocity of droppings as do the accipiters! With the clean sand on the floor and perches placed correctly it is just a matter of a quick rake once a week and the pen should stay looking and smelling very pleasant.

You are close to done now. Check round the whole pen for tools, bits of wood and splinters, nails and so on, and give it a clean and a sweep. At this point we usually put the sand in, depending on whether or not it is easier to get it in from the front before the wire goes up. If you have good access to the service passage you can leave it till last.

Fixing the Wire Front

The wooden frame on the front for the wire should be of tanalised timber and should have a door for the bath to be cleaned and tidied; hang the bath door with the hinges at the top, and then it will not drop open even if you forget to close it properly. We use a piece of 6 x 1in tanalised timber for the bath door, with a catch at the bottom. We used to use

those pins with a sprung wire loop that hold trailer doors shut, but people kept pinching them (sometimes I just love the public!) and so we use small padlocks now.

The wire should be galvanised welded mesh, not chicken wire or old-fashioned wire netting; we don't use chain-link wire either, because I have known birds get their feathers caught in the twisted part of the link. We use 2 x 1in mesh, 12-gauge wire; for tiny owls we use ½in mesh, but once you are over the size of, say, White-faced Scops Owls, the first size is fine. Don't use tiny mesh for medium and large birds because if they hang on the wire with their feet and then turn to fly to a perch they can catch a talon and injure themselves.

Once the wire is up we paint it black with emulsion paint and an old roller. You *can* do it before it goes up and it will stop any paint getting onto the woodwork, but it is a job that needs doing at least once a year and so eventually paint gets on the woodwork anyway, so we paint it *in situ*. It makes

■ *The Burrowing Owl pen: lots of natural perches, low to the ground. Note the door to the bath, and the occupants on one leg as usual (you'd be surprised how many complaints we get about this!)*

a huge difference, because you can immediately see into the pens, which you can't if you leave it galvanised colour.

Painting

This year we have painted a lot of the pens magnolia inside, some on all three walls but most on just the back wall. It has made them a lot lighter, but you will see if you need to do this once you have completed the pen. We used magnolia because at the time it was the cheapest paint to buy in bulk, and it is not quite as bright as white. We use emulsion because it dries quickly, it is water soluble and is non-toxic. Droppings inevitably get on the wall; you will always have to do a certain amount of scrubbing in your once-yearly clean, and even if you used a gloss type

■ *The completed aviaries now housing trained flying birds*

of paint you will scratch it and it will be harder to clean as the years go by. With emulsion you just scrub – some will come off and you give it another coat and hey presto! a pen like new again. With owls you can paint the nest area dark, for more privacy.

Finishing Off

Now the pen should be finished – just make sure there is nothing left in it that could hurt a bird, and that it is nice and clean, and it is ready for its occupant. There only remains to put a padlock on the door so people can't open it for malice or fun.

I would suggest that you have a small amount of gravel path around the outside of all the external walls: it is good for security as it is noisy to walk on; it means that you don't have to mow or strim right up to the pen, which can frighten the birds; and it also means that you can see if anything has tried to dig into your pens.

METHOD TWO

Basically it is the same, except you don't have trusses; instead you have a low brick wall all the way round as the base of your pen, and build everything

off that. As long as you get the walls square, building up from there is relatively easy. You mark out the size of the pens, not forgetting the service passage, dig out the trench for the footings, pour the concrete, let it set and away you go. Concrete blocks will build you a wall more quickly and it will probably be cheaper, but if you go to a builders' yard and look at bricks of 'seconds' standard you can get some quite cheap ones, and bricks do look *so* much more attractive than concrete blocks. Plus it's far less painful if you drop one on your foot. I have nearly got rid of all the concrete blocks that we used in the early days of the refurbishment of the Centre and have gone over totally to bricks, and the difference in looks is amazing.

Once you have built your dwarf brick walls, then you construct the walls with 3 x 2in timber – tanalised where it is not going to be covered with cladding material. For these we build panels as it is easier, moreover these are not only the actual walls but also the supports for the roof. Get the roof done as soon as you can, and you can work in comfort regardless of the weather. Then follow the same procedure as described above for the barn-type pens.

SECURITY

Keeping pens secure is not easy because if someone really wants to steal your birds they will get round almost anything you can put up. Fortunately owls are not normally as much of a target as, say, parrots. Recently we have just put in a new security system. As well as other devices, all our doors are alarmed, and now the wire fronts have a trembler alarm so that if anyone cuts the wire, or bumps it, the alarms go off. The trouble with owls is that during the night, when they are most active, they might well bounce off the wire and this can cause false alarms. This is not too much of a problem here, because noise is not a major factor; however, if you had a number of false alarms on a nightly basis, with neighbours nearby, I can see that they might well get somewhat upset.

Lights that come on if anyone comes near the pen are quite good, except they can be triggered by foxes and cats; however, I believe you can set the sensors so they only come on in response to larger animals, like humans. A security camera will film your birds being stolen, but may not be much help in getting them back.

A good look at what is on the market is the best idea, and then select the alarms that best suit your lifestyle and the area in which you live.

Alarms are only any good if you take notice of them. It never fails to amaze me how people ignore car alarms. I am tempted to ask people not to bother to put them on when they park in our car park, because no one ever goes out to see if it is *their* car being nicked, and unless we ask them to, they never go out to check!

STORAGE AND WORK SPACE

As well as a pen for your birds, you really need some sort of shed or room to keep a travelling box, first-aid kit, a net for catching up untamed owls, gloves, bags and other falconry-type equipment that you will need if you are going to train and fly an owl; also a deep freeze and a fridge, and a weighing machine (this for trained owls only). A 'sick' compartment for emergencies is very useful, should you ever have a problem with your bird.

I know all this sounds like a lot, but you will need all these things if you are going to do the job properly. You should see the list of buildings and equipment I need to run this place – I dread to think what the costs would add up to over the years of investment, and I am a long way from finished yet! If you start off with all the things you need, plus a good food supply, a good vet and good equipment, you should never get caught out when things don't go to plan. There is nothing worse than coming up against a problem with your birds and having to run about trying to sort it out without the right facilities.

Below are two lists of equipment you will need, one for breeding or non-tame/untrained owls, the other for those who want to fly an owl.

List A: for non-trained birds

1 The pen.
2 The equipment shed/room.
3 A freezer to hold the food for your bird/s.
4 A fridge – not so vital unless you want to keep thawed food available for longer periods.

NOTE: In this day and age of environmental health I really think it is probably not a good idea to keep the food you intend feeding to your birds in the same freezer or fridge where you keep food for human consumption.

5 A good, strong, well made falconry glove for handling birds.
6 A soft deep net for catching up untrained birds.
7 A pair of small wire clippers for cutting back talons.
8 A first-aid kit (our vets, Lansdown Veterinary Group, do an excellent one, its contents prompted by years of experience of what might be needed).
9 A decent wooden travelling box with an upwards-sliding door and air holes, but otherwise dark inside, and lined at top and bottom with carpet.
10 A 'sick' quarter, left spare in case of an illness or injury where your bird might need confining in a smaller area for treatment.

List B: for those with an owl for training

All of 1–10 above, plus the following falconry equipment with which to train your owl.

11 Aylmeri jesses, plus two sets of slotted straps for when you carry the owl.
12 Two pairs of thin, permanently attached hunting straps, one pair to have on the jesses and a spare pair. Remember these should be renewed yearly.
13 A couple of swivels of the right size.
14 A leash (not for tethering the owl, but it is a good idea to have safe equipment on your bird for handling sessions).
15 A falconry bag.
16 A dummy bunny if you want to train the owl to chase it, or teach it to go hunting.
17 Bells for the leg and tail if you are going to be flying it away from home at all.
18 Telemetry, if you feel so inclined.

Once you have all your facilities built and finished, and the equipment sorted out and neatly put away where you can find it, you are ready to get your bird or birds.

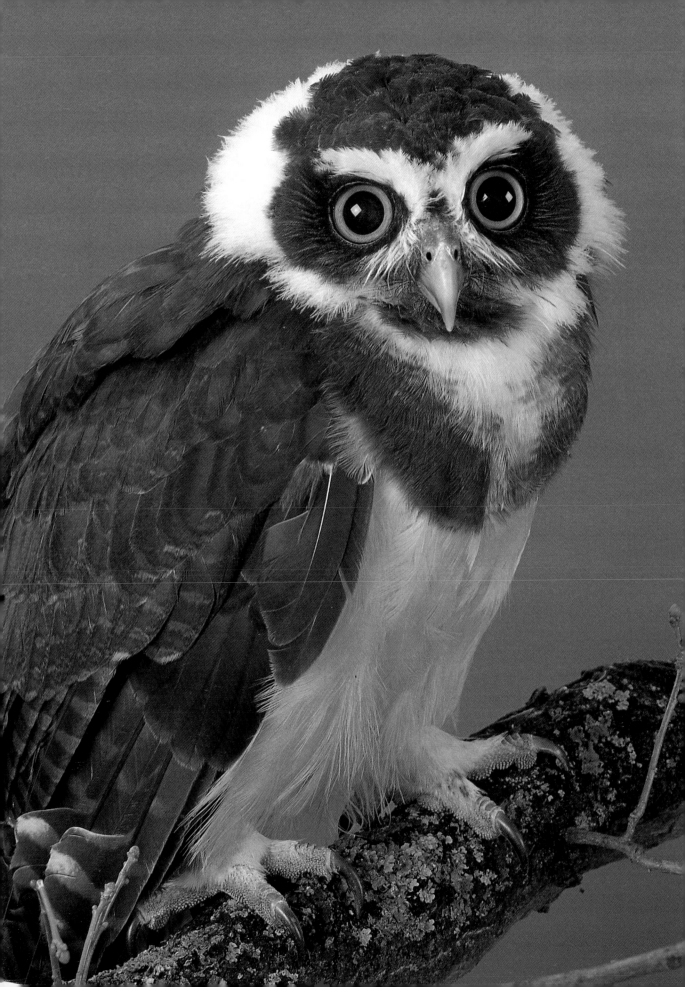

■ Now I know how many Little Owls we bred!

OWLS FOR BREEDING

O	*wls have been bred in captivity for well over one hundred years – in fact, thanks to some excellent research by Bernard Sayers who very kindly let me have his information, the earliest record is for the Great Horned Owl which is recorded in Ibis as being bred at Arundel Castle in 1834. So actually they have been bred in captivity for 164 years! However, it is in the last three decades that real strides have been made, with twenty-eight species being bred out of the forty-three that Bernard lists; on page 61 is a table of first breeding of owls, with very grateful thanks to Bernard Sayers who gave it to me.*

■ *Juvenile Spectacled Owl*

SOME OF THE PROBLEMS

Once a species starts being bred, the most important factor is to have enough birds of different bloodlines so that in-breeding will not become a problem. This is often a major difficulty, and a number of species that were being bred, have faded away for that very reason. The beautiful Savigny's Eagle Owl, one of my favourite species, all came from one pair that originated from London Zoo and they are now on the road to extinction as a breeding species in the UK; we have not bred them here for ages, and I know of no one else who has viable pairs any more.

Successful breeding itself leads to different problems. When a species is first bred, it will often fetch very high prices; however, after a very short time, as the number of birds being bred increases, the prices fall, and all too soon it is actually quite difficult to move on the captive-bred young to good new homes. Barn Owls, European Eagle Owls, and to a lesser extent Bengal Eagle Owls, Snowy Owls, Boobook Owls and Burrowing Owls, are all getting more difficult – and in some cases downright impossible – to move on; at least, and perhaps I should make this point quite clear, difficult to move on to the *right home*. Selling baby barn owls at £25 each in a pet shop to anyone who will buy them, regardless of the buyer's knowledge or ability, or of the facilities they have, *that* is still easy to do; but in my book that is pretty reprehensible behaviour, and any breeder of owls who is doing that is *not* welcome here. (I don't think much of puppies being sold in pet shops either,

or rather I don't think much of the puppy breeders.)

The *very first question* you should ask yourself is, why you want to breed owls, and what you are going to do with the resulting young if you succeed. If you can seriously answer that question with no doubts or shame, go ahead – but always remember that the market will become limited, whatever the species. Tony Warburton, who at the time of writing is the Taxonomy Advisory Group (TAG) chair for Owls in Federation Zoos in the UK, considers that after about twenty pairs are up and running, it gets much harder to place young in suitable homes. And yet for a serious breeding programme, to give us a solid stock of captive birds which will last 100 years returning 90 per cent genetic diversity we should probably have upwards of 100 pairs together.

I realise that I am possibly going on at boring length about what you are going to do with the young birds you breed, but it really is something that you have to think about. If, for example, you decided to get a pair of Burrowing Owls – which I think make great aviary birds – and they breed successfully and raise five young, this means you now have seven Burrowing Owls. And what if you can't get rid of them, and you leave them together, and three pairs breed the following year? Now you have upwards of twenty, plus you have started in-breeding which could lead to bad problems for the owls in the future – and all this in only two years. Admittedly this is one of the worst case scenarios, but it can happen.

CHOOSING A SPECIES FOR BREEDING

If you are determined to go ahead, your first decision will be what species to breed – being sensible, I hasten to add: there is no point in consulting a book of owls of the world and deciding that you want to breed a highly exotic species that

has never been seen in captivity in the UK, because you won't be able to get it in the first place! Think what you want to achieve, and choose a species that you can manage, and can get hold of.

Then you have to build an aviary, or maybe

Common Name	Scientific Name	Year	UK Breeder	Source
BARN OWLS	**TYTONIDAE**			
Barn Owl	Tyto alba	1867	E. Sheppard	Zoologist 1867:949
African Barn Owl	T. a. affinis	1988	Lilford Hall	C.B. 25/3/89:13
Dark-breasted Barn Owl	T. a. guttata	?	G. Dangerfield	B. Sayers. Pers.Comm.
Grass Owl	T. a. praticola	1995	F.A. Keens	Pers. Comm.
TYPICAL OWLS	**STRIGIDAE**			
European Scops Owl	Otus scops	1899	E.G.B. Meade-Waldo	A.M. 1899:159
Collared Scops Owl	O. bakkamoena	1972	H. Smith	A.M. 1972:59
Tropical Screech Owl	O. choliba	1977	Twycross Zoo`	C.B. 12/1/78:1
White-faced Scops Owl	O. leucotis	1923	E.F. Chawner	A.M. 1923:201
Western Screech Owl	O. kennicotti	1994	F.A. Keens	Pers. Comm.
Great Horned Owl	Bubo virginianus. v.	1834	Arundel Castle	Ibis 1899:30
Magellan Eagle Owl	B. v. nacurutu	1968	London Zoo	A.M. 1968:191
Eurasian Eagle Owl	B. bubo bubo	1849	E. Fountaine	Zoologist 1849:2566
Turkmenian Eagle Owl	B. b. turcomanus	1973	P.J.M. Smith	A.M. 1974:156
Savigny's Eagle Owl	B. ascalaphus	1972	London Zoo	A.M. 1972:211
Aharoni's Eagle Owl	B. bubo interpositus	1988	F.A. Keens	B. Sayers Pers. Comm.
Bengal Eagle Owl	B. bengalensis	1974	K. Simmons	A.M. 1976:136
MacKinder's Eagle Owl	B. capensis	1962	London Zoo	A.M. 1962:147
Spotted Eagle Owl	B. africanus	1901	J.L. Bonhote	A.M. 1902:39
Abyssinian Eagle Owl	B. cinerascens	1968	London Zoo	A.M. 1968:191
Milky Eagle Owl	B. lacteus	1981	P. Dugmore	Proc. of Owl Syp.
Brown Fish Owl	Ketupa zeylonensis	1985	Paignton Zoo	C.Bath Pers. Comm.
Javan Fish Owl	K. ketupa	1967	London Zoo	A.M. 1968:17
Spectacled Owl	Pulsatrix perspicillata	?	J. Spedan-Lewis	A.A.P. p24.
Jardines Pygmy Owl	Glaucidium jardinii	1915	E.F. Chawner	A.M. 1915:244
Ferruginous Pygmy Owl	Glaucidium brasiliensis	1988	B. Sayers	Pers. Comm.
Pearl Spotted Owlet	G. perlatum	1995	C. Barnard	B.Sayers Pers. Comm.
Boobook Owl	Ninox novaeseelandiae	1975	B. Sayers	A.M.1976:134
Snowy Owl	Nyctea scandiaca	1875	E. Fountaine	Zoologist 1876:5042
Little Owl	Athene noctua	c.1890	Lilford Park	?
Spotted Little Owl	Athene brama pulchara	1977	G. Dangerfield	I.Z.Y. 19:337
Burrowing Owl	Athene cunicularia	1895	Lilford Park	Ibis 1896:426
Burrowing Owl	Athene c. nanodes	1929	J. Spedan-Lewis	Sales Cat.1929
Tawny Owl	Strix aluco	c.1866	T. Sweetapple	Zoologist 1868:1131
Rusty-barred Owl	S. hylophila	1976	B. Sayers	Pers. Comm.
Rufous-thighed Owl	S. rufipes	1992	B. Sayers	Per. Comm.
Ural Owl	S. uralensis	1992	Hawk Conservancy	C.B. 3/4/93
Barred Owl	S. varie	1992	B. Sayers	Pers. Comms.
Great Gray Owl	S. nebulosa lapponica	1989	P. Dugmore	Various Sources
Hawk Owl	Surnia ulula	1993	Banham Zoo	D. Armitage Pers. Comm.
Striped Owl	Rhinoptynx clamator	1989	B. Sayers	Pers. Comm.
Long-eared Owl	Asio otus	1994	F.A. Keens	Pers. Comm.
Short-eared Owl	A. flammeus	1981	G. Dangerfield	I.Z.Y. 13:301
Tengmalm's Owl	Aegolius funereus	1995	B. Sayers	Pers. Comm.

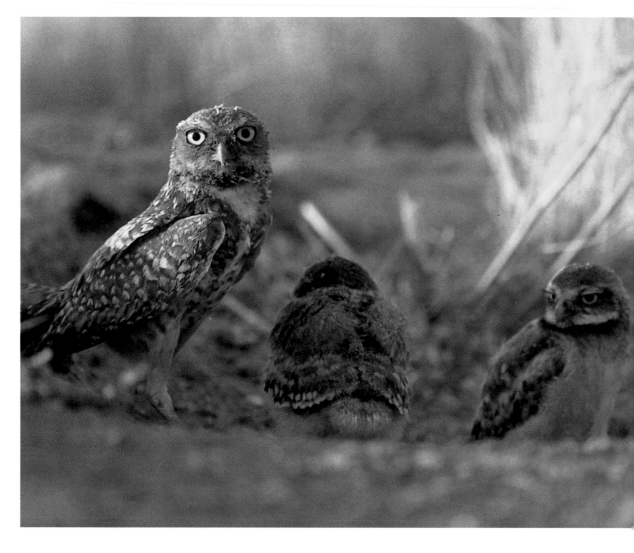

■ *A Burrowing Owl parent on look-out duty while the young come out to have a look too*

several, depending on your plans. And believe me, you will never have enough aviaries, I know, and so do all my friends who keep birds of prey and owls. I now have over 110 pens, and if fifty more fell out of the sky into the right place tomorrow, at least one quarter of them would be full by the end of the week, and the rest by the end of the year – and I would still need more space!

I cannot attempt to suggest which owl species you, or anyone, should go for, which I know is not particularly helpful, but it is nevertheless true. If you are a person beginning in breeding owls, then your choice will probably be limited to those available on the open market; but once you start to know your

way round the owl world, then you will meet people with the less common species and you will learn who has got what, how available they are, what their long-term future is, and so on.

I think the best way to learn and to decide is to go to a number of different centres open to the public where you will see a variety of owls: see if a species really interests you, how different people keep them and so on, and then you can decide from there. Without doubt you will have to travel a fair distance in order to see a variety of collections – but if you like owls, then you should enjoy seeing them all, and it will certainly be a learning experience. At the time of writing, a good person to contact is the Director of the Owl Centre at Muncaster Castle in Cumbria; he knows exactly what is going on in the owl world, and at the moment is the TAG (Taxon

female from another, they are still related. You will therefore have to do some homework, and find out if the people from whom you intend to get a bird, know exactly where their stock came from. (I have to admit here that I do not know where all my birds originated from.) In fact, the only way of being absolutely sure that birds are not related is to have them DNA tested, and that is expensive and time-consuming, and unless the laboratory knows the species and has what are called probes, they may well not be able to tell anyway. Nevertheless it is the best way in the long term.

Your next important consideration will concern accommodation, because the species of owl you decide to try breeding with, will dictate the size of pen you are going to have the fun of building.

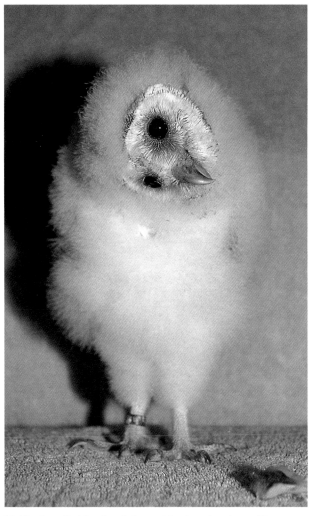

■ *The Barn Owl: bred easily in captivity, they view the world from many angles!*

Advisory Group) chair for Owls in Federation Zoos in the UK. Be warned, however: he is very persuasive, and might inveigle you into concentrating all your efforts on one species of Scops Owl, or perhaps something even more obscure if you are not careful! Otherwise contact The Federation of Zoos to check who is the Owl TAG chair.

Do not succumb to any desire for an owl that is not available on the market in the UK or in Europe, because there is no point in wanting an owl that you are unlikely to be able to get hold of. Try with a species that is readily available, and importantly for which there is still a market.

Most important is to start off with an unrelated pair, a task which regarding many species is extremely difficult. You may well find that even if you buy your male owl from one person and your

ORDERING YOUR OWLS

Once you have established that the pair of birds you are going to get are as unrelated as they can be, you may have to put in an order with the breeders. You will probably be putting your name down for a young pair: although older birds may be around, bear in mind that unless you are sure of their history you could be buying a whole load of problems. Perhaps this is a generalisation, because I have passed on older owls that are fine, and so have friends of mine; but certainly I would be very wary of the rarer owls, because if there is a still a good market, then the chances are that older birds are only for sale because they are not breeders, or have some sort of problem.

The advantage of buying young birds is that you should know what you are getting, you certainly know their age, you should know how they were reared, and so you get what you pay for. Whether or not they breed in the future is unlikely to be the fault of the breeder, it is more a question of luck in many cases.

The disadvantage of buying young birds is that they have to mature and get to breeding age, which with some species can be several years. But then, if you are not a patient person you shouldn't even entertain the idea of keeping, breeding or training owls, or any other bird of prey. Patience, optimism and a lack of greed is vital for the welfare and sympathetic husbandry of any livestock.

THE DO'S AND DON'T'S

Always order your birds in writing: it is safer. I am one of those people who are quite good if letters arrive in the post, because they go through a set procedure of being opened and read and put into the relevant in-tray, to be dealt with – later! Faxes to me are rather more likely to be treated in a less satisfactory way because they don't come into the main office and they can get mislaid. I much prefer the Email system now: it's a great way of communication. Notes or letters given to me by hand are definitely not a good idea, as they get put into pockets of coats that may not get worn again for weeks, and they get dirty and forgotten. And phone calls are the worst – straight in one ear and out the other. You can't beat a letter, especially if you have kept a copy. Moreover for those breeders who ask for a deposit, a letter with a cheque is the best way – and ask for an acknowledgment of the receipt of your cheque. Then they know that *you* know they got the letter in the first place!

Don't contact the breeder too often: the odd phone call during working hours doesn't hurt, and will remind those selling of your order; but I have had people buying birds from us here whose order I have very nearly cancelled because they pestered us so much, phoning every week to see what was happening to 'their birds'. And don't get cross if a breeder fails to breed your bird for you, because things can and do go wrong.

THE UPS AND DOWNS

Be warned, those of you considering going in for breeding owls. Breeding birds can be a really hard undertaking, and there are a million things that can go wrong. Birds that should have laid, may not, or will die just to spite you; eggs can be infertile, get broken, get chilled, go bad; young can fail to hatch, die early, get eaten, get rings caught in things on the nest ... and heaven knows what else.

It really annoys me when that word commercialism is thrown at us here and at other breeders. If those who don't breed birds had any idea of the ups and downs of the breeding season, they would all soon realise how completely they had failed to understand just what is involved. Occasionally I have a phone call from someone who has, say, recently started breeding birds, and they actually have the decency to

admit that they had had no idea how traumatic it could be – and that helps, I must admit.

I find that, emotionally, the breeding season is like a roller coaster ride: for instance, you have an incredible high because a pair of birds is seen to be mating – and then they never lay. Or a new pair lays eggs – and then breaks them before giving them any natural incubation. Or the eggs are fertile but fail to hatch, for whatever reason, either under the bird or in the incubator. Or the eggs hatch and you put the young back with the parent who rears them really well for two weeks – and then eats them. You end up feeling exhausted and wondering why you ever bothered. And as for making money – well, I'm damned if I see how people do. If you take into account the initial set-up costs, of birds and aviaries, and then the food and all the time it takes to look after and maintain them, *plus* the time and stress the breeding season takes – well then, the pay is lousy! So just be pleased if your chosen breeder succeeds and you get your owls…and if all this still doesn't put you off wanting to breed from owls – then nothing will.

If you are wanting owls for breeding I would recommend that you get young that are parent-reared, if you can, or at least hand-reared in a group; *don't* buy a bird that has been hand-reared singly. Although imprinting in owls is different from imprinting in the diurnal raptors, nevertheless you will have a better chance of breeding from your new birds if they have had a natural childhood. Ask the breeder if you can have the birds just after they have fledged, but before they can fly really well; in this way they will settle into their new home more quickly. However, make sure they are feeding themselves before taking them.

If you are paying large sums of money for birds, it is probably advisable to have them vetted by a good, experienced veterinary surgeon. He or she will have to be acceptable to both you and the breeder, and you, as the potential buyer, will have to pay for the vet's time and for the certificate; but at least you will know that you have strong, healthy birds. The easiest way to go about this is to get an agreement from the breeder that you will collect 'your' birds and take them straight to the vet for a health check; should they fail – and you will need a certificate to prove that – you will then return the birds immediately and have a refund. Now some breeders will be afraid that this practice might lead to people trying to exchange the birds, returning the wrong ones. However, this only goes to point out the vital need for owl breeders to put closed rings on all their young birds so they can be properly identified, and so that in-breeding problems can be avoided in the future.

Should a breeder refuse to allow birds to be vetted, you should consider going elsewhere.

COLLECTING YOUR BIRDS

TRAVELLING BOX DESIGN

I f you are going to keep birds, I would strongly suggest that you have a decent travelling box made. It should last you for years, it will mean that you always have it to hand in the case of an emergency, and generally it is really good practice to be able to house your livestock in the best fashion.

I have to say that I wouldn't give house room to any of the pet carriers that I have seen available on the market at the moment. The cardboard ones are really not that suitable for birds, and the lid in particular is not conducive to getting large, annoyed or scared birds out without ending up with holes in you. I also hate the plastic sky kennels that many people use: they let in far too much light, the door fastening is awful, and anyway birds should not be put into boxes with wire fronts – most people

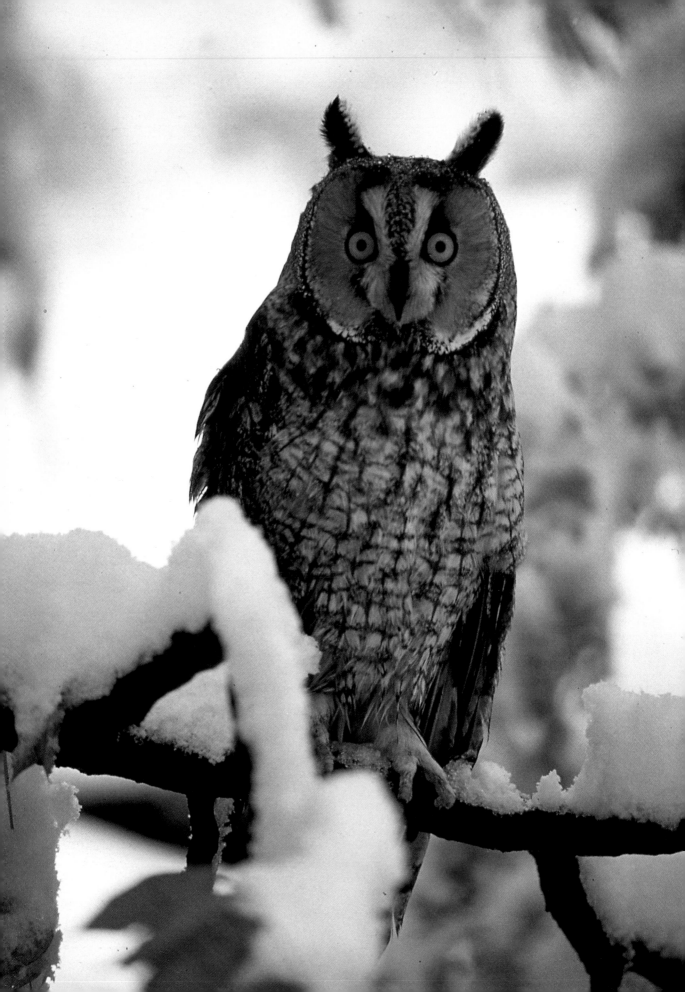

■ The Long-eared Owl has orange eyes, which is thought to indicate that it is less nocturnal than those species with dark brown eyes

■ The Hawk Owl is extremely diurnal during the summer months

■ *A well-designed travelling box. A door which slides upwards makes it easier to extract untrained or sick owls*

then fix a wooden or plastic front to cover all the bits of wire, and I just can't see the point; really you might just as well build your own to a decent design, from scratch.

I like a box made of plywood, with no windows, only holes drilled to let in plenty of air. When you drill the holes, put the piece of ply on an old bit of timber and drill through into that; then it won't splinter as it would if you were to drill it without any backing. Make it a good structurally sound box, but not so heavy that you need heavy plant machinery to lift it up.

Without doubt, an upwards sliding door at one end is the easiest way to get an owl in and out, whether trained or not; it is especially good for birds that are not trained. However, that does mean that the box must be easy to lift in and out of the car, because if you are travelling a trained owl you will not be able to slide the lid up inside the car – you will need to have the box outside, or at least on the edge by the door.

It is very important to carpet the floor of whatever you are using: there are few quicker ways to get foot punctures than putting a bird in a box where it is going to slip round while travelling. We now put carpet on the ceiling of some of our boxes as well, just to make them that bit more secure.

The box should be slightly longer than the length of the bird you are intending to travel, and wide enough that it can stand inside without touching its shoulders on either side. It is neither feasible nor necessary to build boxes that will allow birds to open their wings at full stretch. However, the height of the box is important, and it should be higher than the height of the bird when it is standing up properly on the floor.

Some people put perches in for birds. We never have perches in boxes that are going to be used for birds that are not trained, and we find that most of the owls will travel on the floor of the box anyway. Nor should perches be used for baby birds, as these could well injure themselves. Perches should only be used for fully grown, fully trained owls. Furthermore, if you design the box so that you can remove and replace the perch, it will make things easier in the long run, and the box more adaptable.

There is no need to travel birds of prey with water as they are very unlikely to drink while travelling anyway. You can only travel birds for a limited period anyway because of the Animal Transportation Act.

If you are going to collect a pair of owls rather than just one, then of course you will need two boxes. And if you only want to build one travelling box, then a strong cardboard box – such as those that televisions come in – makes a good substitute. Carpet the floor, and if you close the top before putting in the owl you can gently slip it through the flaps on the top and you won't be struggling to close them after you have let the owl go in the box.

CHOOSING THE RIGHT TRAVELLING TIME

Don't travel birds in hot cars in the heat of summer: if you do, you will kill them. Birds need to be kept cool for travelling, and hot cars, even with the windows open, are a death trap for them; many a poor dog is killed in this way as well. Either wait until the hot weather breaks, or if you or the breeder wants to have the bird collected, go early in the morning so you are driving back at a cool time, before the sun has got hot, or later in the day, so you drive once the worst of the sun has gone. Also, don't stop and spend hours in the motorway service station, but grab sandwiches when you fill up with petrol.

TAKING POSSESSION

Never just arrive on a breeder's doorstep, but always ring and ask when is a mutually convenient time for you to come and get your owl – remembering that if you are intending to have it vetted, you must arrive home in time, or leave long enough to get to the surgery and then get home. You are likely to have to pay for birds with cash – and I have to admit that I don't like accepting cheques for birds, and certainly not if I don't know the person and have not had a cheque from them beforehand. So take cash with you

and get the breeder to count it out in front of you, and then no one will feel short-changed. You must ask for a captive breeding document, which preferably gives the ID or the ring number for the parent birds if they have them, the date or month the bird was born, and the ring number of the bird you are buying.

I would strongly advise you to make sure that your new birds or bird have closed rings on, and check them to see that they are marked and fit the bird well. All annexe A birds – which includes all the European species of owls as well as some other owl species – require a sales license known as an Article 10 certificate and a closed ring as from 1 June 1997. If you have any doubts, contact the DoE to see what species needs what in terms of rings and paperwork. However, a seriously good rule of thumb is to make sure that the bird you buy is ringed.

Here at the National Birds of Prey Centre, we tend not to let people watch us catch up birds, preferring to do this quietly and out of view because it is less stressful both for the birds and for us. However, we always show the bird to the buyer before boxing it up, and really no buyer should accept a bird handed to them in a box without having a good look at it first. It is important to check its feet, its legs and wings, its face and eyes, and the inside of its mouth; if all these look healthy, then you should be all right. Anything else should be checked by an expert – namely the vet.

Once you have looked at the bird, put it into your box, take possession of the paperwork and make your payment, and get on the road as soon as possible – don't hang about once the bird is boxed. If you want to see the breeder's other birds, and if that intention is acceptable to him/her, or if it is a place like my centre and you want to look round, ask for the bird not to be boxed until you have done so and are ready to go.

If it is a big place like this centre, check when might be a good time to have the bird caught and boxed. We have four flying demonstrations during the

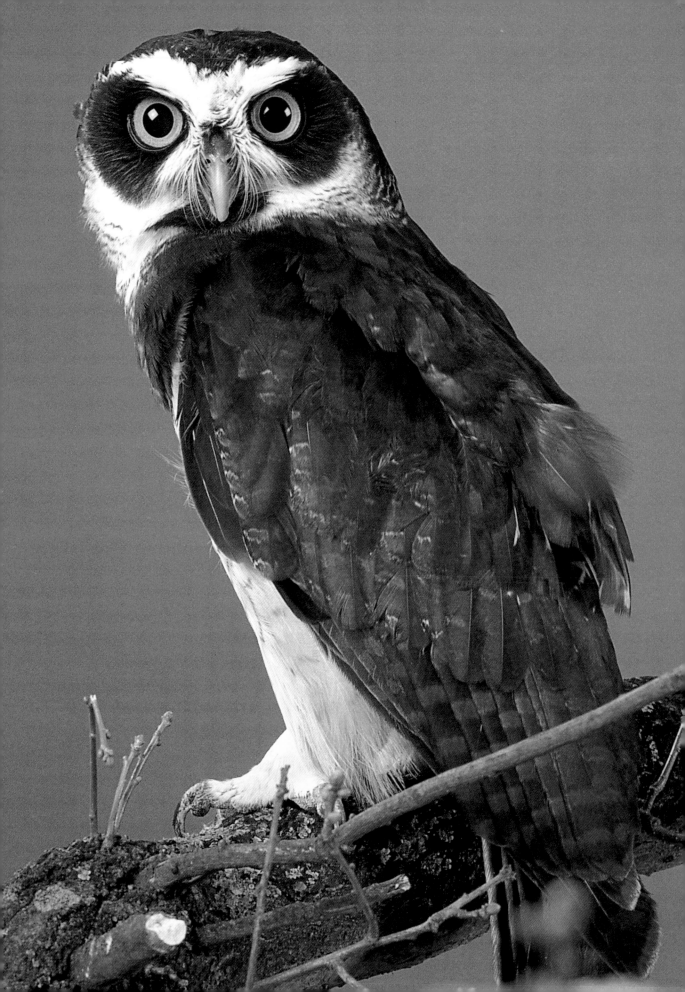

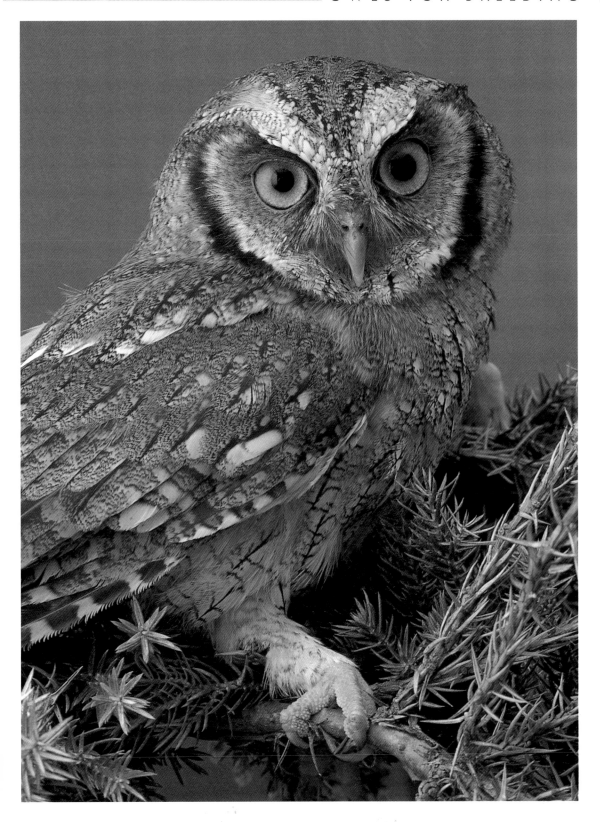

The Spectacled Owl comes from tropical South America. It is known to feed on crawfish and crabs in some parts of its ranges

Tropical Screech Owl – despite its large appearance in this photograph it is one of the tiny owls!

summer months, and if we are short on birds' staff, catching up birds that are leaving can be a real nightmare, especially if the buyer decides he or she wants to leave in the middle of a demonstration.

And don't try bringing your whole family, back to great-grandparents, with you if you collect a bird from me: I will let in a couple free of charge, but not a huge group of people.

SETTLING IN NEW BIRDS

Once you have all you need, get home as fast as is acceptably possible. If you are going to have the bird/s vetted that day, phone to make sure that your vet is expecting you and has not had an emergency call-out. Once the birds have been passed by the vet, get them home and into their pen and settled as quickly as possible. One of the huge advantages of an owl is that it doesn't matter if you get home after dark because you can still put the bird or birds into their new pen – unlike the diurnal birds of prey who really need to be put into a new pen during daylight hours. Having said that, I would not advise putting two owls that have not been together before, straight into a pen in the dark where you can't see what is going on: you need to be able to watch them for problems, and although *they* can see in the dark, *you* are not quite so good at it! So if you are introducing new owls to one another, either get home early enough to watch their initial reactions, or leave one of the birds in the travelling box until the morning. It won't hurt them; I have travelled birds from abroad for well over eighteen hours before I have been able to get them out of their boxes, and I have never had any problems – as long as the box is large enough for the bird to be comfortable, and as long as they are kept cool.

Another tip: whenever you introduce new birds into an aviary, cut off just the tips of the talons from both the birds – the one in the pen already and any new birds. It is probably a good idea to take off the very tip of the beak as well, knowing how well owls can bite.

The trauma of catching up, boxing, travelling, being vetted and then put into new surroundings is pretty major. Once the bird or birds are in, just leave them alone, apart from checking them a few times a day. They will need time to adjust and

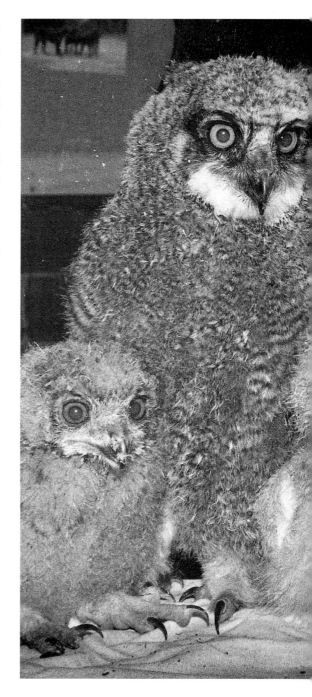

settle – just think how *you* would feel, having experienced a similar process, and you get closer to feeling what an animal who actually doesn't understand what the devil *is* going on (unlike you) might be feeling.

Don't panic if the bird/s don't feed straightaway; they will be feeling scared and so will lose their appetite for a while, and as long as they were fat before they came to you, it is not a problem. Make sure you know what diet the breeder used, so that for the first couple of weeks you feed your owl the same. If you consider that it was not good enough, or you want to change it to a better one, leave it a few weeks until the new birds have settled into their new environment. Don't try radical diet changes in very cold weather.

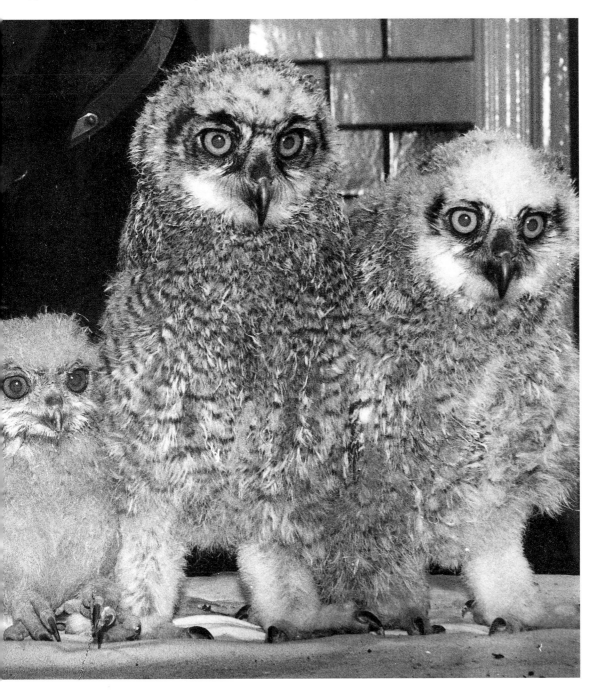

■ *Baby Eagle Owls*

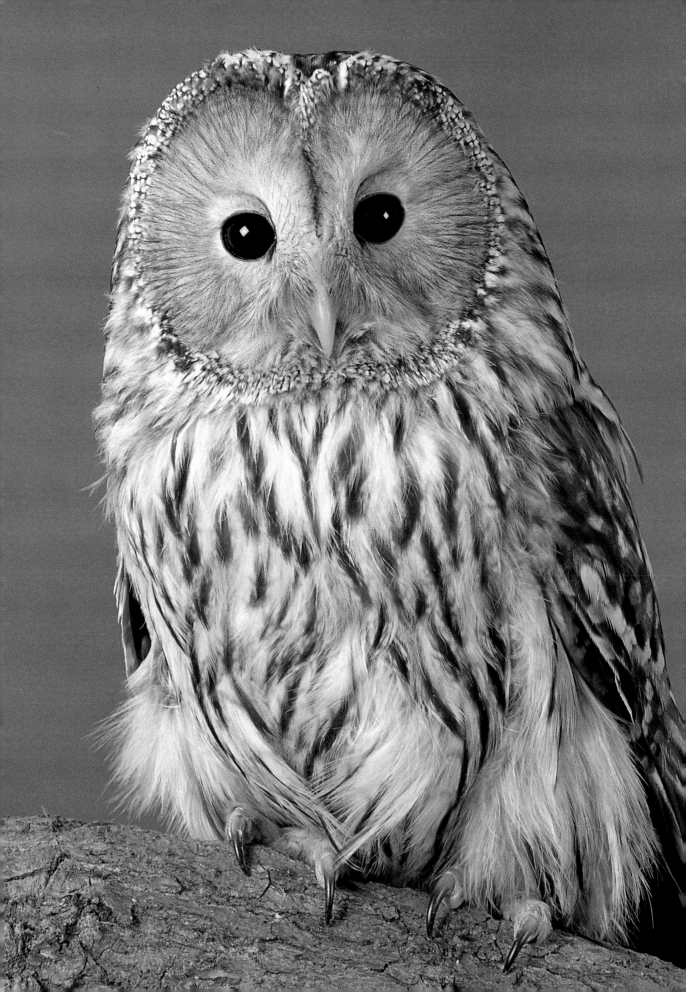

MAINTAINING & MANAGING YOUR OWLS

As there is little chance of breeding from your birds straightaway, they will have to be cared for and maintained for months, at the very least, and quite possibly years before they get round to breeding. They will need to be fed every day, to have clean water to drink and bathe in, a clean tidy pen with comfortable perches in which to live, and an eye kept on them to make sure they are happy and healthy.

Ural Owl

FEEDING

As I will discuss later on, it is probably wiser and more natural to feed owls in the evening if you can, rather than in the morning, *unless they have young*. Owls do tend to prefer feeding during the evening or night-time, which is hardly surprising really. By feeding them in the evening, the food will be lying around on the feed ledge for a shorter period before the bird eats, and that is a very good plan, especially in hot or very cold weather.

HOW MUCH TO FEED

This is one of the commonest questions I get asked, and it is an impossible one to answer because I am usually asked over the phone or sometimes by letter, so I have no idea of the size of the individual bird. It could be the runt of the clutch, or it could be a huge specimen, it could be male, it could be female, it could be that the owner doesn't even know its sex, or has got it wrong, it could be in fat condition or verging on thin before we start, it could be ill, it could be still growing, or it could be in breeding condition – and this is just to give you a few different scenarios. Moreover, if I tell you to feed it one very small dodo per day, and then it turns out that your particular bird needs more than a very small dodo per day and subsequently dies of starvation, who are you going to blame? Me. Well, apart from the fact that I can do without the blame, I don't want to be sued by people because their bird died.

Basically, *all birds are different*, and what they need to eat on a daily basis depends on many different factors. These include the age of the bird; its fitness; the way you keep it; how tame it is; the weather conditions at the time of asking; the type of food you are using; the type of food it was reared on; how often you fly it; how old it is; what sex it is; which subspecies, if you even know, or have been told the truth by the breeder you got it from (if the breeder knows...) and probably other factors as well, such as, is it in breeding condition, is it feeding young, egg laying, not well, and so on and so forth. As you can see, there is no easy answer, so

when I tell you that I *can't* tell you, you will understand why and realise that there is more to weight and feeding than meets the eye – or the word processor, in my case!

Feeding birds so that they will be obedient and fly, and more importantly return, is much more critical than feeding non-flying aviary or breeding birds, and I will cover that particular topic in the section which deals with the training of owls. Now we are concentrating on aviary birds, so what I will do is give you a list of the species that we feed here on a daily basis – *not* the flying owls, but those which are not handled and which are in pens for breeding or moulting, or are resting or retired.

FOOD TRIALS

Several years ago we had a student here doing food trials with our captive falcons – he fed them certain foodstuffs in the morning, and after monitoring them during the day, he then collected the food remains in the evening. We thought that this was such a good idea that we took it on board at the Centre, and now we feed the diurnal birds of prey in the morning and do a food collection in the evening. (This is *not* done with species that have young, or with the owls.) By doing this we found out if and when we were overfeeding the birds, and also who was eating and who not; furthermore we were not then leaving food about all ready and waiting to encourage rats, mice and other vermin. We also found out more quickly what food types each bird really preferred. So in fact by this small task each day we learnt a great deal on a daily basis about the birds, were able to monitor health more, checked the birds once more in the day, saved on food bills and reduced the number of potential vermin – not bad for half an hour's work, really. I suppose in a way we do it with the owls, if we are feeding them in the evening, as we did in the very cold weather, because we then feed the diurnal birds in the morning and at the same time check all the owls.

To do this successfully with owls you would have to feed in the evening; as I have said, this is the

best time anyway, especially in the summer or in hot weather when it is best to avoid having food lying about on feed ledges until the evening, since they are unlikely to feed until then. Do a food collection in the morning, and you will soon know if you are overfeeding or if your owl is not eating, because there will be food left over; then you can adapt your feeding policy accordingly. Pairs of owls with young should be fed morning *and* evening, however, so they have food available in the daytime if they require it. Moreover, in the extreme cold we were having at the start of this year, we found that if we fed the owls in the morning along with the other birds, the food was frozen by the afternoon if not before, so those who were not eating straightaway but leaving it until after dark got nothing, or frozen food if they could manage it. So we changed the feeding time and waited until just as it was getting dark, and that worked.

I suppose the message here is never to have a closed mind, always be prepared to change what you do according to how circumstances change, and be prepared to listen to other ideas before dismissing them. Don't panic if birds leave food for a day, or even two or three – *unless* they are tiny owls. Our eagle owls could probably go without food for two weeks when they are in fat condition. In fact it often takes well over a week to get the large flying eagle owls back down to weight – though remember, never take things for granted: for instance if your eagle owl was unwell and you hadn't noticed it, or symptoms were not showing, a week with no food could kill it.

As you can see, there is a great deal more to feeding than first meets the eye.

WHAT TO FEED

Here is a list of what we feed our owls on a daily basis. (NB Never use wild, shot rabbit: farmed rabbit is safest.)

Larger Eagle Owls

European Eagle Owl, Great Horned Owl and such-like: four to five chicks each depending on the weather, five in cold weather, four in hot; *or* one decent-sized quail; *or* one rat; *or* four to five mice; *or* about one-third of a rabbit; *or* half a full-grown guinea-pig.

Smaller Eagle Owls

Bengal Eagle Owl, African Spotted Eagle Owl: three to four chicks; *or* one medium quail; *or* one medium rat; *or* three to four mice; *or* about one quarter of a rabbit; *or* a third of a guinea-pig.

Medium-size Owls

Tawny Owls, Barn Owls and suchlike: two to three chicks; *or* one medium quail; *or* half a rat; *or* two to three mice; *or* a rabbit back leg. (Forget the guinea-pig!)

Small Owls

White-faced Scops, Little Owls, Burrowing Owls and the like: one to two chicks; *or* half a quail; *or* one to two mice; *or* half a rabbit back leg *or* a whole rabbit front leg.

Tiny owls

European Scops, Pearl Spotted Owlets: – one chick skinned; *or* half a small quail skinned; *or* one mouse skinned. Perhaps try some live mealworms or crickets, or locusts (these can be found advertised in the magazine *Cage and Aviary Birds*). I have no idea how many they will eat, if indeed they will, but it has to be worth a try – you will just have to experiment – I'm going to! Let me know what happens if you try it.

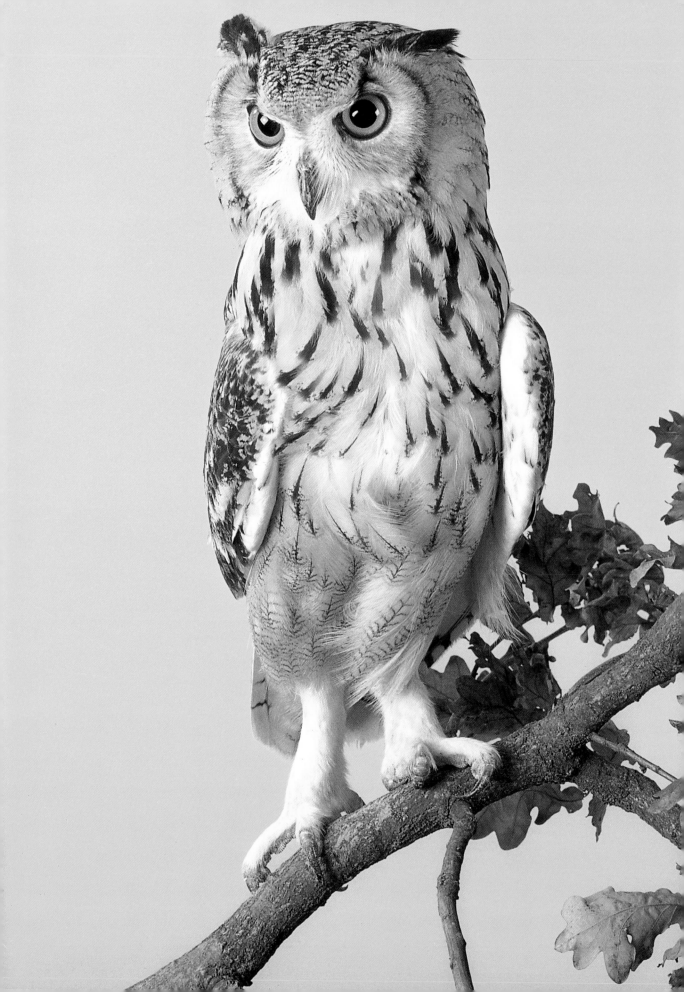

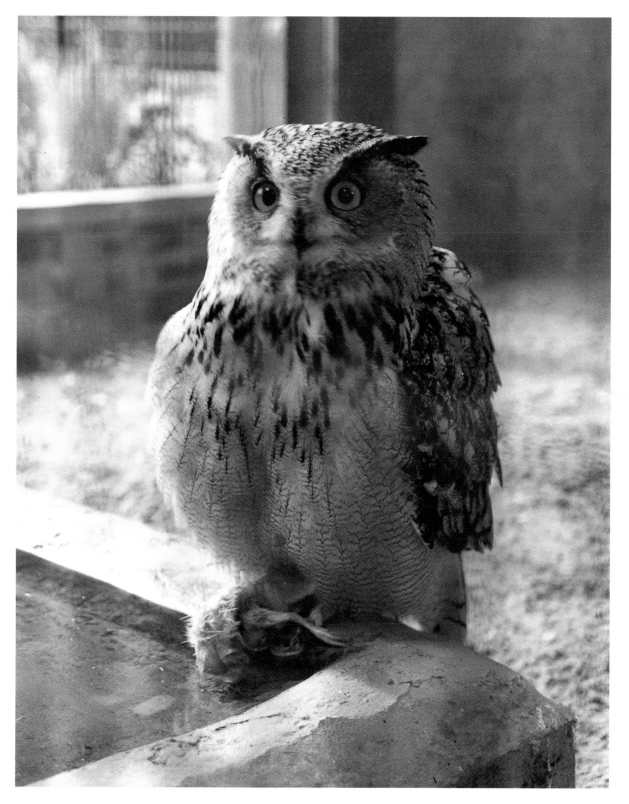

The Bengal Eagle Owl (or Indian Eagle Owl): one of the nicest owls to fly

Turkmenian Eagle Owl: this particular chap is a great character, and a good father

All of these amounts are for *one individual bird*, not a pair; pairs get double the amount stated for a single bird. All will depend on the individual bird, the weather and the time of the year, and all will require reviewing regularly. If all the food is going and you know the owls are eating it and not some other animal such as a rat stealing the food, then try feeding a little more – remember you can cut mice and chicks in half. And if birds are wasting or leaving food (particularly in hot weather), cut the amount down a little and see if that helps. There are no hard and fast rules: it's a question of constantly adapting.

Some birds will refuse point blank to eat certain foodstuffs, and this may well be a consequence of what they have been fed by the breeder, or whoever else had them before. Not everyone feeds a good mixed diet, and I am afraid to say that many people still feed a diet of day-old chicks and nothing else. If this is the case, then it can be hard to wean your owl onto a different type of food. But it really *is* important, partly because no one food type as a diet is good for birds, and partly because if your food supply were to dry up for any reason, you need the birds to eat other stuff, otherwise you could find yourself in big trouble, especially if the weather is really cold and you have a bird that is refusing to eat what you have for it.

I strongly believe that day-old chicks will be available as a feed source for only a limited time. Eventually someone will sort out the science so that producers can breed the sex they need commercially, and then there will be no hatchery waste.

PROVIDING WATER

There are still a number of people in the bird of prey world who think that birds of prey and owls do not need water. *They are very wrong.* Just because these birds may not drink a great deal, or because you don't see them do it, doesn't mean that they don't need it. It is very important that owls have the chance to drink and to bathe at all times, unless it is so cold that the water freezes, in which case it is better to feed more chicks (with the yolk sac) so they can get their fluid that way.

As I said in the building of the pens, put in a bath that can be cleaned from the outside, so that during the breeding season you can do so without disturbing the birds. Clean it at least once a week in the winter and preferably twice, and three times a week in the summer and more if you can. Once a day in hot weather, when the water will turn green quickly, is great if you have the time to do it. Another tip is that if you let the tap and hose run for thirty seconds to a minute before using it to fill the bath, you will get less bacteria in the water. Put the hose over the garden when you do it and in that way you will at least be putting the water that you are otherwise wasting, to good effect. You can also put a pinch of Virkon disinfectant into the water – check with the manufacturers the exact amount – which will help to keep it clear, and be safe for the owls to drink.

MAINTAINING YOUR AVIARIES

We like to give our pens at least one really good clean out each year. To do this we catch up the owls in the pen, using our nets. We check them over physically, cut back talons and beaks if they need it, and worm and spray the birds for internal and external parasites. We occasionally have the vet there to take blood samples, just to monitor the birds; it is important to have samples from healthy birds every now and then, so that we have parameters within which to work, then we can identify quickly when a bird is ill. We then box them, and put the boxes somewhere quiet and dark.

Once the birds are safe and secure, we clean the pen from top to bottom, scrubbing all the walls and perches and the nest ledge or box, depending on what they have. The sand is raked and sieved, and all the dirty sand removed. Any walls that are painted are re-done. The nesting area is cleaned completely, and fresh sand placed there. The feed tray is checked – it should be clean, as you should do it on a regular basis (see below). Any sand that needs renewing is wheelbarrowed into the pen, and the whole thing is raked. Then you should either spray or fog the aviary with something like Virkon, which is a disinfectant. Leave it to dry for a while, and then release your owls back.

If this is done once a year, or maybe twice – although if you have placed your perches well in the pen, then you should not need to do it more than once – then all you will need to do is clean the bath and feed ledge regularly, and we like to rake the pen out once a week. If you have a good base of 4–6in (10–15cm) of clean sand at the start, it is a five- to ten-minute job to rake the droppings and rubbish to the back of the pen, or wherever the door into the service passage is. Pull the pile into the passage, sieve it, and rake or shovel back the clean excess sand. Then you can shut the door, stop disturbing the owls and clean the passage in your own time.

We 'unibond' all the concrete passages to stop the concrete dust from rising when we sweep them. If you then shovel up the droppings and rubbish and remove them, the passage can be swept clean. If it is very dusty, give it a quick spray with the hose and that will lay the dust and make it pleasanter and safer for you and the owls. The tools that you need for keeping the owls clean you might keep hung up in the passage, so you know where they are and can get them quickly. It's not a bad idea to keep a catch-up net in there as well.

FEED TRAYS

We have feed trays or drawers in all our pens and these need cleaning on a regular basis. The amount they need cleaning will depend on how the owls use them. If they feed on the tray then it gets fairly revolting pretty quickly, whereas if they just remove the food to eat elsewhere, then it stays cleaner for longer. Use your common sense, and clean it every time it needs it.

Really that is all there is to keeping your owls well fed, watered and clean. When it comes to breeding from them, the rest is up to them, at least at the start.

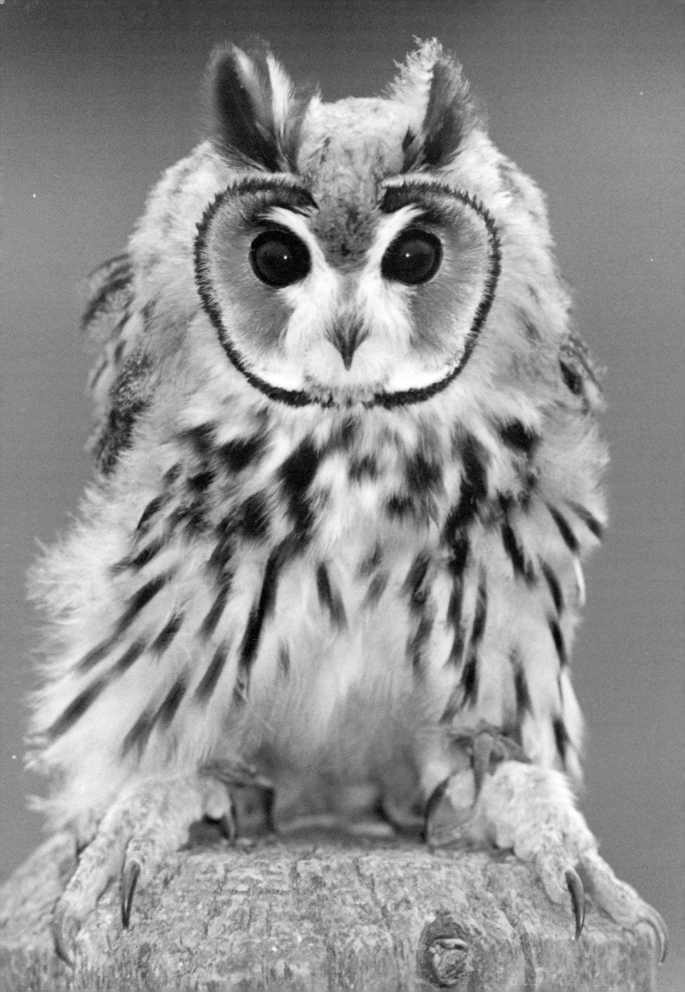

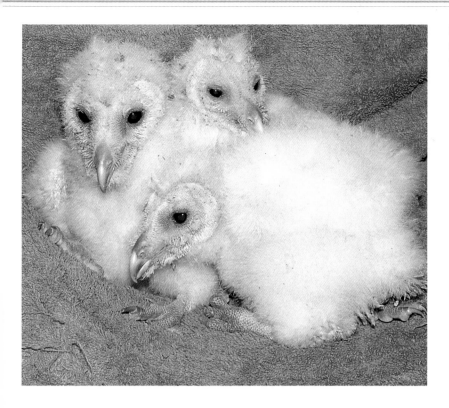

FIRST ATTEMPTS AT BREEDING

So when will your owls breed? This is a good question really, but the answer is, I haven't a clue! When trying to breed owls, you get the aviary right, which hopefully you have done; then you find and obtain birds that have a known origin, age and so on, and you put them together; next you feed them a good quality, varied diet – and then basically you wait. There are, however, one or two things you can do to maximise your chances of success.

Rockling as a baby: note how large the feet are on a Striped Owl

SEXING BIRDS

First you must be confident that they are a pair: I spent two years waiting for a pair of Iranian Eagle Owls to breed, and these were guaranteed breeding because they had bred before. However, this was before the parent birds came to me, and the young were removed for selling on, and sadly it transpired that the original father was sold with one of his offspring by mistake, and I got the mother and daughter! This only happened because the young birds were not ringed. I have been as guilty of this as others, but now we are ringing all our young whatever the species, and this coming winter – when hopefully we will not have another outbreak of Newcastle's disease in local poultry farms to make life difficult here – we shall be ringing all the adult birds with split rings. We microchipped most of them this winter. but had to stop catching up birds after Jan 6th for a variety of reasons. So be advised: if you want to be a responsible breeder of birds – or any other species, come to that – please put unique identifying rings onto all your birds. It is neither difficult nor expensive, and it will make a tremendous difference in the long run.

If, like me, you end up with a pair of birds where it isn't obvious that they really are a pair, and they are not breeding – don't wait too long, have them sexed. There are new processes all the time. At the time of writing I have recently been approached by a company which undertakes to sex birds genetically – you can send either a blood sample or a small feather taken from the bird and they will sex it for you. I don't know how reliable it is, because I don't know if they have data on all the raptor species, but it could be worth contacting them (see Useful Addresses) to see how reliable they consider it to be for the species you are interested in. The enormous bonus is that all you have to do is to pull out one small body feather: there is no invasive surgical procedure, and therefore no risk from anesthetics, and that has to be good.

If one of your owls lays an egg, don't worry, because that one is bound to be female! But then of course you have to be sure which one laid the egg. In fact it should be easy to tell: catch up both birds, and the one that laid the egg should have a brood patch: a soft, flaccid, oily area of skin showing on her tummy. The other bird should not have this – unless they are both female and both in breeding condition! You see how complicated it can get.

The other way of being sure that you have a pair is to have them surgically sexed. For this it is advisable to approach a vet who is experienced in surgical sexing, because it is done under a general anesthetic and this will always contain an element of risk to the bird – it is never worth risking the bird if your vet is not confident, so go to one who has done it before. (See Appendix for a list of vets that are well known in the raptor world – with apologies to any I have missed out: this was not intentional).

COMPATIBILITY

Once you are sure you have a pair, then you need to spend a little time watching and listening to them, especially in the run-up to the breeding season. Our owl courtyard is extremely noisy at this time of year, in fact so much so that it is hard to tell which birds are making which noise. You are looking for birds sitting together, making a scrape in the nest ledge, or showing signs of interest in the nest box; or perhaps the male getting food for the female and trying food passes, although the problem with owls is that much of their courtship is done after dark and it is difficult to see what is happening.

Really at this stage you are just hoping for compatibility, and if you find that one owl is constantly looking miserable and is always in a lower perch position than the other, then you have probably not got a compatible pair. Although I have to say at this point that birds never fail to amaze me: we have a pair of Bengal Eagle Owls – at least we know they are a pair now – which have never looked good together; in fact if I could have got rid of them, I would have done so. But damn me if this year they haven't laid and have four fertile eggs –

and even up until the eggs were candled, myself and all my staff would still have laid money on them not even being a pair, and certainly not compatible. Well, we were wrong, and they have been pretty compatible at least four times! What I am trying to say here is that with owls, it isn't always easy to tell what is going on.

Until you have eggs there is little you can do other than to keep the birds as well as possible, feed them good food and make sure you have a male and a female. There are various hormone implants that can be used, but I really believe that these are a last resort, and certainly not something that should be considered until you know you have a real problem with a pair of birds which have been given every other chance to do the job naturally.

Owls are not that difficult to breed once you have the situation right; it's just a matter of getting things right and then having a little patience – but if you don't have that patience, then don't go into breeding anything because it won't be the right thing for you to do. I had a phone call from a chap this year who had just managed to get a male ferruginous buzzard to put in with his female; he has had her for ten years, the male is adult and he took a while to introduce them. However, he is now talking about hormone implants, even though they have not been together for three months and it is still March; moreover this particular species does not normally lay until mid-April and a first-time layer

can be later. All it needs is a little patience, but some people just don't have it.

If I was not a fairly patient person – at least with the birds – there is no way I would still be in this job. It took us thirteen years to breed African Fish Eagles, and then after two years the female decided that she would rather kill the male than breed with him. Two years on I have switched the pairs, and the breeding male has had four fertile eggs with a new female. Sadly I failed to hatch any of them – it was my fault, not theirs – but still you can't be impatient. I relate this episode to point out that things take time, and just when you think you have got it right, it all goes wrong again; but you just have to learn to deal with it.

A WORD OF WARNING

One thing I have noticed is that after each breeding season I tend to wish away the rest of the year and start concentrating on the next one – and this is not good because you shouldn't let breeding a few damn birds take over your whole life. I think I have the right to give you this advice, because I have done exactly that: my centre occupies 100 per cent of my time, and that is not good for anyone. Admittedly I am always busy, and the work I do here is very varied and few people have the sort of set-up that I have to keep their life busy, but be warned against becoming too consumed by this hobby, to the exclusion of anything else.

EGG LAYING

Now you have no option but to wait until the female lays an egg. However, you could pass the time by reading as much as you can about owls. Also, it would be sensible to keep a log book that you write up every day, noting behaviours, how much food is eaten, what the temperature outside is and other such data that might be useful at a later date. In fact the new legislation that came in on 1 June 1997 requires all breeders of Annex A birds (this includes species such as the

Barn Owl) to keep records, so start now and you will have good, useful and legal records.

You should also consider what you are going to do if your birds do lay eggs. Are you going to leave them to hatch and rear their own young? That is the easiest way of doing things since you don't then have to get involved in incubators, weighing machines, records, thermometers, hygrometers and the like. The down side is that the parents may fail to rear the young. But personally, unless it is a very

■ *The fertilised egg, with the heart and blood vessels formed, and the air cell just showing. The black tick mark is on the shell*

rare species, or you are already experienced in incubation and rearing birds, I would leave it to the birds, at least to start with.

The only thing I would suggest you do is make a candler, so you can check you have fertile eggs. But other than that, leave it to the birds, at least for the first breeding season, and maybe two; if after this time they still are failing, then you could consider a more highly managed breeding programme. The reason a candler is important is there is little point in leaving birds to sit on infertile eggs, so it is best to check them at about ten days of incubation (that means ten days after the female has started sitting seriously, not ten days after the first egg, as she may not have started to incubate right away).

EGG LETHARGY

When birds are starting to lay eggs, they go into what is known as 'egg lethargy'. The female can look pretty miserable, she will go off her food, sit hunched up with her feathers fluffed out, and generally not look well. This can be a real problem, because how do you know if she is in egg lethargy, or if she really is ill? Sadly, there is no simple answer, although if she is on the ground then you probably *have* got problems – unless of course the nest is on the ground, when it is more difficult to assess the situation.

If you are concerned, then very carefully catch up the bird: if she really *is* having problems, such as being egg bound, you will find her all too easy to catch because she will probably be unable to fly; if this is the case you need to take action fast. If she can fly, use the net, but whatever you do, catch hold of her very gently. If she is egg bound you should be able to feel the egg in her abdomen, but don't press hard because you do *not* want to break

the egg. Put her in a box with a fairly warm hot-water bottle wrapped in a towel (the hot-water bottle in the towel, not the owl) beneath her and get her to a vet who knows what to do for egg bound birds. Or get her to your vet, *as long as* you have made sure that he or she will ring an expert on any problems such as this if not experienced themselves. Of course all this is liable to happen on a Bank Holiday Sunday, when you have visitors and the car won't start. But don't panic – that's what is called Sod's Law.

Sometimes it really is difficult to decide if a bird is looking normally 'sick' because of egg laying, or is genuinely ill because things are going wrong. But if you have a gut feeling, go with it: it is better at this stage to save the female than to worry about spoiling the breeding season. You should get one egg every other day, though sometimes a bird will go three days, sometimes more between eggs; but if you get a long break, this is the time to suspect egg binding. (It is important to have an idea of how many eggs your species of owl normally lays or you won't know if she should continue laying; remember that a few species lay only one egg in a clutch.) Birds are more likely to get egg bound in cold windy weather, or cold snaps during warmer weather, particularly if your pen faces into cold winds; or if the birds are lacking calcium.

Once you start to get eggs, then you can feel as if you are getting somewhere. Alternatively if you are like me, then things get miserable, because I hate the incubation side of this job.

MONITORING EGGS

For those of you who are interested in research, or would like to assist with research, I am going to put a letter and a form in the back of this book. If you feel inclined to help with fresh egg weights and measurements, read the letter, photocopy the form, fill it in with the data we need and send it to the address at the bottom. It is quite staggering how little is known on fresh egg weights and measurements, incubation periods, and pip and hatch times, and it is something that people working with birds in captivity can remedy. And actually you can do it for us on the eggs of any species, not just owls' (I will

■ *The developing egg: how the yolk lies in the egg. Don't forget, always stand or hold your egg blunt end up, not down as shown in these illustrations. The air cell should be uppermost*

air cell

qualify that statement: no chickens' eggs, please!). You name it, the information is probably needed!

Anyone who helps will get collated information back at the end of the breeding season, and I really would like to encourage you to help with this project: weighing and measuring eggs will not affect your breeding success; indeed, it may well help it, and others, in the long term. However, you will need a set of scales that will weigh down to 100th of a gram, and a pair of calipers.

For those of you who don't feel like doing this, don't worry; but your next move, all of you, is to candle the eggs *eight to ten days after the female has started to incubate them properly*, to see if they are fertile.

CANDLING EGGS

Make yourself a small egg-carrying box, and place the eggs blunt end up. This is not always easy to distinguish in owls, as they have more rounded eggs than some species. Alternatively if you don't want

■ *Candling eggs*

to get that organised, use a clean egg box – although I would say, at this stage, that the more organised you can be for captive breeding, the better, especially if you are going to involve yourself in artificial incubation. If you have clean equipment, especially made for the task, you will have fewer problems and accidents in the long run. It's up to you, but personally I can never see the point of doing only half a job.

Some people advocate catching up both the birds before taking the eggs. I have to say that I don't agree, although we do always have two people to do the job. A female owl can be very aggressive when she has eggs, so wear a good thick glove because the chances are that the first thing she will do as you approach the nest ledge is to grab at your hand; you can then either catch her at that time, or you can use a net. The other person, also wearing a glove, should be watching the male. It is rare that males will attack, but it is not unknown – we have a very few males here that will, although the majority sit away at the front and watch. If you are worried or inexperienced wear a thick coat, like a duffle coat, and something on your head. We don't do much in that line here, but then we have been taking eggs and returning young for a very long time indeed now.

The main thing – apart from not getting yourself hurt – is that you don't want the female (or the male) dancing about on the eggs, so you need to get her away as quickly and quietly as possible. How we do this depends on the behaviour of the individual female: thus some we will just get off the nest and release; those which are more persistent one of us will hang on to, while the other person takes the eggs. If you are just going to candle the eggs and then return them, either box the female, or get someone to hold her while you candle eggs.

Pull on pair of those disposable latex gloves that come in boxes like Kleenex, so that you don't contaminate the eggs; then pick up the eggs gently and place them blunt end up in whatever box you have. Take them into the dark service passage and hold each one gently to the light of your candler. It is a good idea to practise this with some hens' eggs so that you are comfortable with handling eggs and

with the candler. Of course, this does mean you need a dark service passage, with electricity, but I am assuming that you are going to build wonderful pens! Owls' eggs are quite easy to see through, and even a very strong torch will allow you to see vein growth and the developing embryo. And with your nice dark service passage, you need not take the eggs away from the aviary area.

You can make your own candler using an old coffee tin. Cut the bottom off the tin and make a hole 1½ inches in diameter in the other end. Place the tin over a light bulb fixed to some sort of support. Cut a piece of sponge to fit over the top of the tin with a corresponding hole cut in it. The egg rests on the sponge while you check it. Remember to turn off all other lights when you are using the candler.

Handle eggs very carefully: it is important not to jolt or jar them because the developing embryo is very fragile and can be damaged if you are rough. When candling, rotate the egg very slowly to look for development. You should see vein growth easily, or half shading, a heart beating, or an embryo moving around in the egg. It is really very easy to see signs of fertility in owl eggs, but you *must* be sure that the female has genuinely given enough incubation for there to *be* development. If all you can see is a yolk floating round the egg then you are most likely out of luck and they are not fertile. You should see the same thing in the infertile hen's egg – if you can get hold of fertile hens' eggs and candle them, this will really help you to see what a fertile egg should look like. Incidentally, I have occasionally been asked if an egg is fertile because it has an air cell, and the answer is no, they have an air cell, fertile or not.

If the eggs are not fertile, then I would recommend removing them altogether. I see no point in leaving a bird with clear eggs, unless you are actively trying not to breed from it – in which case it is a good way to succeed in failing, if you see what I mean. If you have boxed the bird and you are not going to replace the eggs because they are clear, tidy up the nest ledge quickly and then release her back into the pen. If you have someone holding her, do the same thing: clean up, then release. This is so the nest is ready, clean and tidy should she recycle.

However, if the eggs are fertile, but you are *not* going to go into artificial incubation, then return the eggs, gently but swiftly. If the nest ledge is really grubby or has lots of old food stored – a charming habit that some owls have – then very quickly give it a tidy up, before replacing the eggs. Put the rubbish into a bucket for ease of removal, then return the eggs, and release the female. Leave the aviary block quickly, and give the birds time to settle and get back on the eggs before going near again.

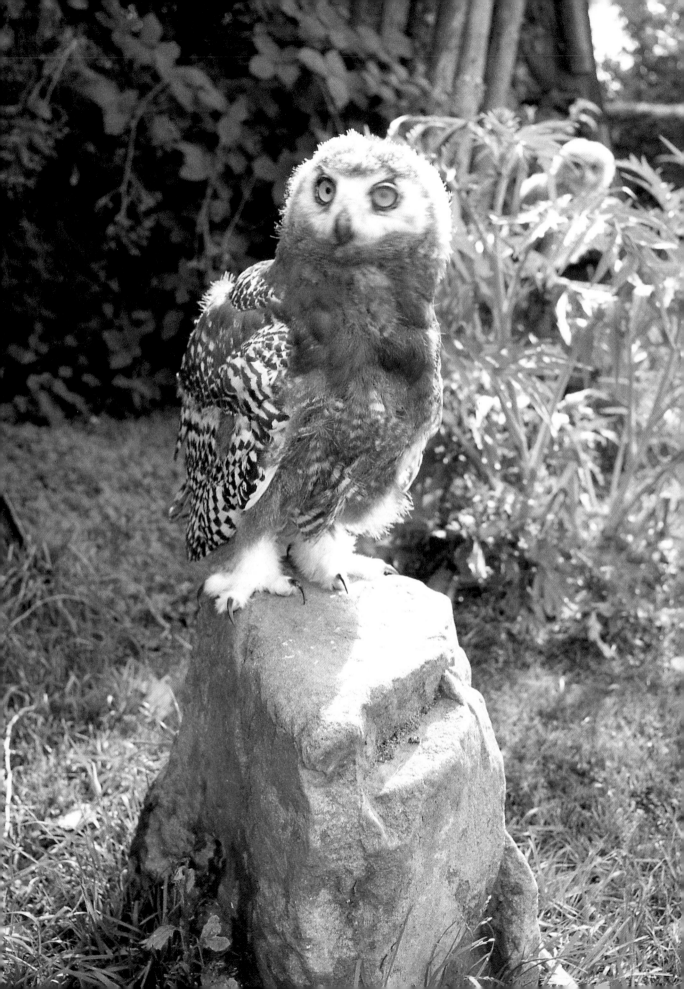

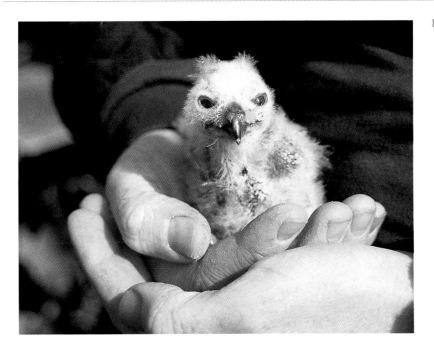

INCUBATION

*F*or the incubation stage there is natural incubation, double clutching and artificial incubation. Double clutching is really only possible if you have either other pairs of owls that will sit on your eggs for you, or broody hens available, or you have an incubation set-up. If you seriously want to go for the latter, that's fine, but I do mean seriously – you must either go for it, or not bother.

This is where you can start to make a difference in breeding success as not all birds will make good parents and rare birds can be helped to produce more young. All of these techniques are useful in increasing production. But the welfare of the parent birds must always be taken into consideration first and foremost. Incubation can be an exact science if you understand it well. There is no magic formula or hidden secret and specialist books have been published which if you are interested, you should read.

■ A baby Snowy Owl. These owls can be aggressive and will kill smaller species even at this age

KEEPING RECORDS

I have eight incubators, and two more for hatching: except for the hatchers, each one is set at a different humidity so that I can move the eggs as they require a higher or lower weight loss. I now use a computer software incubation program called AIMS written by David Le Mesurier (company name Avian Management Services AMS).

When I enter the daily weights of the eggs the program tells me what weight loss I am getting, it tells me which incubator I have that would be best for the right weight loss, and it also warns me when my eggs are due to pip. Did you know that eggs have to lose weight to hatch? If you didn't, then you need to do some serious reading before going into artificial incubation.

AIMS has a stock program which means I know where my birds are, and it means I can enter the right parents for the egg. Once the egg has hatched it will automatically put the young bird into my stock list, write out a captive breeding document for me and even fill in a CITES permit application, or possibly the new sales or movement application form when they are available. All this is very impor-

tant for a collection like mine, as I am legally obliged to keep records. However, in case you think that is not your problem, you would be wrong, because with the new 1 June 1997 legislation you too will have to keep breeding records for all Annex A species, and this includes nineteen species of owl.

As well as the incubators, I have a set of electrical balances to weigh the eggs, plus a pair of digital calipers to measure them so the program can calculate the fresh egg weight if I don't know what it is. The program only works if you are prepared to enter the data that it needs to help you. There is no doubt that if you do it, the data it will give you is second to none. But it is for the *serious* breeder, as are numerous incubators, hygrometers, thermometers and so on.

I am sure there are people out there who will contradict me and say you only need one incubator, just sling in the eggs and away you go. However, although this might work for a while, I almost guarantee that over the seasons you will get a worse and worse hatch as time goes on.

DOUBLE CLUTCHING

If you want to double clutch, the fertile eggs must be removed after they have been candled; you can then use a chicken to brood the eggs for you. These are not my favourite birds right now, after all the Newcastle's disease scare round here, but if housed and cared for well, they make excellent incubators. Do *not* let them hatch the eggs, however; they are liable to kill the young as they don't look or behave much like hen chicks.

Once you have removed the eggs, most, but not all species should recycle after about two weeks, though some take a little longer. Be careful not to leave the first clutch of eggs with the birds for too long because if you do they probably won't recycle, as they will have gone past the egg production stage.

Two weeks is the longest I like to leave eggs, and ten days is better – although having said that, the longer the eggs have of natural incubation, the easier they are to hatch. The hardest of all eggs to hatch in an artificial incubator are those that have had no natural incubation under a bird. So seven to ten days of natural incubation once the female starts to incubate properly will make your job a little easier.

Some individual birds will not recycle, and there is no way of identifying these; however, if you try for a couple of seasons and a female consistently won't do it, then it is probably best not to bother. I had a peregrine that no matter what you did, she would not lay more than three eggs per year. Some people like to pull eggs – that is, remove each egg as it is laid

– to increase the clutch, but the big problem with this is that, unless you have another pair of birds that are sitting, or some reliable hens, you will have to try hatching the pulled eggs from day one with artificial incubation – and it ain't easy, no matter what anyone tells you. I prefer to double clutch if we are trying to increase the number of young from a pair.

It is important to give the birds very good food, and to add some calcium to help the female since you are asking her to produce more than the usual number of eggs for you.

Once the pair has recycled, then you can leave them to sit on the second clutch, while you have nightmares with the first one.

You can now play it two ways: you can either hatch and rear the first clutch and leave the female bird to the second one (as long as you know she knows her stuff and will rear well); or you can replace the first clutch of young when they are about ten days old, and take the second clutch of eggs and incubate them. I usually follow the second option, as even with good parent birds there can be accidents, and these are more likely to happen in the first ten days; so by rearing the young by hand for the first ten days or so, and *then* replacing them, you know you have strong healthy babies under the parent birds and they are easier to keep an eye on. I also prefer to replace young after they have been ringed, because then you don't have to worry about going into the pen to try on rings, or having to find them in the sand if they have fallen off.

If you don't want to replace the young with their parents, and if you have more than one owl hatch, then you can hand rear them together; owls don't seem to imprint in the same way as some of the diurnal birds of prey, so as long as you don't spend too much time with the young, if they are reared in a group they imprint enough on each other to be suitable for breeding later. However, if you have only one baby owl it is really better to try and get it reared by parents or foster parents so it does not get too human oriented. All our really imprinted owls are ones that have been reared alone, for whatever the reason, and I think this is better avoided if possible, even for birds that are going to be trained; then even the birds being used for flying are still potential breeders in the future. For instance, if you know someone else who is breeding owls, you can always pool resources and put young owls together, or use a particularly good pair of adults to rear them. There are many ways of approaching the problems of captive breeding.

ARTIFICIAL INCUBATION

At this stage we should perhaps look at my favourite occupation of all times: artificial incubation. You will have probably have gathered that this method is not one I enjoy – I also doubt if I will ever change my mind about it, either. However, it is a part of life here and so I have to deal with it, both in fact and in this book.

Artificial incubation is not easy, and should be approached in a serious manner; there is no point in just playing at it – either you work at it wholeheartedly, or you leave it well alone. If you are having problems with breeding using natural methods, find someone who is following a serious artificial incubation program, and see if they can help you. However, you will find that – quite rightly – they will either charge you a fee or will expect a certain percentage of the young. Avian Management Services were going to try and provide an incubation service for people, but check this first.

If you are going to go for artificial incubation, the first thing you will need is an incubation room. Unless you live alone as I do it is not safe or fair on others living in the house to have incubators where they can get knocked or played around with. I am very lucky, I have a house with a number of rooms and so what was the 'butler's pantry' is my incubator room. I could do with it being a little bigger, but generally it works, and even better, the temperature and humidity remain very stable so I can get reasonably low humidity without too much hard work.

If you have a window in the room then get one of these blinds that do not allow light through. You don't want sunlight hitting any of the incubators, and so it is best to avoid it all together. The room should be easy to get to and to keep clean – cleanliness is the key word for all your incubation.

INCUBATORS AND FUMIGATION

As a result of advice early on this year from AMS who produce the incubation software program that I now use, I have changed our incubation techniques here this year. It has been hard work, but I hope it will make a difference, eventually. I have always tried to keep the incubators and the incubation room very clean, but up till now I have let people come and go as they needed to. Now it is a much more regimented regime: almost no one except myself goes in there unless it is absolutely necessary; and the incubators are physically cleaned and scrubbed, and then fumigated every two to three weeks, depending on what is happening, although not all at the same time; I try to get one or two done each week.

For cleaning, the incubator is emptied of eggs, which will go into an empty and clean incubator running at the nearest in humidity. The dirty incubator is then taken out of the incubation room. It is stripped down and cleaned with hot water (except for the electrical bits) and Hibiscrub or Virkon, or ChickGuard. It is then moved into a room with windows that open onto an area without people or animals. Make sure no humans, or any livestock are liable to be coming into the room nor have fish in tanks in the room while you are fumigating. I use a mixture of formaldehyde and potassium permanganate for fumigating the incubator, but it is very poisonous and carcinogenic. (See tables of Croner's Substances Hazardous to Health in Appendices p157.) I use it because I am very careful how I handle it, and any problems to do with my person are my own concern; however, it would be illegal for me

■ *The incubator room with six of the eight Brinsea incubators. Note that the window blind would be fully down all the time when the incubators are in use*

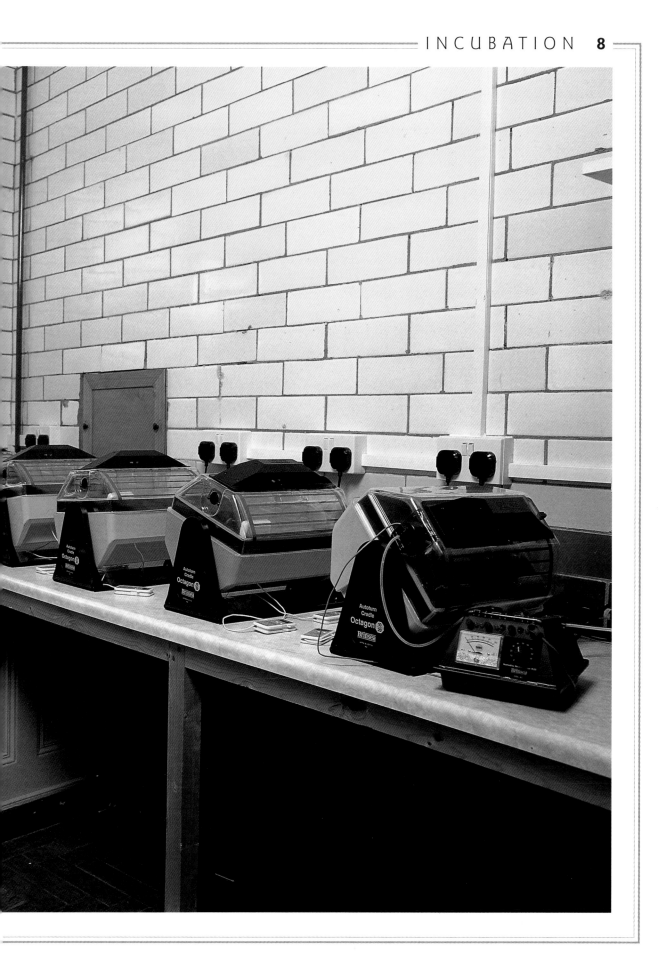

to ask my staff to use these chemicals. Alternatively you can fog the incubator with Virkon, but I know nothing about this process, so if you decide to go for this option you should contact the manufacturers and ask them, or contact AMS.

If you decide to use formaldehyde, you must proceed with the greatest care: wear gloves handling it, as it stains your fingers once wet, and don't whatever you do breathe in the fumes. The potassium comes in powder form, and I put it in a ramekin, a china or glass bowl about twice the size of an egg cup, and deep enough for the mixture not to bubble out over the top. If you mix a tiny amount of water with the powder, it seems to work better.

Switch on the incubator so it warms up. Add the right amount of formaldehyde, quickly place the container in the incubator, away from the sensors, shut the lid, leave the incubator running, and count to about twenty seconds so the fumes have time to circulate round the incubator – and don't breathe while you do it. Then turn the incubator off and leave the room, shutting the door; leave it for about one hour. At the end of this time go back in and remove the bowl, prop open the lid, and turn the incubator back on for another hour or until you find no residual smell. Then it can be placed back into the incubation room and switched on again.

Do not put any eggs back in until it has settled for several hours and the temperature and humidity are steady, and all trace of fumes gone. When fumigating, you can leave the water containers in but empty of water, and also the probe of the thermometer, but not the hygrometer as it doesn't like the fumes. Talking of these pieces of equipment, I used to use a hairline hygrometer but found these to be very inaccurate unless they are calibrated regularly, and also mercury thermometers. However, with the changes to our system through AMS we are now using two Brinsea Spot Check thermometers in each incubator, and a thermo-hygrometer made by RS, from a catalogue called *Electromail*. These are much more accurate, especially if you check them first.

I have always put my eggs lying on their sides in the incubators; it just seems a more natural position. I now have eight Brinsea Octagon 20 Mark IIIs and this is a really nice little incubator,

although the angle it turns through is alarming, especially if you have valuable eagle eggs in there. But they are quite safe, and it certainly doesn't have the huge temperature variation that the Roll-X suffers from – I am now using my two remaining Roll-X incubators as hatchers. We have found that the Brinsea Octagon is easy to clean, holds the eggs really well, has a fairly steady temperature and as well as being reasonably priced, is also quite small and so doesn't take up much room. I hatched the only successful eagle egg in an Octagon this year, having lost all the others in a Roll-X; I have also hatched five merlins out of five. (Octagon update, late 1997 – four out of four African Fish Eagle and five out of five Bengal Eagle Owl eggs hatched well.)

I have not used the Octagon for long yet, so I can't make a real judgment, besides which I have used the Roll-X for many years and, like many people, I am always loath to change from something I know well; however, the Roll-X do have some fundamental problems that have not been cured over the years of its production – and it has been around a very long time. The Octagon is a much newer design and has been made for the small breeder. So now most of my Roll-X are gone and we are having a change here at NBPC.

The Octagon is relatively simple to put together, although it took someone else to show me how to control the airflow, which I would not have found on my own (probably because I didn't even look for it). It is also difficult to read the hygrometer, which is placed inside the incubator; you need a torch to decipher it. However, it is an ideal incubator for the smaller breeder who is not going for hundreds of eggs. I drilled two small holes in the base to put in the probes for the spot check thermometers and the read outs just sit next to it for easy reading.

CLEANLINESS

You should get your incubation room cleaned and set up well in advance of the breeding season. It is no good rushing around turning incubators on and trying to get them up to temperature when you already need them for eggs. It takes at least forty-eight hours for the temperature to settle, and a week

is more like it. You should also do what I hate almost above all things, and that is to map your incubator. This means that once it has settled and is running at a steady temperature, you need to spend time moving the thermometers from one part of the incubator to another, checking the temperature, because it will vary across the incubator, in some areas hotter and in others colder. The best way to do it is to fill the incubator will dummy eggs and put the probe of the thermometer on each egg with blue tac and read that each hour, marking each temperature on a chart. You can then leave the dummy eggs in the incubators and every time you want to put in a real egg, just switch it for the dummy.

I would suggest that, if you are serious about artificial incubation you should try to obtain a manual called *Incubation Protocols* which is being produced by Avian Management Services. I have a rough first draft and have been using it as my guide this season, as it gives you information on how to set up your incubators, map them, what instruments to use, where to get them and how to test them; it also suggests formulas for fumigation, and so on.

I could try go into more detail here, but I have always tried to accept that in some aspects of what I am trying to do, there are people who know more than I do; therefore I suggest you look in the back of this book for useful addresses, and if you want better advice than I can give you in the incubation field, use AMS.

This year I have disinfected all my eggs before taking them into the incubator room, by dipping them for thirty seconds into a solution of ChickGuard and warm water which is a proprietary egg disinfectant. It smells pretty awful, but it certainly cleans the eggs. Any eggs that have fecal material or dirt encrusted on the side should be very carefully scraped with a scalpel blade before dipping. The water should be a little warmer than the temperature of the egg. Do not touch the solution with bare hands because it is not good for you. Wearing disposable latex gloves, I usually hold the egg very gently in the solution and rub any dirt away. I have to say that I am not confident about disinfecting eggs yet – time will tell if it's a good thing to do.

There is one problem and that is, if you have marked the egg with a felt-tip pen (which should *not* be alcohol-based, have let it have natural incubation under a bird, and are then disinfecting before finishing off the incubation in the incubators, the mark may well come off while you are cleaning it. So jot down the egg number and make sure it is readable after the egg has been cleaned; if it is not, re-mark it. If it is an egg that has had no incubation you can let it drip dry on a sterile egg tray; but if it *has* been incubated then it will have to go into the clean incubator still wet.

MONITORING PROGRESS

I run all my incubators at 37.3–37.4°C (99.1–99.3°F), though it is not always easy, as incubators do not run at the same temperature all the way over their surface area (which is why they need mapping). I have hatched many species of owl at this temperature. The humidity will depend on the weight loss the egg is going for, and you will only know that if you weigh it. You will need to know the fresh egg weight, and then calculate 15 per cent weight loss over the incubation period to the time that the egg is due to pip. The bad news is that there is very little data on incubation periods, pip times, fresh egg weights and so on, so you could well be working in the dark – I certainly am.

All this we hope will be remedied over the next few years as the survey forms being sent out to breeders come back to us and the

■ *A fully-developed embryo having achieved internal pip, ie the beak has broken through to the air cell*

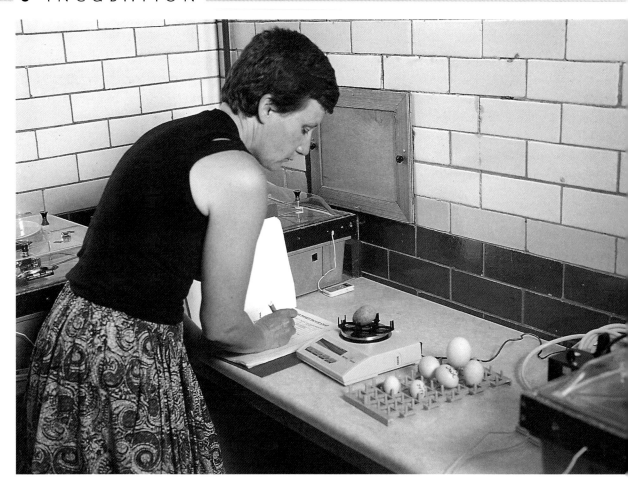

The author weighing and recording eggs

Weighing eggs using a machine donated to the NBPC by Mettler Toledo

information is collated, analysed and becomes available; so the more information you can let us have on this, the better it will be for all of us and for owls.

Your incubator will probably turn your eggs twenty-four times a day on automatic, and some do more. I used to hand-turn my eggs another three to five times per day. Now I have different incubators I don't. However, I still go into the incubation room regularly to check the temperatures in the incubators, look at humidity and check the eggs.

Unless you keep an eye on things you really can't know what is happening. I am now – finally, and after years of meaning to, and never getting round to it – weighing all my eggs regularly. I try to do it every day, but it doesn't always work out that I can; as it is I am usually weighing the damn things at between 22.00 and 01.30 the next morning. We have also tried to obtain as much data from our eggs as possible this year, so we do know fresh egg weights, measurements, the days to pip and to hatch. It is all writ-

ten down, and most of it is entered into the computer so that by the end of this year we should have some much more accurate data on hatching owl eggs, and that should help *all* captive breeders or would-be captive breeders of owls. It should all be available from AMS, as David is collating all the information.

Candling the eggs regularly will also let you know how they are doing, and because owls' eggs are fairly easy to see through, this means that you can often see the first internal pip, before the embryo breaks through the shell.

Unless you weigh your eggs you will not know what is happening, and I know I have been very guilty of this for years. My only excuse is that I do lead a pretty hectic life, with the candle burning at both ends and sometimes in the middle as well, during the breeding season. You can hatch eggs without weighing them, but only if you let the eggs have as much natural incubation as possible – and even then you are going to be working in the dark. And worse, you are never going to learn from your mistakes, and nor is anyone else.

HATCHING

Once your eggs start to pip, things get very nerve-racking. Generally, pipped eggs are moved into a wetter incubator so that the hatching embryo does not get stuck to drying membranes. However, if an egg has not lost enough weight, it really needs to be in a *drier* environment – though, of course, if you have not been weighing eggs you will not know about the weight loss, so it won't worry you – you may just lose the young owl instead.

As soon as the egg pips you need to stop it being turned, which if you have only one incubator is a little tricky. You really need several incubators dedicated to hatching eggs only, and ideally not in the same room as your other incubators. Do not interfere with pipping eggs: unless you have got the incubation wrong, or the embryo has a problem, the eggs should hatch themselves. It is best not to interfere until they have been pipping about sixty hours, and even then you have to be really careful.

I have thought about trying to tell you how to hatch problem eggs, but it is almost impossible to describe in writing. If you go into an egg too early it will bleed, because you will rupture blood vessels that are still active; if you do that, the embryo will die. If you don't go in and the young bird needs help, it may also die; so it is a real dilemma. You can chip away at the shell and damp the membrane with cotton buds, but you have to be very careful. Once the blood vessels have closed down then it is

safer to go in and help the chick. What I tend to do, is try to get the head out and free, but leave the chick in the lower part of the egg; then at least it can breathe properly. Once the yolk sac is fully absorbed then you can *very carefully* remove the chick; but be careful to watch for heavy bleeding.

As this is not supposed to be a book on incubation I am not going to go into much more detail than this – in fact this is further than I meant to go anyway. For those of you who are intending to use artificial incubation techniques, read some books on the subject, get the AMS *Incubation Protocols* manual, and practise on some hens' eggs before you tackle those of valuable owls.

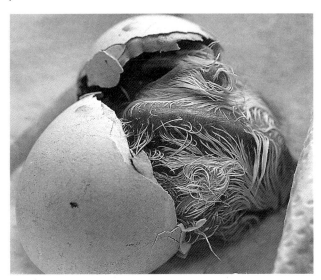

▨ *Past the danger point and home free*

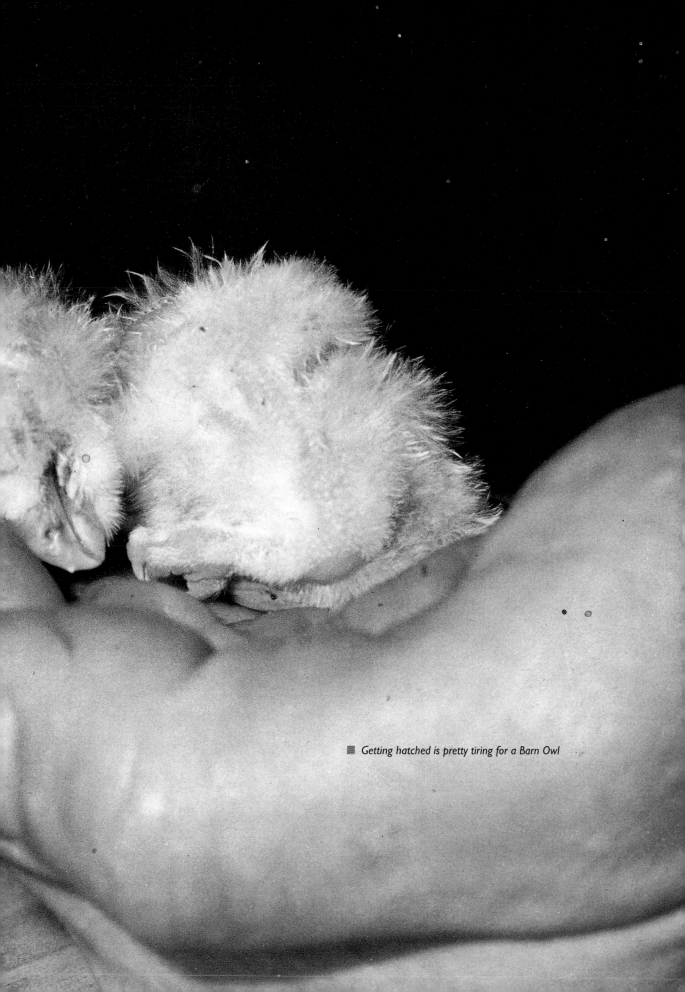

Getting hatched is pretty tiring for a Barn Owl

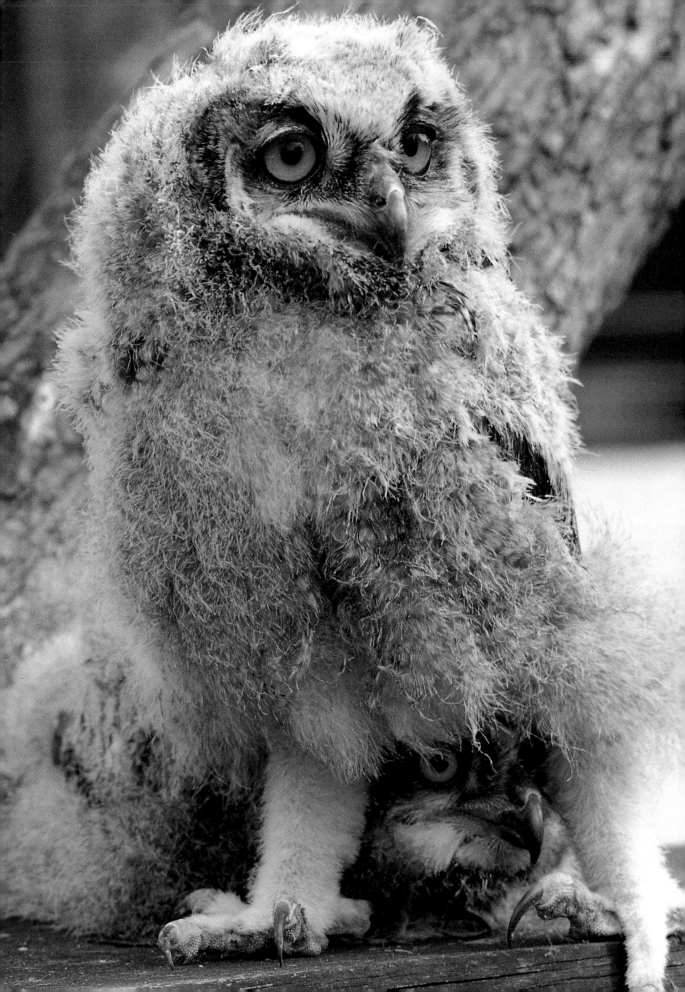

REARING

*T*his is more my field: I have, I know, reared more species of raptor than probably any other person. Not only have we bred fifty species here at the Centre, but I also hatch and rear eggs for friends, and I have covered a large number of owl species. In fact as I write at the moment, I have so far reared this year Rufous-thighed Owls, Brown Wood Owls, Hawk Owls, Tawny Owls, Iranian and Bengal Eagle Owls, Striped Owls, the European Eagle Owl, the Spectacled Owl, Little Owls, Ural Owls and Great Gray Owls, also Tropical Screech Owls, with others still to come.

■ These Turkmenian Eagle Owl babies show confidence...and lack of confidence!

POST HATCHING

Once your baby owl has hatched, the first thing to do is to disinfect the umbilical cord that attached it to the membrane in the egg; this is a prime site for infection to get in, and should be cleaned straightaway. You can use a number of different disinfectants, available from your vet, though never spray from an aerosol can straight onto the baby bird; this will kill it. Once the chick is dry and disinfected, then move it to a brooder that you have had on for at least a week to settle to the correct temperature; as long as they have had a good hatch and look well, most of my babies go straight into the brooder running at 35°C (95°F). If I have a chick that is weak and had a tough time, or, like hawk owls, is small and relatively devoid of down, I put it into a brooder running at 37°C (98.6°F), close to the temperature at which it was incubated; they will do better like this, as they are not using important energy to keep warm. But the strong healthy young all seem to do well at

■ *Note the very obvious egg tooth on this young owl. This is the tool the owl uses to break out of the egg and which eventually falls off*

35°C (95°F). It is very easy to have birds too warm, which quickly leads to infection.

To house the babies during their first few days of life I use well scrubbed and disinfected plastic

■ *A baby Hawk Owl. Note how the breast feathers grow in lines*

The still air incubators which I use for all my newly hatched young

Brinsea produce a brooder that runs using the top of an incubator. I use it if I need to isolate any young that are sick

half-gallon (2litre) ice-cream cartons or margarine tubs. I put clean sand in them about 2in (5cm) deep, and I do this several days before the young hatch so the sand is dry and warm. I use sand for a number of reasons: I have piles of it in the work areas as we use it in the aviaries; it holds warmth well; I can make a cup-shaped hollow in it with my fist so the baby does not lie on a flat surface; it absorbs droppings; and when it is dirty and I want to get rid of it I can throw in on the garden and it lightens the heavy clay soil we have here.

On top of the sand I put two kitchen paper towels. Various friends of mine use towelling material and put it all in the washing machine each day – but as far as I am concerned this is just another job for me to have to fit in. Kitchen paper towels are absorbent, clean, easy to use, and I don't have to wash them!

I clean the boxes out every time I feed the

young. I also weigh the young before and after each feed. This is not vital, but if you have several young together in a box and one has been sick, often the only way to identify the ailing chick is to weigh them all and find out which one has lost the weight.

Included in the Appendix are some filled-in weight charts to show the sort of food quantities that I give young owls in the first few days. The next section describes the type of food that we use to feed young owls, and how we prepare it.

FOOD AND PREPARATION

Like all our baby birds, the young owls get fed on a good varied diet. We usually mix day-old chick with quail and rabbit and some mice or rats. We use mice and rats slightly less, mainly because I hate skinning them. All the food is skinned, and all bar the chicks and mice are gutted. The feet are removed from all of them, the tails from rats, and the heads and tails from rabbits. We have a very large commercial mincer which will mince whole quail, quartered skinned rabbit and whole rats, as well as the smaller items, so it is really useful during the breeding season. We mince the food every morning and then keep it in a fridge, taking it out to feed whenever we are going to feed. We add a vitamin supplement (I use MVS 30 made by Vydex), a probiotic (I use Avipro made by Vetark) and a calcium supplement (I use Nutrobal, also by Vetark); these are sprinkled on the top of the bowl of freshly minced food as it is prepared each morning and mixed in.

Always clean out and disinfect your mincer as soon as you have finished mincing the food; if you leave it you will find it is absolute murder to clean, besides being a great place for all sorts of nasty bugs to breed and kill your baby owls.

We usually feed the food cold, straight out of the fridge, although if I have a weak or sick baby I will warm up just a small amount and throw away what I have not used; like this I am not constantly warming and cooling the whole food supply for that day. I feed the baby owls with a pair of angled forceps, touching the side of the beak of each one with the food, and hooting as I do so. If it doesn't want to feed, I don't feed it. I have found that force feeding is generally a bad idea, and should only be used as a last resort.

The most important thing to remember is not to

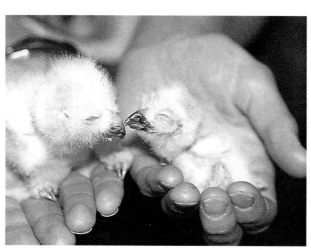

■ *Asynchronous hatching (ie not all hatching on the same day). The older baby is noticeably larger*

■ *All baby birds should be kept on a cupped, not a flat surface, so that their legs cannot splay out*

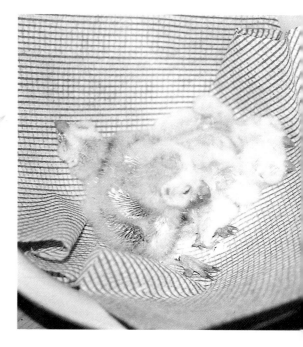

feed the youngster too early, and not to overfeed; more young owls have been killed by overfeeding than by any other cause. Overfeeding happens either when feeding too often, four times per day should be the maximum except for tiny species, or by people force feeding – which is rarely a good idea. Unless it is a really tiny baby – such as a European Scops Owl at under 10g (0.3oz) hatch weight – I do not feed for the first twelve to twenty-four hours. All young owls are hatched with a yolk sac if they have had a good hatch, and that will last them at least twenty-four hours. I have had a wild baby Little Owl brought to us here at the Centre which had hatched three days before it got to us and which had had no food – and it was fine. So even if they are screaming at you for food, don't feed them too early and don't feed them too often.

Most baby owls (and most of my other young birds) are fed four times per day, at about 0800, 13.00, 17.30, and last thing which can be anything from 22.00 to 01.00 depending on what other work I am trying to get done in the evenings. Very occasionally with the tiny owls, such as Pearl Spotted Owlets, I will go to five feeds for the first few days, until they reach a reasonable weight. With some of the larger owls you will see by the weight charts (see Appendix) that they only want three feeds per day and do very well on them.

There is no doubt that owls will feed better late at night, rather than in the middle of the day; however, unless you really want to change your whole life around and become nocturnal, the young birds *will* feed in the day and will soon get used to your regime. Even so, it is worth remembering this, so if you do have a bird that is not doing so well, see if its behaviour is better late at night, than it is during the day.

If a young owl does not feed at one feed, don't panic: just observe it quite closely. One missed feed may just mean that it is simply not hungry, but more than one could mean that it isn't well, or that you are keeping it too hot. Making the right judgment in this sort of situation takes considerable experience, both to learn and to put into practice. And remember that although a young owl may go without food for a day and will not die of starvation, it *does*, however, need fluids, and this is where fluid treatment may well be advantageous.

As your baby owls grow you should be reducing the heat. They will tell you if they are too hot – panting and lying spread out, or too cold – huddled up and crying. Not difficult, really! You will also need to put them in larger containers as they develop: I go from ice-cream containers to washing-up bowls, and end up in large seed trays from a garden centre. All have sand in the base with tissue laid over the surface, and they are cleaned out at each feed.

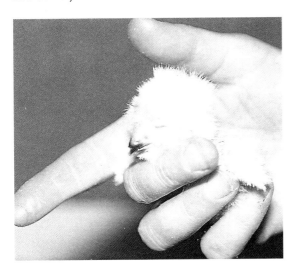

▨ *Always handle baby owls very carefully*

▨ *Feeding baby owls with forceps: don't force it to feed if it doesn't want to*

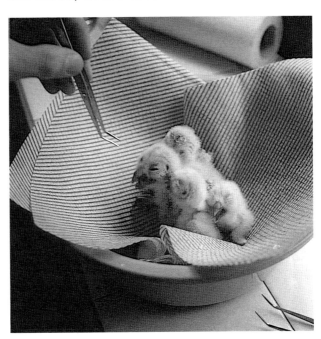

RINGING

Once the young owls are old enough you should ring them; this will be between ten days to three weeks, depending on the species. The larger ones such as Eagle Owls will need ringing at two weeks or sometimes earlier, the smaller species such as Rufous-thighed Owls can go to eighteen days before the ring will stay on. Since June 1997, all European species, plus a few other species – that is all the birds on Annex A – will require ringing with a commercially produced ring. They also need a sales licence issued by the DoE if you want to sell the bird, and possibly a movement licence for birds that are not being sold but where you want to move them from one country to another within the EU. They will need a display licence if you are a falconry centre, an owl centre or a zoo, or gaining commercially, such as film work etc.

Incidentally, the definition of a zoo is a place that has non-domestic animals on view to the general public for more than seven days a year, regardless of whether or not people pay to come in. So any place that fits that description is technically a zoo, and therefore comes under the Zoo Licensing Act, in which case it will require a licence to display any Annex A birds to the public. That includes a pub garden with a few birds, stately homes, garden centres and so on.

Rings are obtainable from a number of different sources, but again with all this new legislation coming in at the time of writing this book, I would strongly suggest that you contact the DETR to see if special rings have to be used for any of the species that you are dealing with. Mostly I think you will be able to get them from the commercial producers, but that may change.

Whatever the owl species, I would strongly urge you to ring all your birds, so that they can be traced and identified in the future, and so that in-breeding can be avoided.

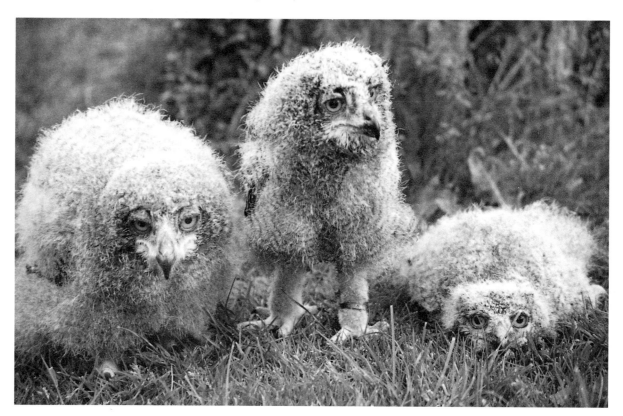

■ *The ring on the middle owl is clearly seen. These three are learning about the wide world but one is obviously not too happy about it*

'SELF-FEEDING'

Once the owls are old enough to ring – about two to three weeks, depending on the species – they should also be old enough to feed themselves. This is very useful if you are not going to put young birds back with foster parents or parents; it also means that you don't have to have quite so much contact with the young birds and so are less likely to imprint them badly. Just put a bowl of the usual minced-up food into where you are keeping them and they will discover it and start to feed; you will soon find that the bowl empties quickly and you can fill it up three times a day. If they finish it quickly and are still calling for more, increase the amount; if they are leaving stuff, decrease it. During the day or so that it takes for them to learn to look for the bowl, give them one feed a day by hand, just to make sure they are getting enough to keep them going.

RETURNING YOUNG TO PARENTS

Ten days to two weeks old is the best age to put young owls back with their parents, and we organise this in much the same way that we return young to the diurnal birds of prey. If it is a rare species of first-time layers, it is a good idea to try them with a commoner species first, if you can – we did that last year with our striped owls. For the first clutch we left them to it, and they ate the young, or the young disappeared, or they died and then the parents ate them (you can never judge a bird unless you know exactly what happened; there is always more than one possible answer). Anyway I digress – back to the Striped Owls. They laid again that year, however, and this time we took the eggs leaving them with dummies. Then close to the time their own eggs would have hatched, we tried a five-day-old baby European Eagle Owl – these are very common – with them, and they looked after it brilliantly. We just had to make sure that we took it out before it got too big to come out of the doors in the nest box! We then switched to their own baby which I had hatched and reared to two weeks, and they finished the job, rearing a very nice Striped Owl with no problems.

When returning young to parents you should have two to three people, organised in much the same way as when you take up eggs, because basically that is roughly what you are doing. You could try just one baby owl to start with, to check that all is well, and then add the others, if any, later. To proceed, you first put the young safe in a bowl. Then take them into the pen, and if the female does not leave the eggs, you will have to remove her physically, in the same way that you did for taking eggs. Pick up the eggs that she has been sitting on, and place them safely, blunt end up, in your egg-carrying box. Next the baby, or babies, should be put swiftly into the nest and the mother released back into the pen. The eggs should then be dealt with – these may be a second clutch of eggs, in which case they should then be taken by a third person straight to the incubation area to be dealt with as before; or they are dummy eggs, which can be placed in the service passage to be disinfected later and put away.

■ *This baby Spectacled Owl was hatched at the NBPC but his parents live elsewhere. He was reared with a mixed group of owls*

■ *I had not seen Asian Wood Owls before rearing several young for a friend. They are gorgeous owls (see p27)*

■ *You can mix young to a certain extent, but you do have to be careful as some of the species can be aggressive even at this stage*

Young Eagle Owl just about to get very cross!

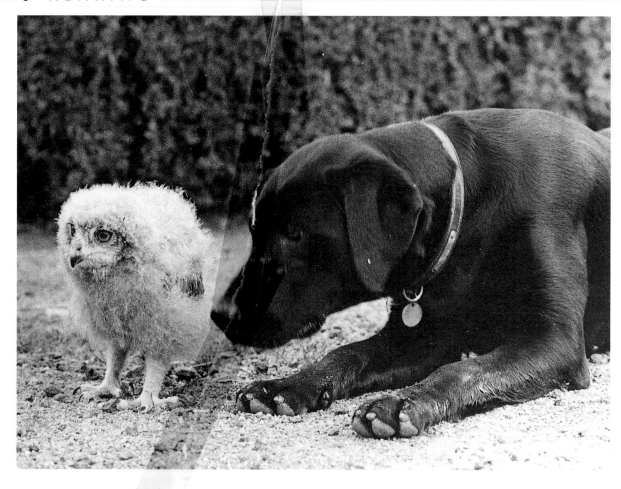

■ *This old photo shows my first and much loved Labrador Bramble, with a baby Savigny's Eagle Owl. She was 100 per cent safe with baby owls but you must know your dog very well to trust it to this extent*

Then comes the fun bit: you have to go out of the pen, and watch, and wait. Some birds will get straight back on the nest and cover the young beautifully. A very few may attack them; most will spend some time ignoring the young, maybe flying over and looking, and then, if you are lucky, they will finally settle down and brood them. I can never make up my mind whether it is best to leave a dummy egg or two with the parents so that they are more interested in the nest area than they might be if the egg weren't there, or that by taking it out they are more fixed on the returned babies. If anyone else has any firm ideas on this, please let me know! But let me warn you – and I have been doing this and making many mistakes for longer than most – there are *no*

fixed rules. Every pair of birds, and indeed every individual bird, is different, and will react in a different way. Add to that the fact that the behaviour of pairs may change over the years, and eventually you will learn that each day, each pair, each egg and each young have to be treated in such a way that you are always watching out for the unexpected.

WHEN THINGS GO WRONG

If either of the pair attacks the young then you will have to move very swiftly to make sure they are not damaged. Bang loudly on the side of the pen so as to distract the adults while you get in and rescue the young. If from the very outset of returning them you are seriously concerned, you can put the young in a small wire cage so that the adults' initial reaction can be gauged without the young being at risk. However, this also has its drawbacks in that the young can't be brooded, and if it looks as if the par-

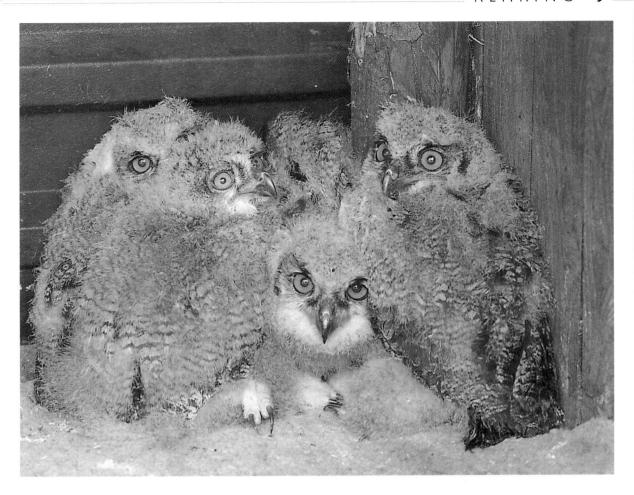

Four baby Eagle Owls snuggling up for warmth

ent birds are going to accept them, you have to go in again to take the young out of the cage, thus disturbing them. This is not a procedure I have ever tried so I can't advise you on this one; I think I would only use this technique if I had a pair of birds that had failed to rear young in the past with the various different methods already described, and then only as a last resort.

Sometimes things can go wrong even when you think you have got it all going well. We put young back with our Great Greys and they did really well to start with, but then ended up killing quite large babies. So there will always be unforseen problems, and huge disappointments, and if you are not prepared for those – don't keep livestock, it's as simple as that. We are currently experiencing one of our worse breeding seasons ever: out of eleven eagle eggs I hatched only one, and quite apart from the disappointment and sorrow, this represents quite a substantial amount of lost income as well. A couple

of my staff have actually said they don't know how I cope with the blow each time I lose an egg, for whatever reason, and certainly there are times when I am not sure how I cope either, but you have to.

All this may make it look as if breeding birds is all doom and gloom, but really it's not, and there are parts of it that I love. But if you counted the number of eggs laid by captive birds of all species around the world, and the number that actually come to be real live healthy birds, the percentage of eggs that don't make it for whatever the reason is huge. That is why we are so keen that people record what they do, weigh and measure eggs if they can, pass on information and generally share their experiences, because that is the only way we will become more successful. If we are going to keep birds in captivity we have a moral duty to learn as much as we can in the process.

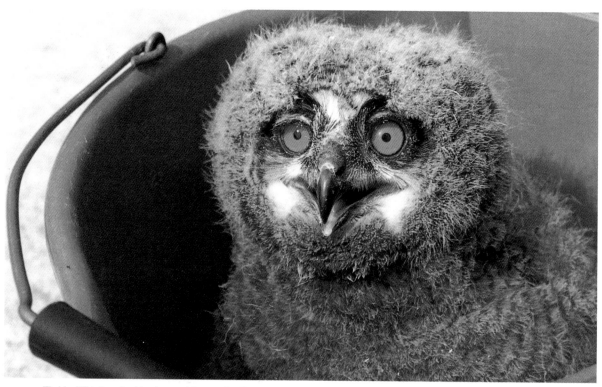

■ Hey! This is a food bucket and I'm not food!

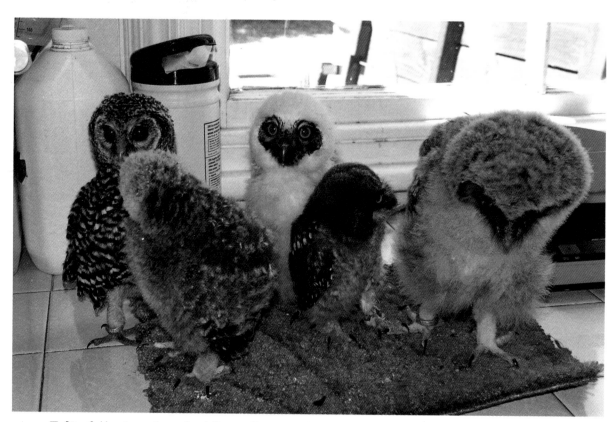

■ Bits of old carpet make good anti-slip mats for young owls. Here (from left to right) are a Rufous-Thighed Owl, an Asian Wood Owl, a Spectacled Owl, a Hawk Owl and an older Asian Wood Owl

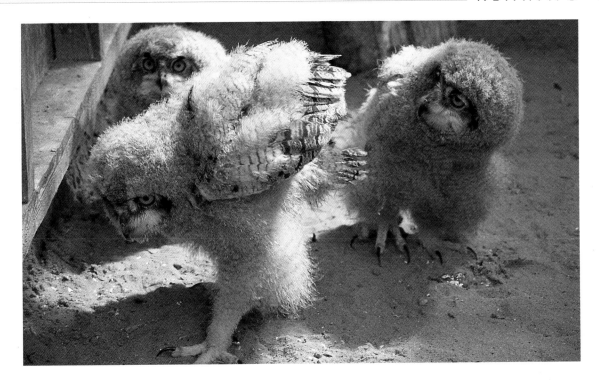

WHEN THINGS GO RIGHT

Once you have a pair that are rearing young that are healthy and have been ringed, and that only need you to make sure they have enough food to grow well, and to keep an eye on their development, the whole thing becomes a good deal more fun. We feed all the pairs of birds which have young twice a day, judging the amount of food they need by making sure they are not stockpiling it somewhere in the pen, and are using all we give them. It is the same method as judging the amount to give youngsters that you are hand rearing but which are feeding themselves: put lots of food on the feed tray, and if it all goes and is not being left around, add a little more, and a little more, until you find that not all of it is going – in that way you will get to know what they need. Remember, though, that as they get to full grown they will need less food because they will not be turning so much of it into new owl!

Hand-reared babies should be off any heat by three to four weeks depending on the weather, the time of the year and the species. We try to get them out into nursery pens at about four weeks old; here they harden off, and have plenty of room to play and learn to fly. A word of warning: be careful about baths in nursery pens, because baby owls can drown. Make sure they are very shallow and of a non-slip surface.

■ *Young owls playing on sand*

■ *Picking up a young owl to put it into its pen*

■ *If you want to make your owl feel happy on the fist make sure that he doesn't fall in the early stages of training*

SICK OWLS

If you have sick babies, or adult birds for that matter, you can give fluid treatment. We use a preparation called Lectade, which we get from our vet. It comes in liquid form and then we mix it with water in a ratio of 11:1 – that is, eleven parts of water to one part of Lectade. It should be given in a crop tube, which is a soft plastic or rubber tube fitted onto the end of a syringe without the needle. This is very gently pushed down the bird's throat, making *absolutely* sure that you avoid the air passage in the middle of the tongue. Then the fluid is slowly pushed out of the syringe with the plunger. If you have never done this, get your vet to show you how to do it (it will also be a good test to see if the vet knows what he or she is doing!).

If you have a bird that is unable to keep solid food down you can use a preparation called AD Diet, made by Hills. Many vets are agents for Hills. The AD diet is a paste-type food made for convalescing dogs and cats. Don't use the dog one because it is too grainy; but the cat one is great, and you just mix it with some diluted Lectade until it is runny enough to go down your syringe, and then administer it in the same way as the fluid treatment. We kept a wild Golden Eagle that was suffering from lead poisoning alive on this stuff for six weeks, and not only alive, but actually putting on weight.

The amount to give to a bird will depend on the weight of the individual bird: ask your vet.

NEW HOMES FOR CAPTIVE-BRED OWLS

Once your owls are ready to leave the parents, you have the joyful task of finding new homes, or selling the young that are surplus to requirements. At the National Birds of Prey Centre I try very hard to make sure that all the birds go to good homes; sometimes I make mistakes, but generally I think we do our best. We ask everyone who goes on our list of 'birds wanted' to send us a letter giving their experience and a photo of where they are going to keep their new bird. This is much more difficult if you are having to advertise birds because most people who answer an ad don't want to be bothered with all that, and particularly if you are trying to sell one of the commoner species, it is very hard to be choosy. But you can often gauge over the phone the competence of the people you are talking to, and you can ask them to bring a photo of their pens when they come to collect a bird. I might add here, that if I get in new birds I always send or take a copy of our guidebook which shows people the sort of pens we have here. So you can see, it has to work both ways.

If you are interested in breeding the rarer owls and in the conservation side of captive breeding, you might like to contact Tony Warburton, at the time of writing the TAG chair for Owls in the UK federation Zoos. There are a number of private breeders in his TAG and they are always interested in people who want to breed a particular species, or even help by running stud books and so on.

When you have got homes or buyers for your

birds, make sure that you ask people to bring a suitable box to collect the bird. If you are selling it, I usually ask for cash, as that is the easiest way of not having any problems. Make sure they do *not* collect birds in very hot weather; also that the box is big enough and secure enough – I have sent people away to get better boxes if they have arrived with really bad ones. Make sure the box has carpet in the bottom so the young owl does not slip. It is probably better not to send the young bird off with a very full stomach, so don't feed it on the day it is going. And don't allow people to put more than one owl in one box either; it only takes one accident for one owl to injure the other.

I would also advise that you don't let birds go too young; in fact, I think it is an unacceptable practice for breeders to allow birds to go too young. Parent-reared birds that are to be used for breeding can go once they have left the nest and are feeding for them-

selves; or you can wait until they are fully grown and flying round the pen – in that way your adult birds are having the natural pleasure of rearing young to the time when they would become independent anyway. For hand-reared birds that are going for training, five to six weeks for the larger owls is a good age, as long as you have given them plenty of handling, and three to four weeks for the smaller species.

I do *not* think it is a good idea to let young birds go at two weeks old or earlier; you are expecting far too much from the new owner's rearing, especially if they are new to having an owl, and it is not fair either on them or on the young owl. You are also putting them in a situation whereby they are rearing owls that are unlikely ever to breed naturally, which is a shame; whereas if owls are together in a group until just before they start to jump about the pen, they will be more likely to be able to join the breeding stock, if needs be, in the future.

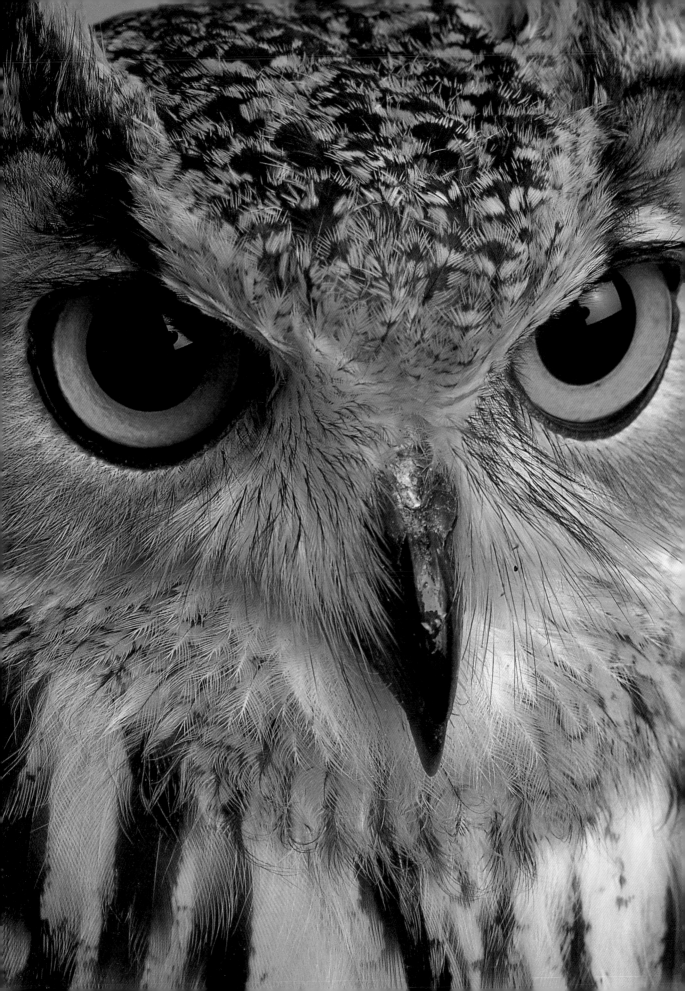

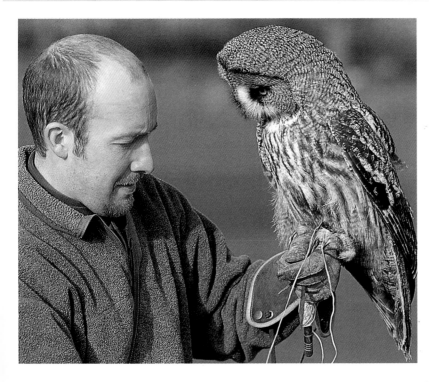

TRAINING AN OWL

Most of the owl species can be trained, but whether or not they all should be trained is another matter. For example I think it would be wrong to hand-rear and imprint for flying a species of owl that is either rare in captivity in the UK or rare in the wild. In this case it would be more important for these individuals to be kept in the breeding population, than to have for flying, whatever the reasons. The smaller the species, the harder it is to train and manage because the easier it is to kill it by stress or by bringing its weight down too low.

Jammu, a Bengal Eagle Owl born at the NBPC. He and his brother are the stars of my video on owls

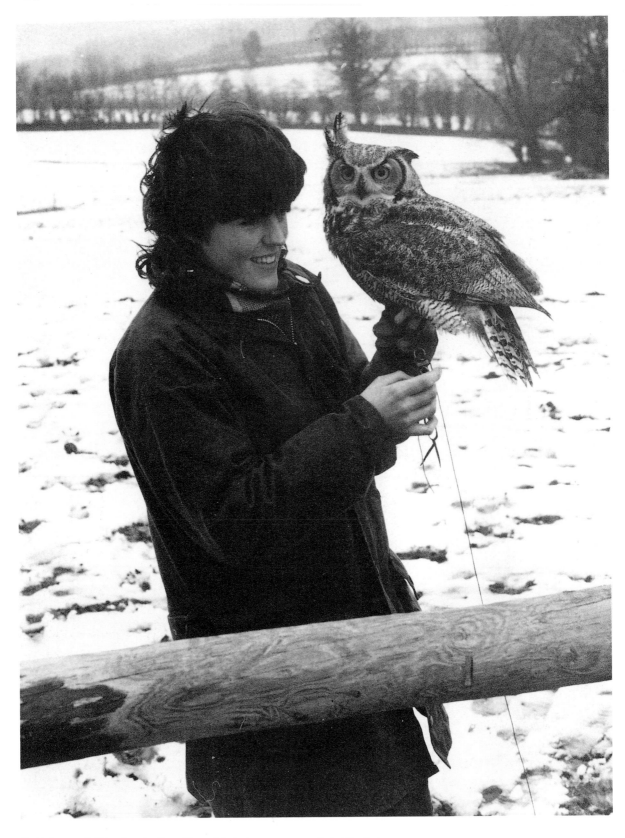

■ *Melanie with Columbus the Great Horned Owl who was very good at sitting in trees –
for hours! Don't forget that training has to be done daily, whatever the weather*

TRAINING 'WILD' OWLS

I feel very strongly that it is cruel, unwise and downright misery (both to the owl and the trainer) to train owls that have not been hand-reared. Now I am quite sure that there are people who have done this and who will say that it is the same as training a diurnal bird of prey that has been parent-reared. But I am afraid I don't agree; we have tried to train 'wild' – that is, parent-reared owls here, and some species will try to die rather than respond, others remain very wild, and none of them in our experience enjoy the training. Nor do they end up being nice, tame, friendly birds, or become anywhere near as relaxed about life as a hand-reared bird. To get them to work they have to be cut down in weight very hard, and it is just not worth it.

I just can't see the point of subjecting a fairly wild owl to the training process, when it is perfectly possible to get hand-reared birds that are suitable for training; and if it is a species that is difficult to get, then perhaps it falls into the first category I spoke about, which means you should wait until they are more readily available anyway.

Owls are very different from the diurnal birds of prey – as you will have seen in the biology section in the front of this book, they are not even related. That is why they tend to be nicer to handle as hand-reared birds than the diurnal birds of prey. However, don't forget that the tamer an owl, the more likely it is to be extremely noisy, which means you may well have neighbour problems if you are living close to other people. On the other hand, don't think that if an owl is not tame, it will be quiet. It won't be!

WHICH OWL IS BEST FOR A BEGINNER?

So, which owl is the best to start with? I have already written about this in *Training Birds of Prey*, but am told by my publishers that it is not a problem – so I shall proceed! I and my staff have trained ten or more species of owls, from the commonly kept Barn Owl, as well as many of the Eagle Owls, Tawny, Burrowing and many others, so we have an idea of which have good temperaments and so on.

As with training the diurnal birds of prey, beginners should not consider the smaller owls. The smaller the bird, the easier it is to bring its weight down too low, and you will kill it; even though it could be called an accident, it is still your responsibility. So I would always suggest the medium-sized owls for beginners, such as the Bengal Eagle Owl. This one I love: they are a reasonable size, those that I have trained have a good steady temperament, and they are fun to be with. Another owl that is a good size to start with is the Magellan's Eagle Owl, a subspecies of the Great Horned Owl,

although there is dissension about what subspecies it really is. We also fly a Striped Owl here which flies at just over 1lb (0.45kg) and so is a fairly safe weight to manage. If you want to go a little larger, then a male Iranian Eagle Owl is still very manageable.

You could go for the really large owls, but they can be tricky, and they can get aggressive during the breeding season once they are old enough to breed. Besides which, until you gain some practice and experience you will find the large owls to be a real strain on your arm.

Once you have decided which owl you want and which you are most likely to be able to get, you need

to find a breeder who is likely to have the birds, and you can then put in an order. Some breeders require a deposit, others don't. You will also have to know when the particular owl species that you want is likely to be breeding; some owls such as the Bengal Eagle Owl can breed as early as December and sometimes even earlier, so you could have a young owl by the beginning of the year. There are quite large drawbacks to that, however: for instance, you would not be able to get your young owl used to the pen if the weather was as cold as it was this last winter. I prefer people to have young owls in the early summer because you then have more time to play with them in the pen, and you don't have to worry about the weather. Most owl species breed in the spring and so young would be ready in May, June or July, but if young are ready in February, that's the time to have one because you don't have any other option!

Once you know when you are likely to get your young bird you can then make any arrangements with your vet, and get your pen, food supply and equipment ready, so it is all up and running before the owl arrives.

EQUIPMENT FOR TRAINING

You must have worked out by now that we don't tether owls at the Centre because we don't think it is either necessary, or a good idea. Several of my friends are convinced that tethering birds may well become illegal in the future, and certainly it is much better for owls to be kept loose in pens and to be flown from there.

One of the reasons that some birds of prey are tethered is that they are inclined to fly at the wire when they see you and consequently can hurt themselves. Owls tend not to do this, and if you put your access door in the back, away from the wire, it is even less likely to happen. It is so much nicer not to have to tether a bird. They can move around when they want, and you don't have to worry about them getting tangled up, which they can do when tethered. Moreover it is a much easier affair to go away for a day or so and leave them without getting worried, and they can be looked after more easily by a neighbour if you are going away for more extended periods. Incidentally, I would like to add at this stage that some time ago there was a small book printed called *The Barn Owl as a Pet*. It was not as well researched as it should have been, and I would strongly suggest that you ignore much of what it says. In fact, with all due respect to the author, I would throw it away, as some of the information in it is downright dangerous to any owl being kept.

As your owl is going to be happily housed in a well designed pen you will need less equipment than for a tethered bird. Below is a list of the equipment or 'falconry furniture' that you will need.

I am going to digress again here. I had a phone call yesterday from someone who wants to get a bird and has no experience, so I asked him what sort of pen he had. He said it was wire, though the back was solid. So I pointed out that really birds are much happier and less inclined to fly into the wire if only the front is wired, and the sides are completely or at least partially solid. I then discovered that not only had he visited here and seen the pens we build, he also had my last book – and yet he *still* ignored what I had suggested! Which is fine, but why then phone me as well? If you feel that what I say or suggest is wrong, that is your prerogative, but *don't* then expect me to help you to get birds, so that you can keep them in a way that I have specifically suggested you don't do. Or if you do want to try it – expect an earful, because that is what you will get.

Be careful about asking too many people for advice; I and my friends see it all the time. People will come and learn with us, they will be told all the reasons how and why we do things, and then once they are on their own they will talk to others, get conflicting advice and end up ruining their birds because they keep switching what they are doing. Choose whoever you wish to have as your guide –

EQUIPMENT LIST FOR TRAINED OWLS

A good, well made and comfortable falconry glove
A falconry bag of some sort with more than two
 pockets in which to keep meat for training
Aylmeri jesses with hunting straps and mews straps
 (see page 126)
A leash
A swivel
Bells (optional)
A creance (training line)
A dummy rabbit (or mouse for smaller birds!)
A bath, if you have not built one in the pen
A weighing machine

What you don't need
Bow perch or block
Hoods
Falcon lure

falconry bag,
shoulder strap
and clip

double thickness
falconry gauntlets

leashes made in both
synthetic and natural
(leather) materials

creance

swivels

belt loop and
clip for hawking bag

'dummy bunny'

and it certainly doesn't have to be me, but make a conscious decision – and *stick to it*.

There are also certain individuals out there who phone round as many people as they can, ostensibly for a 'bit of advice'. They keep getting told that whatever it is they want to do is inadvisable, but they keep phoning – until finally they find an idiot who will agree with them, and they then feel justified in doing whatever it is. We can spot them a mile off: they ask a question, and then

you can feel them switch off when you give them the answer. Usually whoever is on the phone this end tries to help and then puts the phone down, disconnects the caller and without more ado calls him or her a pratt or worse!

Once the owl is full grown it will wear the Aylmeri jesse bracelets the whole time you are flying it. However, I strongly suggest that during the moult the bracelets are cut off and new ones put on after the moult has finished and the bird is ready to start flying again. It is very poor management for jesses to stay on year after year; they should be renewed at least once a year and maybe more often, depending on their condition. The owl will also wear the permanently attached, thin hunting straps

so that you have something to hold on to when picking it up.

The only exception to this are the tiny owls. These should not wear any jesses at all, but should be trained to go into a box. You can use temporary jesses that can be put on just for training, and then removed as soon as the training session is over. Once the training is complete the tiny owls should never need to wear jesses again.

I would suggest that, until you are experienced, if you are going to be carrying the owl around a good deal, you put on the mews jesses, swivel and leash; you are less likely to let it go by accident if you have the full equipment on, rather than just relying on the hunting straps. If you are worried about letting the owl go by accident, tie the leash to the glove before leaving the pen.

As I think I said earlier, we do not put bells on our owls, but then we only really fly them in our own field. If we are taking them out away from home, we put on radio telemetry (radio tracking equipment). However, if you don't want to go to the expense of telemetry, then it is only sensible to put on a leg or a tail bell so you can find your bird if it gets lost. The other equipment is fairly obvious as to its use.

COLLECTING YOUR OWL

As I have stated in other parts of this book, if possible leave the owl with the breeder and its siblings or other baby owls until it is starting to hop around the pen, and is fairly well feathered. Like this it will be ready to start some of the initial training as soon as you take possession of it. You will also have a bird that is very tame, but one which thinks it is still an owl, and this has several advantages. Ring the breeder occasionally to see how things are progressing, but be civilized about the number of times you ring, and also the time of day; I get pretty snappy when people phone after about

8.30pm. I do a full day's work seven days a week and I don't particularly want to continue it any longer than I have to – and I hate being disturbed in the middle of my favourite television programme!

Once you know approximately when your owl is ready for collection, you can plan the trip to everyone's best advantage, including the owl's. If you are collecting a bird from a centre open to the public, don't organise to go on a bank holiday, or a really busy Sunday. If these places are anything like us, we have enough to do on those days, without having to cope with people wanting to collect birds

and ask a million questions as well. So arrange to go on a quiet day, and then both the breeder and you will have time to have a chat and make sure that all is well before you leave with your owl.

Also don't forget to ask what the bird is used to being fed on, so you at least start it on a food type with which it is familiar. When it is feeding well, you can change the food type to whatever you prefer. As I have probably said before – and will do again! – it is not good practice to feed just *one* food type because none is sufficient on its own, in my opinion. You will soon learn what your bird likes and dislikes. Try not to use its favourite food for training sessions, but keep that in reserve for the day it refuses to come down out of a tree, or is misbehaving.

SETTLING IT IN AT HOME

Once you have got your owl home you should be able to put it straight out into its new pen to settle down, though this will depend on the time of year, the weather and how it has been kept. Remember that, even though this is a hand-reared and tame owl, it will still be upset and frightened of its new surroundings for the first few days, so don't panic if it doesn't eat, and looks a bit miserable.

If the bird has been put in at nights rather than left out in a pen, then it is probably wise to do the same thing for the first few days, though again, this depends on the weather. Because we don't let our owls go until they are well grown, they are hardened off and can go straight out, unless the weather is extreme. But otherwise we have a set of night quarters/sick quarters, and here we have a number of approximately tea-chest-sized boxes made of an easily cleaned material and with doors with vertical bars, where we can put our young owls until we harden them off outside. Besides, it is a useful area to have for a sick or injured bird. And as I have said elsewhere, once you get known for having birds of prey, you may find that people start to bring you injured birds, and then a couple of night/sick quarters are invaluable.

Try to collect your bird at a time when you are going to have a couple of days free, so you can give it some time and encouragement. If the weather is very hot, don't let your young owl get overheated in its new pen; the big advantage of totally roofed-in pens, if built well, is that they are cooler in summer and warmer in winter.

Don't try to stuff food down the bird at every given opportunity. It may well be too upset to feed for the first couple of days; this is generally not a problem, however, because the young bird's appetite will soon overcome its fear and it should start to feed. Find out how the breeder has been feeding it – by hand, a bowl of food, food thrown on the floor – and to begin with duplicate that. Once the young owl has started to feed, you are on your way.

As the species of owl likely to be used by beginners are not very expensive, it may work out very costly to have a young bird vetted before buying it. However, it is a good idea to take a mute sample (a sample of its droppings) after a couple of days. Just put a piece of newspaper under where you think it might be liable to do its droppings, and then scrape some of the mutes into a clean, disinfected container, and take it to your vet for a check-up. Sometimes the stress of moving to a new home can cause a build-up of worms or even bacteria. Catch this early and you will save time and funds, *and* stress to yourself and the owl!

If you are really worried about one of your birds, *take it to the vet straightaway*. It never fails to amaze me that people phone *me* up to ask what to do about a bird that they are worried about. I am not a vet, and although we have a great deal of experience here, we don't have the same knowledge a good vet does. My advice to anyone with birds is this: if you have a gut feeling that something is wrong, don't hang about but get the bird to a good vet immediately. You have no idea how many times we have done that here over the years, and saved birds that didn't even look ill, but about which one of us had a gut feeling. There have also been times when we have not followed that feeling, and have lived to regret it. There will undoubtedly be times when you are wrong and you may have wasted the vet's time, and your time and money, but believe me when I say that in the long run you will be glad that you used this policy.

EARLY TRAINING

Training an owl is not that different from training other birds of prey – in fact, with other diurnal birds of prey that we hand-rear at the centre, such as the caracaras, the black vultures and the secretary bird, the training is almost exactly the same.

Each time you go into the pen, particularly if you are taking food in, whistle or call to your owl, using the noise that you are going to use when you call him or her to come to you when flying; in that way the bird will start to associate the noise with you and with food. You could teach the bird its name, but I prefer to use a whistle as the noise carries further and I am not much in favour of a great deal of shouting spoiling the peace of the countryside.

Once the owl is starting to fly short distances confidently about the pen and is landing with ease,

then you can put on the Aylmeri bracelets. I am assuming that none of you are training tiny owls such as Little Owls, or even smaller, but if for some reason you are, let me say that we have found that it is detrimental for small owls to have to wear jesses of any sort, as they hamper their movements too much and can trip them up. So we train these young birds to walk into a carrying box, and as owls often prefer dark places, they learn to do this very readily. If you are worried about flying them loose without having tried them on a line first, put on some temporary jesses, just for the training session, but remove them immediately afterwards. We fly a couple of very small owls and they are carried down

■ *(Clockwise from top left) False Aylmeri jesses, eyelet tool, Traditional Aylmeri jesses, hunting straps and long-nosed pliers*

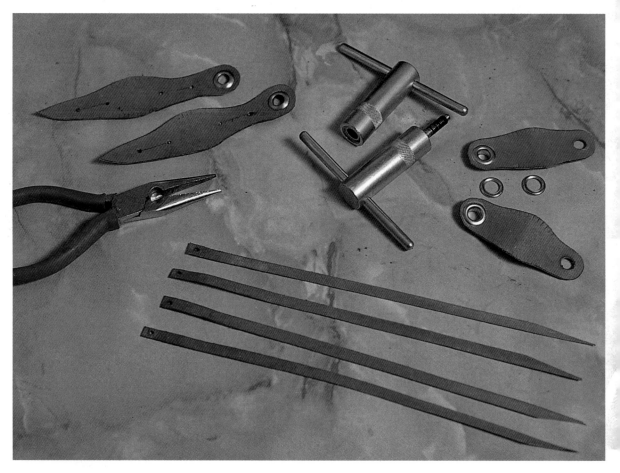

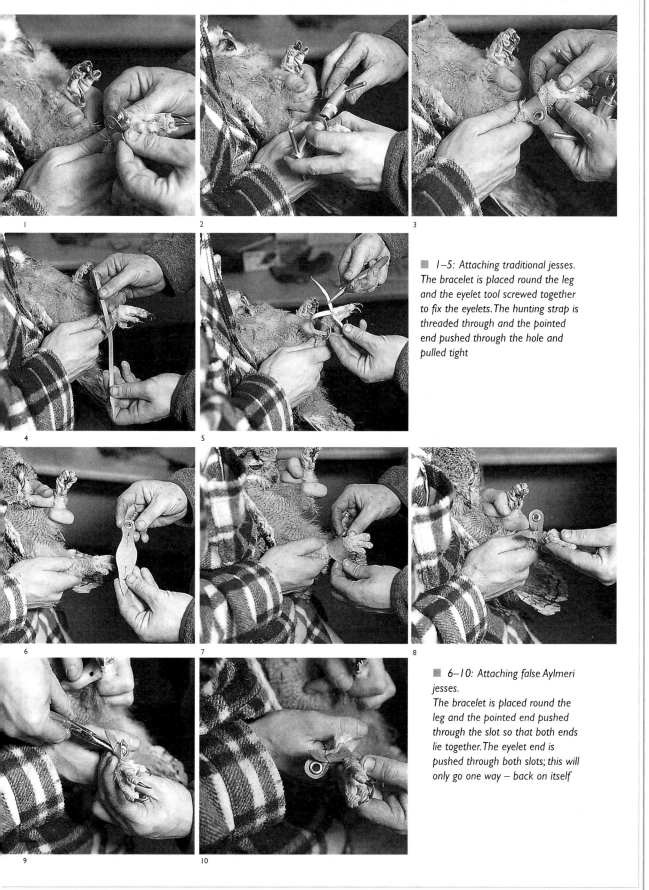

■ *1–5: Attaching traditional jesses. The bracelet is placed round the leg and the eyelet tool screwed together to fix the eyelets. The hunting strap is threaded through and the pointed end pushed through the hole and pulled tight*

■ *6–10: Attaching false Aylmeri jesses.*
The bracelet is placed round the leg and the pointed end pushed through the slot so that both ends lie together. The eyelet end is pushed through both slots; this will only go one way – back on itself

to the flying ground in their boxes, and back again to their pens once they have finished flying.

I would not put the 'hunting straps' on the jess bracelets until your new owl is close to full grown. It is not a good idea to have a heavy young owl bate or flap off the fist and be brought up short because you are holding on to the jess straps; this is a very good way to damage their legs. So if you don't put the straps on until their legs are strong enough to manage being held, you won't be tempted to try making them stay on the fist too early on.

However, carrying them on the fist in the pen, feeding them on the fist and generally getting them used to being on the fist as soon as they can physically manage it, is a very good idea because the more confident they are about this procedure, the better. If you are handling them much before they can fly well you can carry them round outside the pen, but be careful they don't bail off the fist and hurt themselves, or land in or under something that could harm them.

■ *Bollinger jumping to the fist in the pen. Note how John holds the meat in his bare hand to keep it moving and to attract the young owl's attention*

STROKING BIRDS

We don't do that! Generally I am against birds being stroked, especially in places open to the public where they could be stroked to excess. I have to say that the only species of bird of prey that I *know* really likes being stroked is a Common Caracara. Now I fully admit that I have not stroked all the species there are, but I have handled a fair few over the years. Some will tolerate it, others hate it. I prefer *not* to stroke our birds because it doesn't do their feathers good: it strips off the water-proof coating, and if you stroke a bird a great deal you will tend to make it look tatty after a while. If your owl is making a twittering noise and crouching down when you try to stroke it, this is a sign that it is not enjoying it – the noise is typical of a stressed owl.

It is, however, important to train birds to allow you to touch their beaks and feet, and their wing and tail feathers. The problem is that owls are not great at seeing things close up, and once they get used to you giving them pieces of meat from your hand, they don't always differentiate between food and fingers, and the large owls can give a nasty bite, albeit often by accident. As a general rule I would

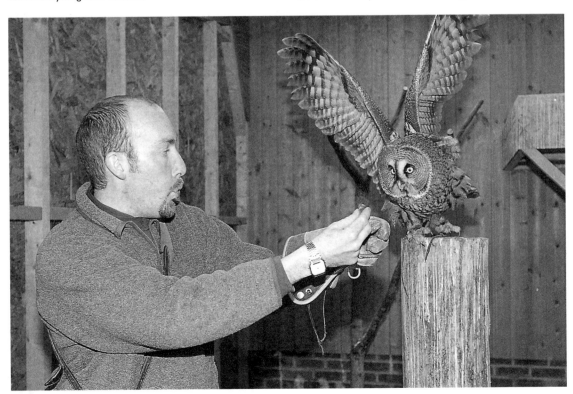

suggest not stroking your owl; I know it is hard to do, because everyone wants to stroke an owl, but especially if you are likely to have other people near your bird, it is better for the bird and its feather condition to leave well alone. Owls, like anyone else, need their own personal space.

FLYING TO THE FIST

Once the owl is nearly full grown and flying well, you can start to encourage it to fly to the fist for food whilst still in its pen (I think I showed a young Bengal Eagle Owl learning to jump to the fist in my video on owls). It's very easy: all you do is get your owl onto a nice waist-high perch and hold your fist just out of reach with a piece of food. Then you can either wave the food around with your other hand, so the owl can see it, and keep touching it to your gloved hand, remembering that by now the owl should be used to taking food from your fingers anyway; or you can put the food in a very visible position on the glove and pat the top of the glove with your bare hand. All the time you should be whistling so the bird associates your whistle with food or work. Once you get your first jump, reward your bird, gently place it back on the perch, and then try again fairly quickly while

the owl still remembers what it has just done! You can try putting another piece of meat on the perch so you get two flights, one to you and one to the perch. Give a good large hand signal so the bird begins to recognise the hand going up as a sign that meat will be there on the perch or fist.

If it won't do it – don't feed it as much as usual. It couldn't be simpler, really: within one or two days it will jump to the fist, or step first and then jump. Do this only about three or four times, and then give it lots of reward, especially if it has had a day without food. Don't overdo the number of jumps, or the bird will lose its appetite and will get bored, and so will respond more slowly, and eventually you will train it to react slowly instead of quickly.

Do this for a few days until the bird is coming readily to the fist over short distances, then slowly increase the distance, though still within the aviary. It is important to remember that you can't really take the owl out of the pen and put it on a line until its legs and bones are strong enough to cope, which is basically when it is close to the feathers being hard down, or fully out of the blood.

■ *Success! This young Great Gray Owl is getting the idea in the secure surroundings of his pen*

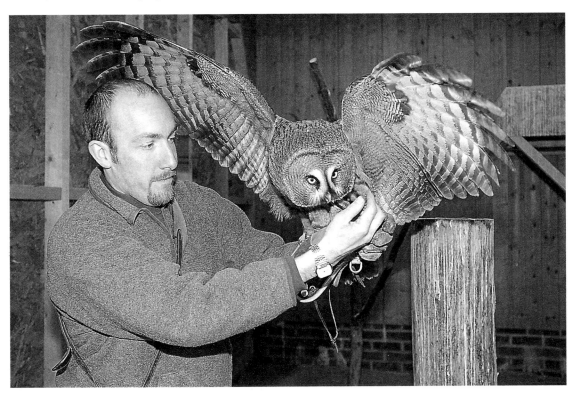

HANDLING YOUR OWL

Once the young bird is strong enough to be held with jesses you can start carrying it around as much as possible, to get it used to all the sights and sounds of daily life. However, I am very against taking birds into towns or heavily populated villages. You can do untold damage to falconry, and to keepers of diurnal and nocturnal birds of prey by taking them to heavily populated areas. The bird only has to bate off the fist and hang upside down for a few seconds and people who don't understand get totally the wrong idea and go off hating the whole thing. Keep away from crowds, it's better for all of us.

By carrying around, I mean that it should be used to your house, garden, family, pets, wheelbarrows, lawnmower, and the other things that it may meet with during its life. Take it to the area where you are going to fly and train it, and walk it round the flying area. If your flying area is a way from your house, travel it in its travelling box at this stage; all of this is training and is good for the bird. Don't, however, take the bird out in the heat on very hot days: either work with it during the morning before about 10.00, or after 1900 hours when the day has cooled down in the summer.

One other thing to consider when carrying and handling your owl: if you are taking your bird where the general public roams freely, you will need, in this day of people suing, third party liability insurance in case your bird scratches, bites, hits with its wings, or frightens anyone. There has actually been a case, settled out of court, of someone suing a bird owner because the bird frightened his child! So take my initial advice, and don't take your bird into the public domain unless you really have to. My third party public liability insurance is just about to be put up to £2,000,000, as £1,000,000 is not enough in these days of people suing for the smallest thing.

The training should progress fairly well if you are patient, and give the bird some time each day in its pen; much of the training will be done in the pen. Also, try to remember to weigh it every day, in the pen, and then you will start to know the weight at which it behaves best. As regards the weights of birds, this is a subject that I have tackled many times, and still many people do not understand it.

FLYING WEIGHTS

Birds' weights change, they do not remain constant: both their flying weight and their non-flying 'fat' weight will change. One of the things that will affect the weight of a bird is the weather. It may well need to be lower in weight in warm weather and higher in weight in the cold of winter; we certainly find that is the case. As the bird gets fitter it will build up muscle which is heavier than fat, and so it will fly at a higher weight. As it starts to get fit it will need to be given more food to build up the muscle and will fly at a higher weight. Moreover, as the bird gets older it will fill out and may well fly at a slightly higher weight each successive year. If you introduce the bird to a new place, or new people, you may find that you will need to lower its weight in the early stages, until it gets used to the changes.

Every now and again play around with the bird's weight: if it has been flying really well for a while, try putting its weight up a little. If it still goes well you can increase it even more until the point when it doesn't react as well; and then you know that for that particular point in the bird's life, at that stage of fitness, and in whatever the prevailing weather conditions, that is its flying weight for the next few weeks – unless, of course, the weather changes or the bird gets even fitter! So you can see, there are many different factors that affect a bird's flying weight, and all should be taken into consideration at all times.

When you first start training your owl you will be playing with it in the pen, so you don't have to worry about cutting its weight down, and in fact you should not reduce its food intake by much until it is fully grown. If it doesn't want to come to you for its morning feed, it will be quite alright to not feed it until the evening feed; but as it will still be using food to grow feathers, you don't want to leave it without food for too long, or you will affect the feather growth and spoil the looks of the bird.

THE FLYING GROUND

This is another area where you need to do some work before you get your owl. Where are you going to fly it? And are you going to fly it on a daily basis?

I would strongly suggest that you avoid public parks, which throw up a number of problems: first, again you would probably need third party public liability insurance to cover yourself in case of problems. Also, some parks close at night, which could be difficult if your bird has decided to sit in a tree for hours. And to a large Eagle Owl, a Yorkshire terrier is just a short-eared rabbit, in fact it is smaller than a full-grown rabbit, and several breeds of dog fall into that category. Furthermore many of the dogs that you will meet are liable to be fairly badly behaved, and if a bird flaps its wings, even while just on your fist, some will leap up and try to attack it. I was doing a television job up in a park near Manchester only a couple of weeks ago and the Harris Hawk I had on the fist bated (flapped off the fist) when it saw a strange dog, which immediately tried to leap up and grab it. I am fairly tough so was

able to frighten the dog off, which was a good thing because not only did the owner have no control, but afterwards became very abusive about the bird. Basically it is just not worth the risk and hassle to expose your bird to a temperamental public and badly trained dogs, so find somewhere else to fly it in peace and safety. If you can't do that, then you should not even try to fly an owl, or you should consider moving to somewhere where you can.

I would suggest you approach the local farmers to see if any one of them would allow you to use a field for flying. Some are very helpful about their land, others less so. But always be polite when asking even if you get refused, and always express your thanks if they do allow you to do so. We go round most of our farmers at Christmas and show our thanks with a bottle of whisky or a couple of bottles of wine. We also pay some for the use of their land if we are hunting on it regularly. If you are intending

■ *The Owl Courtyard with the male Turkmenian Eagle Owl on guard duty! He can ruin flying demonstrations because the trained owls fly past the pen and this owl calls and waves food at them, while his wife sits on eggs*

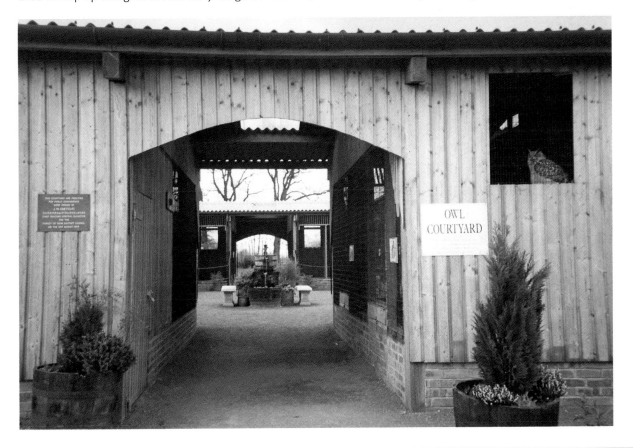

to hunt with your owl, you will need to get permission on several farms, and I would suggest that you make sure they are not close to any major roads, as owls are notorious for getting run over because of their habit of flying low.

If you are just taking your bird out to exercise it, rather than hunt it, try and find a farm that is mainly permanent grass pasture and sheep; the grass will be short if it is grazed by sheep, nor do sheep come rushing up to see what you are doing in the way that cattle do. But watch out for sheepdogs because they are one of the worst dogs for chasing things – it is just in their nature. Arable land is a problem as

it is either ploughed up or growing crops, neither of which make for easy working with a bird; nor will you be appreciated if you walk all over growing crops. The only time I lived away from the Centre for any length of time I was very lucky in that, having discovered the dangers of trying to train and fly birds on public land, I was given permission to fly my birds on the local school playing field, after everyone had gone. But that was a long time ago now, and I don't know if you would be granted this permission these days.

The problem with training a bird is that during the early part of the work it is on a training line called a creance, and this line can catch on the smallest piece of grass, weed or plant. Here at the Centre, the area where we train our birds is mown like a

■ *John and Moosehead Premium. Snowy Owls often prefer to land on a perch rather than the fist*

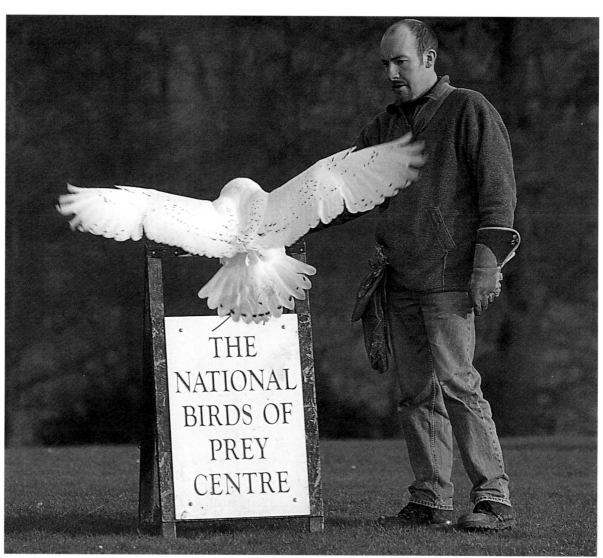

THE NATIONAL BIRDS OF PREY CENTRE

lawn, so this problem rarely occurs: using farmland, however, means that the grass will be longer. In these circumstances you have two options: either always have someone with you to hold the creance up away from the grass, or ask the farmer if you can mow or strim a narrow strip of grass about 6ft wide and 100ft long (2 x 30m); this will give you enough space to train without the line getting caught up.

You have to be aware of this line the whole time you are using it. Make sure it is always at the front of the perch the bird is sitting on, not behind, and watch the wind direction so the line does not blow over things. Make sure that you have control of it at all times, so if the bird suddenly takes off, it can't get stuck in a tree, or worse, be anywhere near electricity poles, particularly those with transformers.

Around our flying ground we have five large posts which we use to call the owl from and to. We also do fist work – that is, we call the bird to the fist as well as the post. As well as posts we use an A-frame perch constructed with a piece of 3 x 2in (76 x 50cm) timber covered in carpet for easy and safe landing. This A-frame can be moved around so that you are always calling the young bird into the wind; it can also be used if you don't have a handy post available for initial training, and it can be really useful if your bird is refusing to come to the fist, because it will often come to that, rather than directly to you. It is also a simple matter to habituate the owl to the A-frame in the pen so it is used to it and quite happy about using it before you introduce it into a new situation. In fact the A-frame can be kept in the pen when it is not being used for flying so it becomes very familiar to the owl.

FIRST TRAINING OUTSIDE THE PEN

When you take your bird out for the first time the most important thing is to choose a good day – not too windy, in fact preferably no wind at all. Get your little pieces of meat ready and in the bag, also your creance, a day-old chick if that is the favourite food of your owl (it is the favourite of all my owls) – this is a 'back-up' in case the owl refuses to move, which it may. For the first few training sessions outside you will really only need to use your lawn. I have to say here, that if you do not have even a lawn in your garden I would seriously consider not keeping an owl because you really do need a reasonable-sized space to keep and work a bird; tiny gardens are just not suitable or fair on the bird.

You may find that the first few times you take your owl out of the pen for training, it will need to be at a lower weight than it has been working at in the pen – this stage of the training will be a great change, since it will be away from the security of its pen for the first time. Put your A-frame on the lawn, as far away from the pen as you can – some birds will not concentrate properly if you are close to where they are used to living, but will always be trying to get back. And if you can't get away from the pen, then position the A-frame so that you are calling the owl towards the pen, and then at least it won't be trying to look over its back all the time. When I am training owls I usually get the creance out and unwind about ten feet (3m) of it on the lawn, tying the end to the perch temporarily so I can find it easily. I lay out more each day as the training progresses.

Once all is ready, go into the pen as normal, call the bird to the fist, and put on the mews jesses, swivel and leash as you should always do for carrying the bird out of the pen. Take it out and into your weighing/equipment room and weigh it. If it is over the normal weight for flying in the pen, it is probably not a good idea to try anything new. It needs to be either the right weight for that stage of the training, which you should have found out during the work that you have done in the pen, or slightly below the weight you have been working with for the few days before.

When you weigh your birds, make sure that you always weigh them in the same way, either with the leash and swivel on, or just the swivel, or neither, but whatever you decide, it should always be done in the same way, because then you don't alter the weight of the owl by the amount the leash and

swivel weigh. Also remember that if you put a bell on at a later date, weigh the bird before you put the bell or bells on and then again after the bell/s are on.

Put the creance onto the swivel; we usually tie the falconer's knot (you can find out how to do that by referring to my other two books!). Don't remove the leash until the creance is secured; in this way you have less chance of letting the bird go by accident. Once the creance is on, take off the leash and put it on your bag strap; I like to fold it twice and then loop it through itself round the strap, so I don't lose it. Place the bird onto the A-frame and try calling it to the fist in exactly the same way that you have been doing in the pen, patting the fist, whistling and generally encouraging the bird. At this stage if you get a short hop and then a couple of jumps of up to about three feet (1m) you will be doing well. Remember to call into the wind.

One mistake that most people make is to call the bird a great many times. Each time the bird comes to the fist or the perch it gets a reward, and

■ *This sequence shows John and Bollinger on a training session in the flying field. Note the training line or 'creance'*

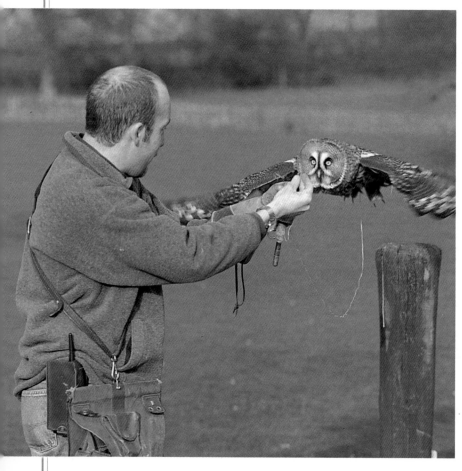

so its appetite reduces and eventually its response time gets longer – but you are still rewarding it. So what you are actually doing is training it to take a long time to come, which is not a good move.

You may well find that during its first training session out of the pen, the bird spends the whole time looking around it and not concentrating on the food, or the fist or you at all. If after five minutes you have failed to get its attention, stop, pick the owl up gently, put on the leash and then remove the creance, and carry it back to the pen. Go in and remove the leash, swivel and mews jesses and let it go in the pen without any food, because the time has now come to be a little mean and pull rank on the bird: no work, no food.

This may sound hard, but it is the best way to do it. Don't make the mistake that a lot of people are making with diurnal birds of prey. For some reason that completely escapes me they are being advised to bring their birds down slowly, reducing the food over a long period. I have had people tell me they have been feeding a fairly large bird only one day-old chick per day because they want to do the job slowly – but this is undoubtedly the best way to get any bird permanently hungry, bad-tempered, very noisy and sometimes aggressive. Imagine if you had nothing but breakfast to eat for a month – by the end of two weeks you would be thinking of nothing but food, and you would be seriously bad-tempered: well, it's the same for a bird. It is much better, quicker and kinder to cut its weight down quickly, and then as soon as you are getting a response, to push its weight back up immediately. You will find that if you feed a good deal of food on the first day of training, your bird may not respond as well the following day – so just leave him without food the following day if he won't respond. Don't sit for ages trying to get a bird to come to the fist: as I have said already, by rewarding it each time it comes to fist or perch its appetite reduces and so its response time gets longer – but because you keep rewarding it for doing just that, you are in fact *training* it to take a long time.

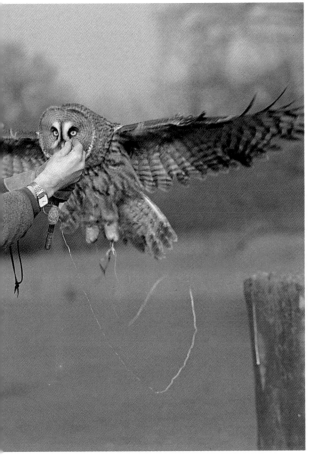

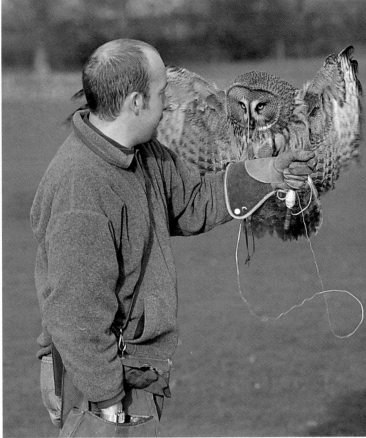

FIRST TRAINING ON THE FLYING GROUND

Once the owl is coming well to the fist and the A-frame in your garden on the creance, you can move to your flying ground so as to be able to increase the distance and get to the stage of the bird flying free. Put the travelling box and the A-frame if you need it into the car, or if you are walking, make sure that perches are in place so you don't disturb the owl on its first day out. Get all your gear ready as usual, pick up, jess and weigh the bird and then box it if you are travelling by car, or walk to where you will be flying the bird if you can do so without passing too many people. Once in the flying ground, tie the creance onto the swivel with a falconer's knot and then remove the leash, hanging it on your bag strap out of the way. Put the bird on the perch, and as you are again in a new place, take the training back a little

■ *We weigh all the flying owls on a daily basis. These are old shop scales adapted with a perch. Remember that the scales must be accurate, comfortable for the owl to stand on, stable and safe*

and simply ask the bird to jump a really short distance to the fist, gradually increasing the distance by twice the length at each jump or flight.

Don't ask it to jump to the fist too many times: remember that each time you do so you reduce its appetite – so never overdo it. It's a bit like going out to dinner and not eating yourself to a standstill: if you leave with a remnant of hunger you still feel like doing things, whereas if you are completely stuffed full of food, you feel like doing nothing. Well, the same goes for your owl. In this first stage of training I usually call a bird to the fist three or four times each day, then increase it to five or six, and then more as the bird knows what you are wanting it to do.

From now on you should weigh the bird each day before taking it to the flying ground. Try not to miss a day at this stage, as the more consistent the training, the better the owl will progress. However, don't panic if you can't. Weather can cause problems, as it is best to avoid days of very strong wind, and most birds don't like to fly in the rain. There

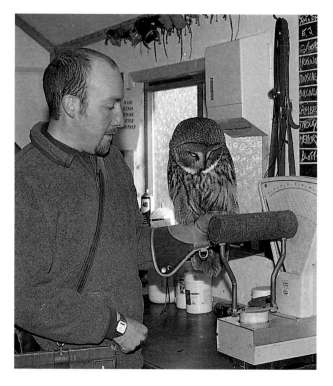
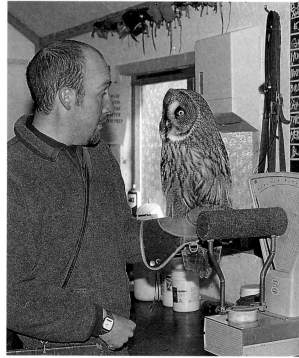

may also be days when the owl is overweight and therefore will not fly, so you will probably have to miss trying on those days. During this period you should be finding out which foods it responds to best; which weight it behaves best at; and what amounts of what type of food will maintain its weight level, or put its weight up, or cause it to lose weight. All this information you should note down in a diary of events, or a day book; then you will be able to look back and use that information in the future.

Move the A-frame round where you are flying so the bird sees new views, trees and what have you; and if you can, try it in different fields or places – though always with the permission of the landowner, and never near roads, or livestock that you might frighten or that might frighten your owl. All of this is good for the bird. Find a tree with a low, easily accessible branch so you can place the owl on the branch and call it out to the A-frame or fist, or even to a piece of meat thrown on the ground. When you do this, have someone else hold the creance so there is no chance of the bird either moving up inside the tree, or getting tangled.

Remember that the owl must see the piece of food being put wherever you want it to land, so attract its attention with a whistle and a wave of your hand before putting the meat on the perch. After a while it will start to trust your signals and may not need to see the food, but in the early stages it is good practice to give it all the help you can.

By this time you will know what the flying weight of your bird needs to be for the weather conditions that you are working in, and for its current stage of training and fitness. You will probably find that you may have to drop its weight down a little each time you make any major changes, such as a change of venue or if there is a herd of cows in the field next door, or anything else that an owl can use as an excuse. One of our owls always did a disappearing act whenever the lawnmower crew arrived; another hated wheelchairs and prams and always went to sit in the cherry tree; our Tawny Owl gets beaten up by mistle thrushes and refuses to fly in the spring, and our Barn Owl hates me and sits in a tree refusing to move if I go down to the field when he is flying. One of our European Eagle Owls doesn't like to be touched and won't come to the fist, but he still does a good demonstration, flying out of the pen to the flying ground, where he does his work and then flies back into his pen. The only problem is that when he is in a bad mood he goes back to the

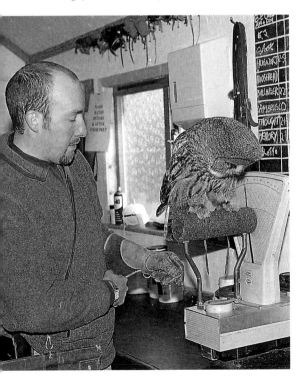
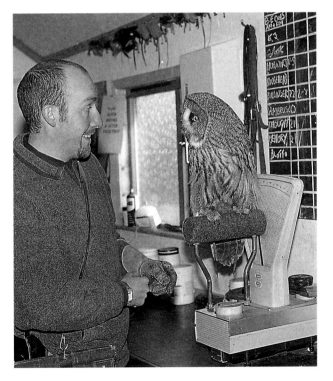

pen early, leaving you looking like a pratt with no owl in the field! So you can see, each has its own idiosyncrasies, which you have to work round.

The more different things you introduce your owl to in the first three weeks of real training, the better. But there will always be the odd disaster that happens, like a combine harvester coming round the corner at the wrong moment, or a motorbike backfiring or whatever; you will just have to learn to deal with those.

FLYING YOUR OWL FREE

Once your bird is coming immediately to the fist, to the A-frame, to posts or out of a tree, and once you are confident, it is time to fly it free. Do exactly the same as usual, but take off everything except the hunting straps and bells. Don't change the training session – do the same as normal, but leave yourself plenty of time and maybe take someone with you to help if you have problems – though make sure the owl is used to there being more people than just you, before letting it loose.

If day-old chicks are your owl's favourite food, then take a couple of these as an emergency back-up; if it suddenly doesn't behave, it may well come to chicks when it won't come for other stuff. Mine do, and this is one of the reasons I never use chicks normally to call the bird but chopped-up beef, or rabbit, or quail, or rat, saving the chicks for when I really have a problem. If it has a different favourite food, then save that up instead.

So now you have a trained owl flying free. Just continue what you are doing, maybe slowly bringing in changes if you want to. See if you can enter it to the dummy rabbit – you can do groundwork on this in the pen by throwing the dummy rabbit down on the floor at feeding time with a piece of meat attached, let the owl feed from it, and learn to let go

of its own accord, while in the pen. Then use it in the field; you may find it takes a bit of time for the owl to start to chase it, but go slowly and eventually you will get there. Try getting the owl to follow on from post to post and then tree to tree. All this takes more time than it would with something like a Harris Hawk – but *you* wanted an owl!

Remember to play around with the owl's weight as it gains more confidence, pushing it up until the bird won't respond well, and then reducing it just a little. Always keep an eye on the weather, as an owl will need more food in the winter.

What more can I tell you? If you are going to try hunting, read on; if not, you will have to learn to deal with any problems that arise as you go. If you do lose an owl, they are not that easy to find or to get back because unlike the diurnal bird of prey, they are more likely to move at night. But having said that, one of our European Eagle Owls went for three days and didn't move from the wood next door. We found him by walking around hooting, and eventually he hooted back. Mind you, we felt somewhat silly doing it.

■ *Note how John's fist is extended well away from his body and held high to encourage the owl to land well. The reward is readily seen in the early stages of training*

■ *Pages 140–1: Barn Owls are universally popular. However the argument against flying them for the public is that you may encourage people to buy one for the wrong reasons*

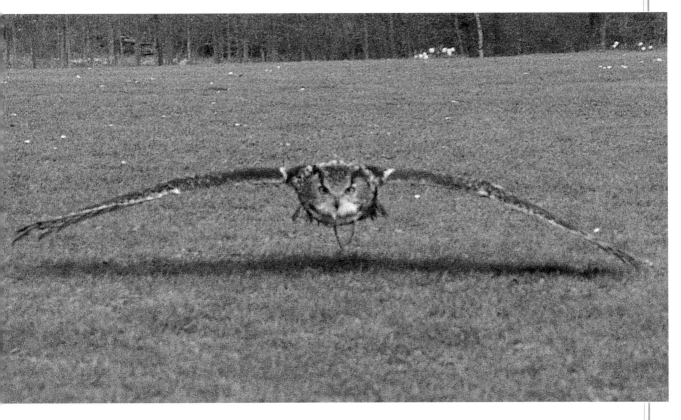

■ *A European Eagle Owl glides across the flying field*

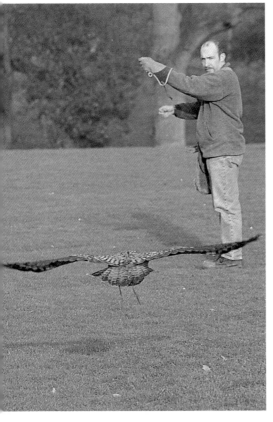

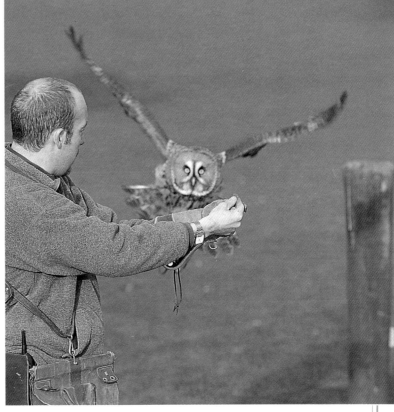

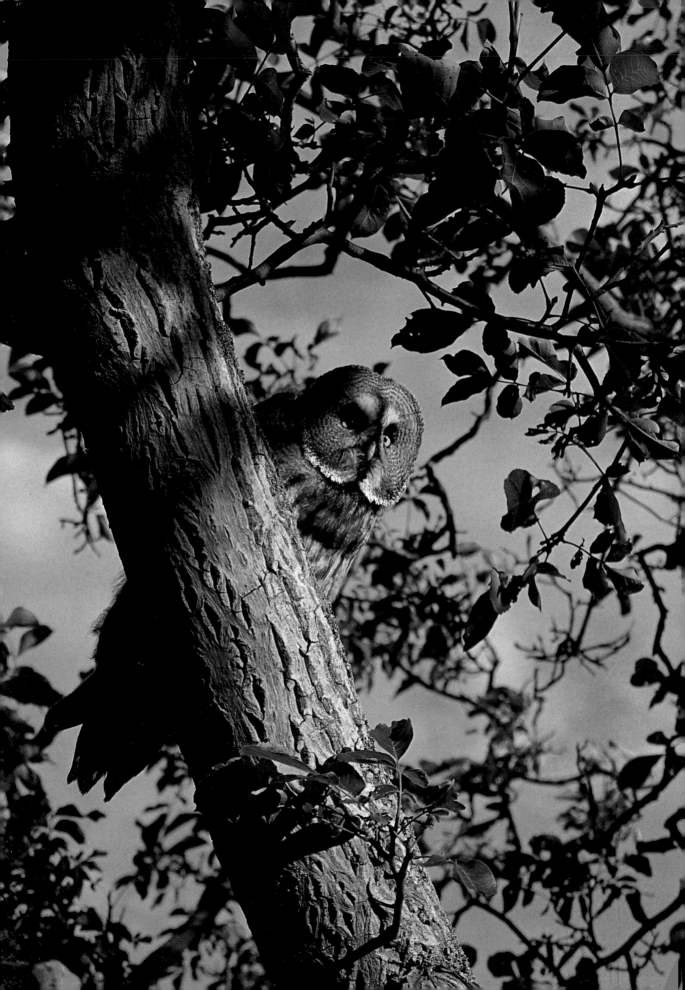

HUNTING
WITH OWLS

*T*he problem with hunting with an owl is that, if you look seriously at the literature covering what owls feed on, you will find that most owls, apart from the really tiny ones or specialist feeders such as the fishing owls, eat voles, mice and shrews. So their natural quarry are pretty small mammals, and these don't make for particularly exciting flying or hunting. Yes, without doubt the large eagle owls catch large quarry, but this does not make up the bulk of their diet, and it could not be said that they are easy to persuade to take quarry of any size in the trained state!

■ *Bollinger in a tree – this is a miracle – he hates trees!*

One of my staff, Craig, in the autumn of last year, tried manfully to get his Eurasian eagle owl 'Flounder' to hunt. He did finally catch one rabbit, with a tremendous amount of effort; he also caught numerous lumps of moulted sheep's wool and sheep droppings! However, once he had caught anything the owl was very loath to give it up – and I mean it was not interested in letting go, without a major struggle, for three hours and sometimes more. Well, that tends to make the evening rather drawn out in my book.

I am not saying you can't hunt with an owl, I am saying that there are easier and probably more visual ways of hunting than to use an owl in the dark or half-light of the day. Actually, if the truth were known, I think anyone who is really thinking about hunting is completely round the bend to try with an owl! However, if you feel that is what you would like to do – give it a try!

The way to go about it is almost exactly the same as you would train a Red-tailed Buzzard, or Harris Hawk, or indeed any of the buteos or accipiters. You will need to go through all the normal training processes which we have just discussed in order to train your owl: carrying on the fist, calling to the fist, calling out of trees, following on (that really takes time with an owl) and chasing the lure or dummy rabbit. You should then check that your owl will travel happily in your travelling box – if you are not already travelling it about – and be obedient during flying sessions away from home. Once you have achieved all that, then it is just a question of going out and trying to get the bird in the right place at the right time to catch a rabbit, or whatever else you are after. There can be no doubt that the evening is the best time for hunting with owls; to take them out during the day means you are asking them to do something that is unnecessarily difficult.

You will need to do a good deal of work with the dummy rabbit, and also with dead rabbits if you can, so the owl really understands what it is supposed to be doing. You will find that your owl probably won't have the same drive to hunt as most of the diurnal birds of prey. However, perseverance is the key word, and quite frankly if you don't have patience, then an owl is not the right bird for you anyway. In fact patience is vital in the handling and training of any animal or bird.

We tend to fly our owls without bells as they rather defeat the object of silent flight. However, this does mean that your owl can be pretty difficult to find in the dark. Craig had a brilliant idea – at least I thought it was! He buys little luminous things that fishermen use on their floats for night fishing; they cost about 60p each, and you just break the seal inside and they glow brightly for hours. He fixes one to Flounder's flying jess and you can see where the bird is for miles – it looks really odd, with this luminous green thing bouncing about in the air. When he glides it just floats, but when he is beating his wings it leaps all over the place. Its advantage is that he doesn't have to wear a bell at all. If you have telemetry, then it is a very good idea to use it on a hunting owl.

To be fair to Craig, one of the reasons his total bag is only two rabbits is that we were not able to fly the birds away from our field for nearly three months because of the Newcastle's disease in the area, so he was not able to take Flounder out. Now we are in the clear and the disease has gone from the area, Craig and his owl are out in the pitch dark, much to his girlfriend Debbie's disgust. He always drops in after they are home again and we get the full story of what Flounder has chased, missed, and done in his evening out! Oh, the joys of falconry!

Like Craig, you will just have to persevere, and keep going out until your owl gets the idea. As with any hunting bird, let it feed up on the first few kills – don't take it away and try for more. I think if I got one kill per day I would probably be pretty happy with that, though once your bird is really confident

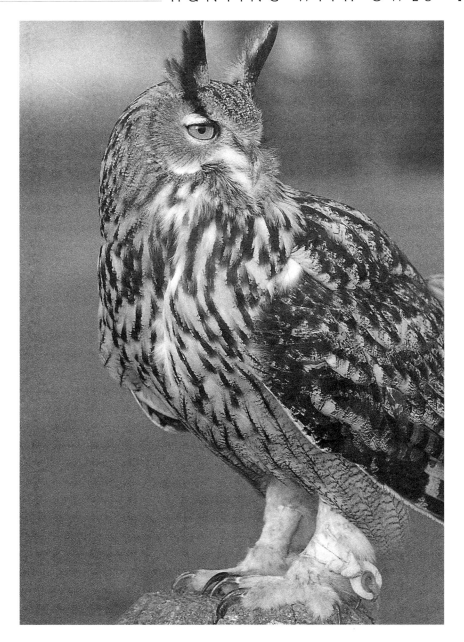

Blotto, who has never caught anything! His brother Flounder did, however

you should be able to ask for more if you so require.

Taking the dummy bunny or a real kill away from a large owl can be tricky. The best way is to cover the rabbit with your bag or a coat, and either teach the owl to go to a small piece of meat thrown away from you, or to step to the fist off the hidden rabbit. Getting birds to step up nicely is always time-consuming and takes patience. If you try to hurry birds, and particularly owls, you will find they tend to grip even harder.

If you get a kill, let the owl feed right up on it so it feels it has benefited from catching something, as you would with a diurnal bird of prey. This will mean that for several days afterwards the bird will be too heavy to fly again, so you will have to wait until it is down to weight.

Remember that the same laws apply to hunting with an owl as any other sort of hunting. Many species are protected and can't be hunted at all, some species have seasons when they can be hunted, and closed seasons when they can't. The rabbit can be hunted at all times of the year as it is a pest.

And the best of British luck for those of you who really want to hunt with an owl!

APPENDICES

LIST OF USEFUL ADDRESSES

The National Birds of Prey Centre
Newent, Glos GL18 1JJ
Tel: 01531 820286 Fax: 01531–821389
E-mail: jpj@nbpc.demon.co.uk
Visit our website at http://www.nbpc.co.uk
Open to visitors seven days a week February to November: breeds birds; runs courses, film work; falconry experience days; lectures; falconry demonstrations; videos; books; mail order service

Licensing and Registration Authorities
Wildlife Licensing Department
Department of the Environment, Transport and the Regions
Tollgate House, Houlton Street, Bristol BS2 9DJ
Tel: 01179 878154

Import/Export Health Certificates etc
Ministry of Agriculture, Fisheries and Food
Import/Export Section
Hook Rise South, Tolworth, Surbiton, Surrey KT6 7NF
Tel: 0181–330 8222

Specialist Veterinary Surgeons
These are all specialist vets but not all are known to me personally, so I cannot vouch for all of them.

Neil Forbes (*Specialist in zoo and wildlife*)
Lansdown Veterinary Surgeons
Clockhouse Veterinary Hospital, Wallbridge, Stroud, Gloucestershire GL5 3JD
Tel: 01453 752555 Fax: 01453 756065

Andrew Greenwood (*Specialist in zoo and wildlife*)
John Lewis (*Specialist in zoo and wildlife*)
David Taylor (*Specialist in zoo and wildlife*)

All at: International Zoo Veterinary Group
Keighley Business Centre, South Street, Keighley, Yorkshire BD21 1AG
Tel: 01535 692000 Fax: 01535 690433

Lance Jepson (*Specialist in exotic animals*)
Fenton Veterinary Practice
21 Portfield, Haverfordwest, Pembrokeshire SA61 1BN
Tel: 01437 762806

Martin Lawton (*Specialist in exotic animals*)
12 Fitzilian Avenue, Harold Wood, Romford, Essex RM3 0QS
Tel: 01708 384444 Fax: 01708 344318

Derek Lyon (*Specialist in zoo and wildlife*)
Gatehouse Veterinary Hospital
Lavister Rossett, Wrexham, Clwyd LL12 0DF
Tel: 01244 570364 Fax: 01244 571215

Peter Scott (*Specialist in zoo and wildlife*)
Zoo and Aquatic Veterinary Group
Keanter Stoke Charity Road, Kingsworthy, Winchester, Hampshire SO23 7LS
Tel: 01962 883895 Fax: 01962 881790

Greg Simpson (*Specialist in avians and exotics*)
Woodlands Veterinary Clinic
Katherine Court, Salisbury Avenue, Warden Hill, Cheltenham, Gloucestershire GL51 5DA
Tel: 01242 255133

Clubs and Associations
British Falconers Club
Home Farm, Hints, Nr Tamworth, Staffs B78 3DW
Tel: 01543 481737

The Hawk and Owl Trust
c/o London Zoological Society, Regents Park, London

Raptor Breeders Association
2 Old Bell Cottages, Ludford, Ludlow, Shropshire SY8 1PP

Other Falconry Centres
The Hawk Conservancy
Weyhill, Nr Andover, Hants SP11 8DY
Tel: 01264 773850

The Owl Centre
TAG (Taxon Advisory Group)
Chairman for Owls
Muncaster Castle, Ravenglass, Cumbria

Falconry Courses
The National Birds of Prey Centre
(address as above)

The British School of Falconry at Gleneagles
The Gleneagles Hotel, Auchterarder, Perthshire PH3 1NF
Tel: 01764 662231 ext 4347

Falconry Equipment, Telemetry etc
Martin Jones Falconry Furniture
The Parsonage, Llanrothal, Monmouthshire
Tel: 01600 750300

Vydex Vitamins
Vydex Animal Health Ltd
Cardiff CF5 4AQ

Brooders and Incubators
AB Incubators
Unit 5, Old Market Street, Mendlesham, Stowmarket, Suffolk
IP14 5SA
Tel: 01449 766065

Curfew Incubators
Southminster Road, Althorne, Chelmsford, Essex CM3 6EN
Tel: 01621 741923

Markham Pet Centre – Roll-X Incubators
Longlands Lane, Brodsworth, Doncaster, South Yorkshire
DN5 7XB
Tel:. 01709 548125

Robin Haigh Incubators
Abbey Bridge Farm, Colonels Lane, Chertsey, Surrey KT16 8RJ
Tel: 01932 560236

Disinfectants
Antec International
Chilton Industrial Estate, Windham Road, Sudbury, Suffolk
CO10 6XD
Tel: 01787 377305

Vetark
PO Box 60, Winchester, Hampshire SO23 9XN
Tel: 01962 880376

Netting and Wire
Ash & Lacy (Moncasters)
Belvoir Way, Fairfield Industrial Estate, Louth, Lincs LN11 0LQ
Tel: 01507 600666

Denben Group Industries
Netting and Pest Control Division
80 North Allington, Bridport, Dorset DT6 5DY
Tel: 01308 423576

Rings
A.C. Hughes Ltd
1 High Street, Hampton Hill, Hampton, Middlesex TW12
1NA
Tel: 0181–979 1366

Lambournes
High Street, Henley in Arden, Solihull, West Midlands B95 5BY
Tel. 01564 794971

Vitamins
Avian Management Services – sole UK supplier of Nekton
vitamins
PO Box 119, Hereford HR4 7YB
Tel: 01981 500110

Vetark (address as above)

Vydex Vitamins
Vydex Animal Health Ltd
Cardiff CF5 4AQ

Aviary Materials
Fingle Farm Buildings
West Fingle Farm, Drewsteignton, Devon EX6 6NJ
Tel: 01647 21226

Netlon Ltd
Kelly Street, Blackburn BB2 4PJ
Tel: 01254 62431

Onduline Building Products Ltd
Eardley House, 182–184 Camden Hill Road, Kensington,
London W8 7AS
Tel: 0171–727 0533

Books and Magazines
Cage & Aviary Birds
King's Reach Tower, Stamford Street, London SE1 9LS
Tel: 0171–261 5000

Falcon Books and Prints
The Parsonage, Llanrothal, Nr Monmouth, Monmouthshire
Tel: 01600 750300

The Falconer's Magazine
D. and L.R. Wilson
20 Bridle Road, Burton Latimer, Kettering, Northants
NN15 5QP
Tel: 01536–722794

St Ann's Books
Rectory House, 26 Priory Road, Great Malvern, Worcs
WR14 3DR
Tel: 01684 562818

Other Products
Avian Management Services – computer programme for
monitoring weight loss in eggs, and to manage stock
(AIMS) AI equipment

Electromail – electrical equipment, fans etc for incubators
PO Box 33, Corby, Northants NN17 9EL

CAPTIVE BREEDING DOCUMENT FOR BIRDS BRED AT THE NATIONAL BIRDS OF PREY CENTRE.

This document confirms that the following species of bird(s) was bred at the National Birds of Prey Centre.

All birds at the Centre have been legally obtained and/or bred and are, where required, registered with the Department of the Environment.

If the parent birds are not at the Centre they belong to owners well known by the Centre and judged to be good quality birds, legally obtained and registered. Young from these birds are parent reared in the normal way at the National Birds of Prey Centre and go with the usual guarantee.

Owls may be hand-reared for flying if required, as may Vultures and Secretary birds.

SPECIES STRIPED OWL

SEX FEMALE

RING NO (if required) NATBIRDPREYV004

PARENT RING NOS (if known) NATBIRDPREYV0001 / NATBIRDPREYV0002

YEAR OF BREEDING 1997

BREEDER N BPC

NEW OWNER JOHN DOE

ADDRESS 1 OWL DRIVE, HOOTSVILLE, DORSET

PHONE 012345 768910

SIGNED BY NEW OWNER _John Doe_

SIGNED BY REPRESENTATIVE OF THE NATIONAL BIRDS OF PREY CENTRE JPJ.

DATE 7/11/97

INT BIRD PREY W

Ring no.	Parents.	Owner.	Species.	Year.	Hatch date.	Hatch time.	Hatch wt.	Marked.	Egg no.	Comments
INT BIRD PREY W	OURS	NBPC	STRIPED OWL	1997	30.3.97	05.30			97002a	
Day	Date	wt. feed 1 before	wt. feed 1 after	wt. feed 2 before	wt. feed 2 after	wt. feed 3 before	wt. feed 3 after	wt. feed 4 before	wt. feed 4 after	
1	30.3.97	25.0	25.06	24.5	23.75	N.t	N.t	24.8	26.35	
2	31.3.97	25.7	29.6	27.1	29.14	26.8	28.2	27.6	29.2	
3	1.4.97	28.2	30.5	29.7	31.4	30.7	32.2	31.6	34.4	
4	2.4.97	33	37.8	36.9	40.4	39.4	42.5	41.6	44.8	
5	3.4.97	43	48.6	47.5	52.1	50.5	56.8	55.2	54.4	
6	4.4.97	52.9	58.9	57.5	63.6	61.8	69.9	67.6	74.3	
7	5.4.97	70.4	79.1	77.7	83.5	82.1	85.8	82.5	93.1	
8	6.4.97	89.7	98.7	—	—	95.4	104.1	103	119.2	
9	7.4.97	111.0	126.6	—	—	118.6	128.8	123.7	137.7	
10	8.4.97	129.6	146.4	—	—	136.8	144.8	160.4	154.4	
11	9.4.97	147.0	160.5	—	—	136.3	167.1	160.5	180.5	
12	10.4.97	169.0	191.8	—	—	179.8	179.7	191	210.4	
13	11.4.97	205.5	221.8	—	—	203.2	224.7	221.2	229.8	
14	12.4.97	218.2	once per day							

149

Incubation record sheet

Please put you name and address on the reverse of the form

Please tick if you want to keep the information confidential ☐

Common / Scientific name, at subspecies level if possible		Laid from	Laid to	Set	Removed from bird	Pip from	Pip to	Hatch From	Hatch to	Weigh when removed from bird (g)	Length (mm)	Width (mm)
	Date (dd/mm/yy)											
	Time (24 h)											
	Date (dd/mm/yy)											
	Time (24 h)											
	Date (dd/mm/yy)											
	Time (24 h)											
	Date (dd/mm/yy)											
	Time (24 h)											
	Date (dd/mm/yy)											
	Time (24 h)											
	Date (dd/mm/yy)											
	Time (24 h)											
	Date (dd/mm/yy)											
	Time (24 h)											
	Date (dd/mm/yy)											
	Time (24 h)											
	Date (dd/mm/yy)											
	Time (24 h)											

DATA REQUIRED ON EGG PARAMETERS TO AID IN ARTIFICIAL INCUBATION

The National Birds of Prey Centre and Avian Management Services are working to establish a centralised database of egg parameters for all species of birds to assist zoos and private breeders in their incubation management.

Artificial incubation is being used by zoos and private breeders around the world to aid in their breeding of hundreds of different species of birds each year. Despite this there is little information available on fresh egg weights, egg weight coefficients and accurate incubation times to pip for the majority of these species. Accurate calculation of fresh egg weights and a knowledge of accurate times to pip are essential for proper egg weight loss control during artificial incubation.

Our intention is to establish a centralised database for all this information so that zoos and private breeders may draw on it to assist in their incubation management.

By completing the incubation record sheet for a sample of your eggs for each species and returning it to us we will be able to compile a database of Kw values and incubation times to pip for each species. From this database we will then be able to produce reports of the mean Kw and pip time together with standard deviations for each species. This information will then be available to zoos and private breeders to assist them in their incubation management. The databases will be maintained by Avian Management Services, bases near Hereford in the UK. They are registered under the UK data protection act, and all the information submitted to them will be confidential if you tick the confidential section on the form. The compiled reports will not identify any individual zoo or private breeder and if the form is marked as confidential we will not disclose the source of the information to anyone who may enquire about that species.

Please use only information from eggs for which you are **sure** about the dates etc. It is preferable if you can let us have weights and measurements for eggs that you know were fresh (within 6 hours of laying) when taken.

If you are using the Avian Incubation Management software to manage your incubation there is no need to complete the form as the programs submission disk will return all the required data to us.

We urge you to participate in this program so that all breeders may benefit from the information from your eggs, and you may in return benefit from their information.

Only by working together and sharing information can we make the maximum use of the knowledge we have.

We thank you for your help.
Jemima Parry-Jones. *Director NBPC*
David Le Mesurier. *Director AMS*

Avian
Incubation
Management
System

AIMS

Taking incubation into the 21ˢᵗ Century

OTHER SERVICES WE OFFER

- Customised versions of AIMS to meet clients specific requirements.

- Incubation consultancy.

- Design of incubation facilities.

- Incubation management protocols.

- NEKTON vitamins, a range of high quality avian vitamin supplements.

- Bespoke database applications.

Avian Management Services
PO Box 119, Hereford, HR4 7YB
United Kingdom

Tel / Fax: 01981 500 110
International ++44 1981 500 110

E-Mail
Internet http://ds.dial.pipex.com/avian/

SYSTEM REQUIREMENTS

AIMS requires the following minimum computer system to run:

- 80386 processor (or higher).

- 4MB RAM if virtual memory is set to temporary or permanent, or 6Mb RAM if virtual memory is set to none.

- Hard drive - designated C

- 3.5" floppy drive

- Mouse.

- Microsoft Windows version 3.0 or higher running in 386 enhanced mode.

- VGA or higher resolution monitor recommended.

If you want the best hatch from your eggs this season don't leave your incubation to chance.

Contact us now for your copy of **AIMS.** The modern way to incubate eggs.

Demo disk for Win95 is now available.

MODERN INCUBATION TECHNIQUES AT YOUR FINGER TIPS

Weight loss control during incubation is vital if you are to achieve the best hatch possible from your eggs.

In the past this has always been a rather hit and miss affair. Using hand drawn weight loss graphs. Moving eggs back and fore between wet and dry incubators to try to keep the egg on the graph line. And having to weigh eggs at the same time each day to ensure the graph was correct.

NOT ANY MORE !

AIMS brings the modern world of computers to the aid of the breeder.

This sophisticated database application will calculate the percentage loss at pip the egg is heading for and compensates for time differences in weighings, to the nearest minute.

It tells you the optimum relative humidity to place your egg in, which of your incubators is the nearest to this and the percentage loss the egg will attain if placed in this machine.

No more hand drawn graphs, no more errors due to time differences between weighing, **just a better hatch.**

HOW IT WORKS

1. Enter details of your incubators.

2. Register your egg.

3. The program will calculate the fresh weight of the egg for you, either using a Kw value, of which many are supplied on the taxon databases, or using regression analysis.

4. Enter the date, time of weighing and the weight of the egg. The program will do the rest.

HOW CAN IT KNOW WHAT HUMIDITY THE EGG NEEDS ?

From the information entered about your incubators and the date and time of each weighing the program is able to calculate the loss in weight per minute in relation to the humidity of the incubator. It calculates the weight that the egg needs to loose in order to obtain the optimum percentage loss at pip and then calculates the optimum humidity to place the egg into.

It then finds which of your incubators is the nearest match to this and calculates the percentage loss at pip the egg will achieve if placed in this machine.

You no longer have to worry about what time you weigh your eggs, or moving back and fore between wet and dry incubators to compensate for incorrect humidities.

You will KNOW what humidity your egg needs to attain the optimum loss at pip.

OTHER FEATURES

- Full stock management.

- Ring numbers - up to two rings per bird.

- Micro chip implant and reader type.

- Import / export permit details.

- Taxon databases to sub-species level.

- Automatically adds bird to stock when you hatch an egg.

- If you change a bird's ring the program will still maintain all previously entered details for it.

- Prints out UK CITES import, export and certificate application forms for you at the touch of a button

- Prints out certificates of captive breeding to go with a bird when you pass it on, this is a legal requirement with many species.

- Full stock movement history.

- Extensive data validation to prevent inaccurate information being added to the system by mistake.

- Full windows graphical interface, simple to use. You don't need to know anything about computers to be able to use AIMS.

And much much more

Egg weight record sheet

1.1 Back with parents – in incubator

EGG NUMBER	310097		DAY	Date	Time	Weight	INC	TEMP	%Rh	Notes
PEN NUMBER			·		24h	grams				
			0							
FEMALE I.D.			1							
FEMALE NAME			2							
FEMALE SPECIES	Bengal E Owl		3							
			4							
MALE I.D.			5							
MALE NAME			6							
MALE SPECIES	B . E O		7							
			8							
DAYS TO PIP	29	Days	9	24.3.97	13 30	61.35				
DATE LAID	14.3.97	dd/mm/yy	10	26.3.97	23 56	60.10				
DATE SET	15.3.97	dd/mm/yy	11	27.3.97	22.30	59.75				Move to 6 45%
TIME SET	01.01	hh.mm 24h	12							
DATE REMOVED	15.3.97	dd/mm/yy	13	29.3.97	00 30	58.97				
TIME REMOVED	17.00	hh.mm 24h	14							
REMOVED WT.	63.78	g	15	31.3.97	23 40					
FRESH WT		g	16	1.4.97	20 40					
			17	2.4.97	21.40	57.56				
LENGTH	55.49	mm	18	3.4.97	22.00	57.24				Needs 25%
WIDTH	45.53	mm	19	4.4.97	23.00	56.90				
Kw			20							
			21	6.4.97	21 30	56.18				
VOLUME	0	cm3	22	7						
DENSITY	0	g/cm3	23	8						
NATURAL INC.	0	Days	24	9.4.97	22.00	55.15				
LOSS FOR 15%	0	g/d	25							
			26	11.4.97	23.41	54.50				
FERTILE		(YES / NO)	27	12						
			28	13						
DATE PIP FROM		dd/mm/yy	29	14						
TIME PIP FROM		hh.mm 24h	30	15						
DATE PIP TO		dd/mm/yy	31	16.4.97	08.27					Pipped + cheeps
TIME PIP TO		hh.mm 24h	32	17.4.97	08 30					audio
DATE HATCH FROM		dd/mm/yy	33							
TIME HATCH FROM		hh.mm 24h	34							
DATE HATCH TO		dd/mm/yy	35							
TIME HATCH TO		hh.mm 24h	36							
MEAN INC TO PIP		Days	37							
MEAN PIP TO HATCH		Hours	38							
			39							
			40							
CHICK TEMP ID			41							
			42							
CHICK RING No.			43							
			44							
			45							
			46							
			47							
			48							
			49							
			50							

Certificate of captive breeding

I hereby certify that the bird listed below
was bred in captivity and that it's parents
were held legally in captivity at the time
the egg was laid.

Species	Iranian Eagle Owl Bubo bubo nikolskii
Ring	1NATBIRDPREYY
Micro chip implant #	None recorded
Date hatched	11/03/97
Egg number	None recorded
Sex	Unknown
Name	None recorded
Mothers ring number	Not in Stock
Fathers ring number	Not in Stock

Signed Date 11/11/97

Mrs Jemima Parry - Jones
The National Birds of Prey Centre

Newent
Gloucestershire
United Kingdom
GL18 1JJ
Telephone No. 01531 821581

This document was printed by
The Avian Incubation Management System
(c) D. Le Mesurier 1996

<div align="center">

Specimen report

</div>

Jemima Parry - Jones

The National Birds of Prey Centre

Report date:
11/11/97

Scientific name: Bubo bubo nikolskii

Common name: Iranian Eagle Owl

System ID: 00111

Ring: 2NATBIRDPREYY

No micro chip recorded

Sex: Unknown

Date acquired: 11/03/97

Acquisition type: Hatched here

Date hatched : 11/03/97

Age: 0.67 years

Rearing: Unknown

Current location: BROODER, brooder room

Mother

System ID: 00095 Ring: IRANIAN Name:

Father

System ID: 00096 Ring: IRANIAN1 Name:

Acquired from : Mrs Jemima Parry - Jones, The National Birds of Prey Centre

Owner : Mrs Jemima Parry - Jones, The National Birds of Prey Centre

<div align="center">

This report was produced by The Avian Incubation management System

</div>

Croner's Substances Hazardous to Health (June 1997)
(c) Copyright Croner Publications Ltd. 1997
Customer Services Tel: 0181-547 3333

Formaldehyde. Formalin. Methanal	CAS 50-00-0
HCHO	UN 2209
Usually found as 37-50% solutions with methanol added to inhibit polymerisation. Colourless solution with pungent odour. Combustible. Above 60°C explosive vapour-air mixtures (7-73%) may be formed. Also UN 1198, HAXCHEM •2YE, formaldehyde solutions, flammable. CHIP requirements cover >25% formaldehyde solution. Approximate odour threshold 1ppm.	f.p. 60°C HAZCHEM 2T (\geq25%)
E.L: MEL: TWA 8 hours 2ppm STEL 15 mins 2ppm	

Medical Effects	*Control Measures*	T; R 23/24/25
High toxicity. Severe irritant. Corrosive. Animal carcinogen	Safety glasses. Safety goggles Impervious clothing and/or gloves Respiratory protection may be required. CCR. SCBA	C; R 34 Carc. Cat. 3; R 40 R 43
I Vomiting. Abdominal pain. Diarrhoea		
S Moderate skin sensitiser. Burning. Redness	COSHH: Potentially exposed employees require health surveillance (assessment)	R 23/24/25, 34, 40, 43
E Pain. Redness. Watering. Blurred vision		S (1/2), 26, 36/37, 45, 51
R Irritant. Sore throat. Cough. Shortness of breath. Possible systemic effects		EEC 200-001-8
X RESP: Pulmonary oedema. (del). Possible sensitiser. LIV; KID: Non-specific injury		EMERGENCY FA 5
	HSE: IACL 88. MDHS 79. TR 2	SP 4

Croner's Substances Hazardous to Health (June 1997)
(c) Copyright Croner Publications Ltd. 1997
Customer Services Tel: 0181-547 3333

Potassium permanganate	CAS 7722-64-7
$KMnO_4$	UN 1490
Dark purple crystalline solid with blue metallic sheen. Soluble in water. Powerful oxidising agent which reacts explosively with combustible substances and reducing agents, both in solution and in the dry state. Decomposition occurs in many organic solvents and on heating, releasing oxygen, with increased risk of fire. Exposure limit covers manganese and compounds (as Mn).	f.p.— HAZCHEM 1Y
E.L: OES: TWA 8 hours 5mg m^{-3} STEL 15 mins —	

Medical Effects	*Control Measures*	O; R 8
Moderate toxicity. Severe irritant. Possible systemic effects	Safety glasses. Safety goggles. Impervious clothing Rubber or plastic gloves. Respiratory protection may be required. Dust mask or SCBA	Xn; R 22
I Nausea. Vomiting		
S Redness. Pain. Burning		
E Pain. Redness. Watering. Blurred vision		R 8, 22
R Cough. Shortness of breath		S (2)
X KID: Non-specific injury		EEC 231-760-3
		EMERGENCY FA 1
	HSE: CS 3	SP 38

BIBLIOGRAPHY

Bunn, D. S., Warburton, A. B., & Wilson, R. D. S. *The Barn Owl* (T. & A.D. Poyser 1982)

Burton, John. *Owls of the World* (Eurobook Ltd 1973)

Eckert, Allan W. *The Owls of North America* (Doubleday 1974)

Hume, R. *Owls of the World* (Dragonsworld 1991)

Johnsgard, Paul A. *North American Owls* (Smithsonian Institute Press 1988)

Mead, Chris. *Owls* (Whittet Books 1987)

Mikkola, Heimo. *Owls of Europe* (T. & A.D. Poyser 1983)

Sparks, John & Soper, Tony. *Owls* (David & Charles 1970)

Weinstein, Krystyna. *The Owl in Art, Myth and Legend* (Universal Books 1983)

Various authors. *The Birds of North America – The Varying American Owls* (The Academy of Natural Sciences of Philadelphia 1993)

Voous, Karel. *Owls of the Northern Hemisphere* (Collins 1988)

LIST OF ANNEX A SPECIES (1997)

This is a list of the birds that require an Article 10 certificate to be sold, including any form of trade involving barter, exchange etc, to be displayed to the general public either at shows or at a falconry centre or zoo, or to be used for any commercial purpose. That includes the parent birds of the young that you might sell.

Barn Owl (*Tyto alba*)

Soumagne's Owl (*Tyto soumagnei*)

Boreal Owl (Tengmalm's Owl) (*Aegolius funereus*)

Short-eared Owl (*Asio flammeus*)

Long-eared Owl (*Asio otus*)

Forest Owlet (*Athene blewitti*)

Little Owl (*Athene noctua*)

Eurasian Eagle Owl (European Eagle Owl) (*Bubo bubo*)

Eurasian Pygmy Owl (*Glaucidium passerinum*)

Lesser Eagle Owl (*Bubo gurneyi*)

Norfolk Island Bookbook Owl (*Ninox novaeseelandiae undulata*)

Christmas Island Hawk Owl (*Ninox squamipila natalis*)

Snowy Owl (*Nyctea scandiaca*)

Sokoke Scops Owl (*Otus ireneae*)

Eurasian Scops Owl (*Otus scops*)

Tawny Owl (*Strix aluco*)

Great Gray Owl (*Strix nebulosa*)

Ural Owl (*Strix uralensis*)

Northern Hawk Owl (*Surnia ulula*)

All the remaining owls are on Annex B for the time being, but the lists are constantly changing.

INDEX

Page numbers in *italics* indicate illustrations

Picture Acknowledgements

All cartoons by John Crookes
Colour and black-and-white artworks by students of Blackpool & Fylde College of Art
Aviary layouts by Fingle Farm Buildings
Photographs provided by the National Birds of Prey Centre, apart from the following:
Steve Chindgren: pp11, 26, 27 (inset), 28-9, 30 (top left), 35, 66

John Cross: pp68, 88, 115 (centre & btm)
Derek Croucher: p123
John S. Dunning (for the Cornell Laboratory of Ornithology): p37
Eric & David Hosking: pp16, 30 (centre left)
Peter Knight: pp10, 27, 30 (btm left & right), 34, 58, 70, 71, 74, 78, 94-5, 118, 119, 126, 127, 128, 129, 132, 134-5, 136-7, 138-9, 145
The publishers would like to thank Martin Jones Falconry Furniture for the loan of falconry equipment for the photograph on p123